PORTRAITURE

Richard Brilliant

REAKTION BOOKS

For Ethel Coolen Devlin, who taught me to face the world

Published by Reaktion Books Limited
11 Rathbone Place
London W1P 1DE, UK

First published 1991, reprinted 1997
Copyright © Richard Brilliant 1991

Designed by Humphrey Stone
Photoset by Rowland Phototypesetting Limited
Bury St Edmunds, Suffolk
Printed and bound in Great Britain
by BAS Printers Limited
Over Wallop, Stockbridge, Hampshire

British Library Cataloguing in Publication Data
Brilliant, Richard
Portraiture
I. Title
757
ISBN 0 948462 205
ISBN 0 948462 191 (paperback)

1002133 196

Contents

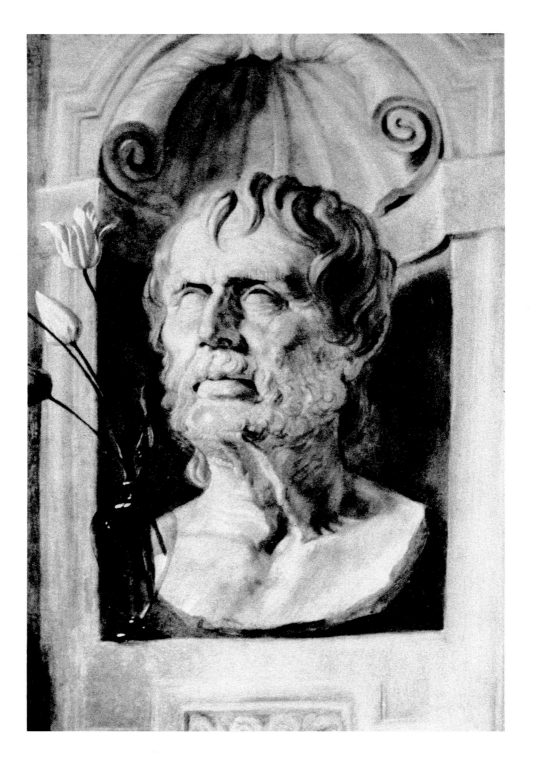

Introduction

Others in museums pass them by
but I, I
am drawn like a maggot to meat
by their pupilless eyes
and their putrefying individuality.

JOHN UPDIKE *'Roman Portrait Busts'*

Neither do I pass them by. I, too, am drawn to the avid contemplation of Roman and all other portraits because they give life to historical persons, freed from the bonds of mortality. Portraits stock the picture galleries of my memory with the vivid images of people, once known or previously unknown, now registered, preserved, and accessible through works of art that have become momentarily transparent. It is as if the art works do not exist in their own material substance but, in their place, real persons face me from the other side or deliberately avoid my glance. Quickly enough the illusion dissipates; I am once more facing not a person but that person's image, embodied in some work of art that asks me to regard it as such.

And yet, the oscillation between art object and human subject, represented so personally, is what gives portraits their extraordinary grasp on our imagination. Fundamental to portraits as a distinct genre in the vast repertoire of artistic representation is the necessity of expressing this intended relationship between the portrait image and the human original. Hans-Georg Gadamer called this intended relation 'occasionality', precisely because the portrait, as an art work, contains in its own pictorial or sculptural content a deliberate allusion to the original that is not a product of the viewer's interpretation but of the portraitist's intention. For Gadamer, a portrait's claim to significance lies in that intended reference, whether the viewer happens to be aware of it or not.[1] Therefore, the viewer's awareness of the art work as a portrait is distinctly secondary to the artist's intention to portray someone in an art work, because it is the artist who estab-

1 *Bust of Seneca* detail from Peter Paul Rubens, *Four Philosophers* (see illus. 13)

7

lishes the category 'portrait'. The very fact of the portrait's allusion to an individual human being, actually existing outside the work, defines the function of the art work in the world and constitutes the cause of its coming into being. This vital relationship between the portrait and its object of representation directly reflects the social dimension of human life as a field of action among persons, with its own repertoire of signals and messages.

This is a book about that relationship and about the things people do with, and expect from, portraits. It is not principally about how individual portraits can be identified but about the concepts that generate ideas of personal identity and lead to their fabrication in the imagery of portraits, deeply influencing their creation and their reception. In this regard I shall also address the reasons why so many viewers feel compelled to ascertain the names given to the images of men, women, and children in portraits – once the art works are known to be portraits – when the same viewers feel no similar compulsion to do so in their encounter with art works in other genres. Neither is this book about the attribution and dating of individual portraits, perhaps because that has been, and remains, an overwhelming preoccupation of so many art historians and collectors. Instead, it is about the way portraits stifle the analysis of representation, about the relationship between the presentation of the self in the real world and its analogue in the world of art, and about the necessary incorporation of the viewer's gaze into the subject matter of portraiture. In sum, this book investigates the genre of portraiture as a particular phenomenon of representation in Western art that is especially sensitive to changes in the perceived nature of the individual in Western society.

Simply put, portraits are art works, intentionally made of living or once living people by artists, in a variety of media, and for an audience. Portraits may survive as physical objects for a very long time and their images may be transferred to other media and even replicated in vast numbers (e.g., on postage stamps) with significant consequences in reception. In principle, however, only the audience is ill-defined at the time of the portrait's making, and it has unlimited potential for new appraisals of the person portrayed or for the generation of misunderstandings born of ignorance. The genre of portraiture, thus defined, excludes representations of named

horses, dogs, cats, or other favoured animals, as well as houses, cars, ships, trains, aeroplanes, and other inanimate things. Since the eighteenth century, at least, the term 'portrait' has been applied to all such images because of their explicit referentiality and, indeed, some individuals seem to relate to pets and to moving objects as if they were human, no doubt a comforting fallacy in a difficult, often hostile world. Despite the interest such images may possess for the study of representation, and for the analysis of the projection of human values on to non-human subjects, they are all excluded from consideration here. They are irrelevant to the core of the genre that involves the representation of the structuring of human relationships going back to the earliest stages of life, when the interacting self comes into existence.

The dynamic nature of portraits and the 'occasionality' that anchors their imagery in life seem ultimately to depend on the primary experience of the infant in arms. That child, gazing up at its mother, imprints her vitally important image so firmly on its mind that soon enough she can be recognized almost instantaneously and without conscious thought; spontaneous face recognition remains an important instrument of survival, separating friend from foe, that persists into adult life. A little later a name, 'Mama' or some other, will be attached to the now familiar face and body, soon followed by a more conscious acknowledgement of her role vis-à-vis the infant as 'mother' or 'provider', and finally by an understanding of her character, being loving and warmly protective towards the infant (in an ideal world, of course!). Eventually the infant will acquire a sense of its own independent existence, of itself as a sentient being, responding to others, and possessing, as well, its own given name. Here are the essential constituents of a person's identity: a recognized or recognizable appearance; a given name that refers to no one else; a social, interactive function that can be defined; in context, a pertinent characterization; and a consciousness of the distinction between one's own person and another's, and of the possible relationship between them.[2] Only physical appearance is naturally visible, and even that is unstable. The rest is conceptual and must be expressed symbolically. All these elements, however, may be represented by portrait artists who must meet the complex demands of portraiture as a particular challenge of their artistic ingenuity and empathetic insight.

Visual communication between mother and child is effected face-to-face and, when those faces are smiling, everybody is happy, or appears to be. For most of us, the human face is not only the most important key to identification based on appearance, it is also the primary field of expressive action, replete with a variety of 'looks' whose meaning is subject to interpretation, if not always correctly, as any poker player knows.[3] That larger physical movements, embodied in gait and gesture, could also be characteristic of particular individuals has long been recognized. Quoting his father, the great seventeenth-century sculptor Gian Lorenzo Bernini, Domenico Bernini observed that, 'If a man stands still and immobile, he is never as much like himself as when he moves about. His movement reveals all those personal qualities which are his and his alone.'[4] Bernini *père* translated actual motion into the baroque dynamics of his portraits, but few portraits at any time, even so-called realistic portraits, ever show anyone smiling or talking or moving with the exception, perhaps, of the candid photograph with its apparent lifelike quality and limited ambition. One must remember that the most human characteristic of all – the act of speaking – splits the face wide open, but portraits rarely show this because the genre operates within social and artistic limits.

Most portraits exhibit a formal stillness, a heightened degree of self-composure that responds to the formality of the portrait-making situation. Either the sitter composes himself, or the portraitist does it to indicate the solemnity of the occasion and the timelessness of the portrait image as a general, often generous statement, summing up 'a life'. Portraits of persons who occupy significant positions in the public eye – statesmen, intellectuals, creative artists, war heroes, and approved champions – usually bear the gravamen of their 'exemplary' public roles; they offer up images of serious men and women, worthy of respect, persons who should be taken equally seriously by the viewing audience. When such dignitaries smile, their smiles resemble the expressions of actors or politicians and are usually taken as something other than true, unaffected expressions of feeling. But even private portraits, made for more modest people who do not occupy the public space in any significant way, have a public aspect, perhaps because their images are indeterminate extensions of themselves that may one day escape from

the boundaries of privacy.[5] In the twentieth century, the older distinctions between the public and the private sphere have broken down, with a concomitant effect on the types of portraiture once considered appropriate for each. When, however, fame comes in fifteen-minute bits, as Andy Warhol trenchantly observed, very little remains private.

Portraits exist at the interface between art and social life and the pressure to conform to social norms enters into their composition because both the artist and the subject are enmeshed in the value system of their society. This may explain, in part, the prevalent formality of private portraits as a code of right behaviour, reflecting the constraints imposed by the conventions that govern one's appearance in public and before strangers. Adding to their force is the conscious or unconscious wish to 'put one's best foot forward' which increases the tendency to conceal the individual's personal idiosyncrasies and expose only those features that are known to make the best impression. In general, despite the overt limitations of their audience, most private portraits with any pretension of 'dignity' resemble funeral orations or eulogies which typically portray the deceased in positive, formulaic ways.

Good reputation is more a given than a gain. Its suggestion in a favourable portrait is achieved by the use of representational conventions – e.g., the standing, sombrely dressed figure – developed by artists and consistent with the expectations of the viewing audience. Thus, the formality and evident seriousness displayed by so many portraits as a significant mode of self-fashioning would seem to be not so much typical of the subjects as individuals as designed to conform to the expectations of society whenever its respectable members appear in public. In this sense, to be portrayed by an artist is to appear in public.

Portraits reflect social realities. Their imagery combines the conventions of behaviour and appearance appropriate to the members of a society at a particular time, as defined by categories of age, gender, race, physical beauty, occupation, social and civic status, and class. The synthetic study of portraiture requires some sensitivity to the social implications of its representational modes, to the documentary value of art works as aspects of social history, and to the subtle interaction between social and artistic conventions.

To consider a portrait and its subject solely as a social arte-
fact is to adopt a restrictive view of the nature of individuality,
as if the social role, or the type represented, were the only
basis for defining personhood. Social roles, however enacted,
are like masks or disguises, carefully assumed by individuals
in order to locate themselves in a society conditioned to recog-
nize and identify these forms of representation in practice
and in art. If there were nothing more than that, then rep-
resenting a person in a role, defined by society, would not be
a disguise to conceal some uniquely private kernel of being,
because there would be nothing to conceal, no inner reality
that the portraitist would be obliged, somehow, to uncover
or express. Personal identity would be constituted as a social
artefact, the product of a consensus from without pointed to
a familiar type, fixed as such on to the surface of the portrait
by a variety of established iconographic devices, fleshed out
by the peculiarities of face and physique, and itemized by
name. There would be very little that was 'personal' about
such a construction of identity, except for the uniqueness of
the genetic mix, and even that comes from elsewhere. A por-
trait conceived in such typical terms would resemble an entry
in the census, given meaning only by reference to the broad-
est social context and bound to the typecasting generalities
that pertain to that context. Despite the admitted importance
of type providing the frame of reference in portraiture, people
are not quite like ants, fortunately for the portrait artist; other-
wise there would be no commissions, no 'occasionality' to
which they would be asked to respond.

In the face of human variety, passive conceptions of
personhood seem too indefinite, as if independence of being
were a mirage and the attempt to represent it delusive. But
human beings incorporate both the general and the particular
in their lives, in their bodies, in their thoughts and emotions,
and in their memories. Memory transcends divisions of time,
obscures physical change, and collapses the disparate stages
of human existence, making possible a holistic conception of
one's life. Personality, then, seems to arise from the particular
instance of the integration of mind and body that marks a
person as a distinct entity within society.[6] Whether this per-
sistent inner character or 'soul' can be empirically demon-
strated or not, if the artist believes that it exists, then the
resulting portrait must contain something more than the eter-

nality of appearance and the banality of social affect.

The artist required to express an individual's personality would, necessarily, depend on his insights as an analyst of character and on the accumulation of his own memories of the subject, confirmed or challenged by the viewer. The operation of reflective and self-correcting memory in the establishment of personal identity was well stated by the philosopher David Hume:[7]

> Resemblance depends on the memory which raises up the image of past perceptions . . . Memory not only discovers the identity, but also contributes to its production, by producing the relation of resemblance among the perceptions in continuing association. Memory does not so much produce as discover personal identity by showing us the relation of cause and effect among our different perceptions.[8]

Conflicting views on the nature of personal identity have confounded the very concept of the portrait as a significant genre of representation because they affect the answer to a basic question presented by art works of this kind: 'Who is the who that is being represented?'[9] Those who would deny the existence of a singular personal identity, separate from its social context, would consider this question irrelevant; identity, conceived in such absolute terms, would be incomprehensible to an artist and, thus, impossible to represent. The allegedly irreducible nature of human beings may present a dilemma to philosophers, resolvable only by an extended metaphysical speculation about the 'beingness' of the 'someone' embodied in the person, let alone secondarily represented by a portrait. After all, what does it mean to be Socrates or Queen Elizabeth or Jackie Kennedy (illus. 31, 45, 60) or, indeed, any other person whom one has identified by name, in life or in art? Portrait artists may not often concern themselves with metaphysics, although Marcel Duchamp seems to have done so in a seemingly self-denying self-portrait (illus. 85). Portraits do, however, confront the issue of truthfulness of representation, given the occasionality of reference inevitably connecting the art work and the person (e.g., illus. 13).[10] There is more than a touch of irony in John Singer Sargent's remark that, 'A portrait is a likeness in which there is something wrong about the mouth.'[11] One way to

look at portraits as a genre involves consideration of the truth value of their representations since the work of art, it is readily admitted, cannot be taken as the equal of the original, even if excruciatingly descriptive (illus. 17–19).[12]

The portrait's success in effectively and reliably expressing something of, and something about, the person depends largely on the quality of the artist's perceptions and on his ability to manifest the peculiarities of appearance and character in a manner that is both accessible and satisfactory to other viewers. However it may be achieved, the artistic definition of identity would seem to be the *focus* of that visual processing of information needed to bring together the various ingredients that constitute the basis of identification. In portraiture the possibilities of identification range far beyond the boundaries of mimetic description (e.g., illus. 22, 26, 27, 50, 62, 75).

Making portraits is a response to the natural human tendency to think about oneself, of oneself in relation to others, and of others in apparent relation to themselves and to others. 'To put a face on the world' catches the essence of ordinary behaviour in the social context; to do the same in a work of art catches the essence of the human relationship and consolidates it in the portrait through the creation of a visible identity sign by which someone can be known, possibly for ever (e.g., illus. 64, 72). This sign constitutes the admission that there is 'someone' out there worthy of identification and preservation, although sometimes people change their minds with violent effect (illus. 4). Portraits make value judgements not just about the specific individuals portrayed but about the general worth of individuals as a category (illus. 15, 41). The relative frequency of portraits in a given society may therefore be an indicator of personal wealth (illus. 47), or arrogant vanity (illus. 19, 44), or of fashion (illus. 5, 7) and, collectively, of the worth assigned to human life itself. The extraordinary attempts made by portrait artists over the centuries to fix the image of persons by visualizing their appearance and/or character and, at the same time, to produce an accessible and acceptable object of art reveals the enormity of the task (e.g., illus. 5, 3, 13, 14).

Portraiture challenges the transiency or irrelevancy of human existence and the portrait artist must respond to the demands formulated by the indivdual's wish to endure. The nature of that response is affected by three questions whose

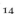

answers may be neither consistent nor complementary:

What do I (you, he, she, we, or they) look like? Through one's looks, a person becomes superficially known. Some degree of resemblance is then the willed connection between the portrait image and the person or persons to whom it refers. In this way, the portrait makes visual recognition by the viewer more or less likely and thereby asserts the existence of the person portrayed and the viewer in the same psychological space (illus. 7, 19, 78).[13] Abstract or non-descriptive portraits therefore challenge the working assumption that easy visual recognition is an essential requirement and attack the importance of physical resemblance as the criterion for assessing the quality or insightfulness of a portrait (illus. 22, 62, 75).

What am I (you, she, he, etc.) like? Depending on the conventions of representation, the portraitist's characterization penetrates beneath the surface of appearances. However, notions of character, themselves shaped by culture, fall into two distinct groups; one is predicated on external social qualifications, such as that queens are regal (illus. 45) and intellectuals intellectual (illus. 28–9), the other on salient aspects of personal behaviour, such as Franklin Roosevelt's buoyant courage (illus. 26) or Zola's critical acumen (illus. 14).

Who am I (you, etc.)? This question can also be answered in two different ways. The more common response is presented in terms of social designators, such as senator (illus. 18), magnate (illus. 51), industrialist (illus. 43), noble lord (illus. 38), married couple (illus. 40), inventor (illus. 65), celebrity (illus. 63), artist (illus. 31, 34, 41, 82, 83). When the response is not articulated by reference to a social construct but, rather, by some perception of an essential characteristic, such as George Sand's alienation (illus. 21), or Goethe's humanism (illus. 54), or Matisse's artistry (illus. 61), then the burden of representation is very great because it requires so much prior knowledge of the subject by the viewer.

Portrait artists attempt to answer these questions in their work, but often with great difficulty. The complexity of the process, the contentiousness of its resolution, and the fragility of its apparent success are fully revealed in Porphyry's classic account of the portrayal of his teacher, Plotinus, the third-century philosopher, by the artist Carterius:

He showed, too, an unconquerable reluctance to sit to a painter or a sculptor, and when Amelius persisted in urging him to allow of a portrait being made he asked him, 'Is it not enough to carry about this image in which nature has enclosed us? Do you really think I must also consent to leave, as a desirable spectacle to posterity, an image of an image?'

In view of this determined refusal Amelius brought his friend Carterius, the best artist of the day, to the Conferences, which were open to every comer, and saw to it that by long observation of the philosopher he caught the most striking personal traits. From the impressions thus stored in mind the artist drew a first sketch; Amelius made various suggestions towards bringing out the resemblance, and in this way, without the knowledge of Plotinus, the genius of Carterius gave us a lifelike portrait.[14]

This passage pinpoints several major issues generated by the making, or taking, of a portrait. First, no one now knows what Plotinus really 'looked like' and no portraits of him survive from Roman antiquity, despite his moral authority and great fame as a philosopher, at least none that scholars can agree on.[15] It would therefore be impossible to establish by what criteria the portrait was, or should have been, considered 'lifelike'. Second, the portrait was made by an acclaimed artist, Carterius, at the behest of a sophisticated and persistent patron who wished to preserve the image of his revered master for posterity. One must assume that Carterius enjoyed a high reputation (in Rome) and, given the response to his portrait of Plotinus, deserved it. As a distinguished artist, Carterius must have brought some individual, personal manner to bear on the work he produced and had become known for a style or approach to portraiture favoured by his patron, Amelius. Unfortunately, modern scholars know nothing about Carterius or his work and can thus only guess what Plotinus' portrait might have 'looked like' on the basis of comparative studies of Roman portraiture in the 260s and 270s. Of course, by the third century AD Greek and Roman artists had long employed the convention of representing philosophers as fully mature, bearded men, so Carterius' lost portrait of Plotinus must also have shown him 'looking like a philosopher'.

Inevitably, Carterius' manner and his approach to the task of portraiture must have influenced the formation of Plotinus' image. That image also developed over a long period of observation; it was subjected to frequent amendment and modification according to some agreed-upon standard of correctness, as defined by the philosopher's 'most striking traits', subsequently enriched by suggestions from Amelius. Carterius made his observations not from the whole spectrum of Plotinus' life but only from the Conferences where, as the greatest philosopher of his age, Plotinus was most distinctly 'himself'. At the end of a long process of image-making and matching against the original Plotinus and the fictive 'Plotinus', as conceived by the patron, Amelius, his biographer and most important pupil, Porphyry, and Carterius, an inspired artist, a 'lifelike portrait' appeared . . . finally.

Amelius commissioned this complicated and difficult work because he wanted to have a portrait that would transcend the limitations of Plotinus' own life, one that would have an existence independent of the philosopher's own body. He also wanted the portrait to have an abstract representative function, a kind of idealization befitting such a great philosophical mind. Amelius and Carterius were extremely ambitious, seeking to deny the perishable transience of Plotinus' life, the life they knew. They also wished to increase the dimension of his being by producing a representational sign – for others to see – that suitably connected his evanescent physical self with his far more substantial philosophical genius. Their transcendent objective was implicitly criticized by Gadamer seventeen centuries later as an impossible ambition because Plotinus' contemporaries had no way of knowing whether what they saw in the portrait would ever be seen by others in the distant future. If their faith in Carterius was well placed, and the portrait had survived, he might have made an image of Plotinus for all seasons.

The portrait is only an intensified form of the general nature of a picture. Every picture is an increase of being and is essentially determined as representation, as coming-to-presentation. In the special case of the portrait this representation acquires a personal significance, in that here an individual is presented in a representative way. For this means that the man represented represents himself in his

portrait and is represented by his portrait. The picture is not only a picture and certainly not only a copy, it belongs to the present or to the present memory of the man represented. This is its real nature. To this extent the portrait is a special case of the general ontological value assigned to the picture as such. What comes into being in it is not already contained in what his acquaintances see in the sitter. The best judges of a portrait are never the nearest relatives nor even the sitter himself. For a portrait never tries to reproduce the individual it represents as he appears in the eyes of the people near him. Of necessity, what it shows is an idealization, which can run through an infinite number of stages from the representative to the most intimate. This kind of idealization does not alter the fact that in a portrait an individual is represented, and not a type, however much the portrayed individual may be transformed from the incidental and the private into the essential quality of his true appearance.[16]

Gadamer's statement on the nature of portraits is at odds with Porphyry's account of portraying Plotinus from an existentialist viewpoint. The modern German thinker seems to value the portrait as a significant consolidation of the self much more than the ancient philosopher. Plotinus, as we have read, strenuously objected to the value of the whole portrait-making enterprise which, at best, would lead to a second-hand image of an image even further from the real 'Plotinus' than he was himself. This assertion was consistent not only with his own philosophical principles but also with the Platonic tradition holding that mimetic transcription had little value and that images, especially as represented by art works, were and remained distinctly separate from the realities to which they so weakly referred.[17] But it was precisely the representative and substitutional capacity of Plotinus' image that was eagerly sought by Amelius. For him and for Porphyry this portrait was no false surrogate but, rather, warranted a high degree of acceptance, even if as pupils of their admired master they had to reject the equivalence of his person to his portrait and, ultimately, of his physical person to his indescribable soul. In their eyes, Carterius' portrait of Plotinus was enough to make them think about him and to feel his presence, confident in the belief that anyone seeing

it would also respond to that residue of his being contained in the portrait.

In portraying Plotinus for posterity, the artist Carterius first made a work of art for his patron. Once he had completed the portrait, it became independently capable of having an effect on Amelius, an effect that united his aesthetic perceptions and personal experiences of Plotinus in a single judgement of quality. Yet, when in ordinary speech we talk about whether a portrait is 'good' or 'bad', we mean whether the image is faithful to the original, at least according to the way we see it. Portraits owe their high reputation and enormous popularity to their unique subject matter and to the intensity of the viewer's engagement with the portrait image at a much deeper level of personal involvement and response than is usually encountered in the experience of visual images.[18] The dynamic, often ambivalent relationship between the viewer and a portrait ranges widely from feelings of reverence and respect for public figures, to the disrespect, even dislike, implicit in caricature (illus. 27), to an outright, destructive hostility (illus. 4). Images of political leaders fallen from power are often destroyed because the act of destruction of the portrait expresses the anger of the viewer against the person represented and his eagerness to obliterate the one-time leader's existence as a historical being. To kill an image is to kill the possibility that the image will cause someone to remember the original.

The survival of private portraits is often a matter of chance, once the private connection that led to their making dies, unless the art work has some supervening aesthetic or historical importance. Private portraits elicit a great variety of emotional responses from the members of their audience, especially because the psychological space is so narrow and the personal attention so focused. This is very much the case with family portraits, or, more properly, portraits of the viewer's family, when the strength of the emotional attachment renders the artistic component of the image nearly invisible. The intensity of family feeling and its translation into a desire for closeness are superbly conveyed by the Latin poem written by the Renaissance humanist, Baldassare Castiglione, about his portrait by Raphael early in the sixteenth century. Perhaps because he could never admit the possibility of confusing his image with himself, Castiglione adopted the fiction

that his wife, Ippolita Torella, was writing to him while he was away from home, consoling herself by interacting with his portrait:

> When alone, the portrait by Raphael's hand
> Recalls your face and relieves my cares,
> I play with it and laugh with it and joke,
> I speak to it and, as though it could reply,
> It often seems to me to nod and motion,
> To want to say something and speak your words.
> Your boy knows and greets his father, babbling.
> Herewith I am consoled and beguile the long days.[19]

Soldiers at war and their families have similar responses to photographs, even without the benefit of an artist of Raphael's stature. One hopes that when Castiglione returned home, his wife was not disappointed, given the splendour of Raphael's portrait as a masterpiece of Renaissance portraiture.

Castiglione's poem acknowledges the double nature of portraiture and how for some viewers the portrait was no art object but a living being.[20] Portraits contain images that with bewildering success pretend not to be signs or tokens invented by artists, but rather aim to represent the manner in which their subjects would appear to the viewer in life.[21] In this book I have tried to expose this pretension and analyse the magical effect which portrait images have on the viewer. Chapters II–IV investigate the properties of this seemingly invisible sign in the making of portraits, with particular reference to the creation of a self and an identity, and to the personal nature of the viewer's gaze. Almost against my will I acknowledge, in Chapter I, that the portrait is also a work of visual art with special powers of representation; any legitimate attempt to understand what portraits are, as art works, involves the consideration of what portraiture itself is, an artistic genre with a long history of conscious development and critical reception.[22] Significantly, some of the greatest artists – of the stature of Rubens (illus. 13), Rembrandt (illus. 32), Manet (illus. 14), and Duchamp (illus. 85) – made the concept of portraiture the worthy subject of their art. They were not alone in doing so, as the classical biographer, Plutarch, acknowledged long ago:

Just as painters get the likenesses in their portraits from the face and the expression of the eyes, wherein the character shows itself, but make little account of the other parts of the body, so must I be permitted to devote myself rather to the signs of the soul in men, and by means of these to portray the life of each, leaving to others the description of their great conceits.[23]

1 The Authority of the Likeness

Family photographs, taken by some willing amateur at a family event, often have an unsettling reception. When the prints are available for public viewing, family members remark on the general quality of the photographs, accompanying their observations with such comments as, 'Oh, that's not Aunt Mary! It looks like her, all right, but something's missing. You just didn't get her right.' A certain truth emerges from such statements because we all make a number of assumptions, usually unstated, about the appearance of people, well known to us, for whom we use a particular name, thinking to ourselves, 'That's Mary.' When our mental image of 'Mary' fails to coincide with her photographic image, we are, quite naturally, disappointed and respond with, 'That's not really Aunt Mary.' What we mean but do not say is, 'That's not Aunt Mary to me.' There seems to be something inadequate or even false about the image presented to us in the photograph, even though we saw Cousin Jack take the photograph. And we expect the camera to take an honest, unadulterated, and correct picture of Aunt Mary but it has failed to do so. In some essential way, the direct, unequivocal analogy between the original Aunt Mary and her photographed image has broken down, even if there is sufficient resemblance between them for us to say, 'That's not the Aunt Mary I know.'

There is great difficulty in thinking about pictures, even portraits by great artists, as art and not thinking about them primarily as something else, the person represented. The reception given to a portrait by the viewer, especially by one familiar with the person portrayed, conflicts with the normative function of a representation to produce something clearly distinct and distant from the person represented. Sartre put the matter quite succinctly:

> My intention is here now; I say: 'This is a portrait of Peter', or more briefly: 'This is Peter'. There the picture is no longer an object but operates as material for an image . . . Every-

thing I perceive enters into a projective synthesis which aims at the true Peter, a living being who is not present.[1]

The immanent power of a portrait image stimulates cognition with such force that the psychodynamics of perception interfere with the comprehension of the image as something different from the image of the actual person.[2] When Sartre says, 'This is Peter', he means that the portrait image is so much like the Peter he knows that, in effect, it has become 'Peter'. A similar transference, strengthened by hostility, often leads to the wilful destruction of the images of the once powerful, such as Stalin. His colossal statue once stood fifteen metres high in Yerevan, but now only a disembodied fragment nestles disconsolately amid the fallen leaves (illus. 4), a broken idol no longer revered, a portrait killed by hatred. Conversely, respected public figures continue to maintain themselves through the portraits that dominate so many public places all over the world. Exemplary of this vivid imagery is the sculpted pair, Vittorio Emanuele II and Garibaldi, heroes on horseback, shaking hands – yes, shaking hands – in the central piazza at Fiesole (illus. 2), as if the bronze statues were transformed into gesturing actors, seemingly engaged in an interminable conversation in the public space.[3]

Portraits can elicit responsive behaviour from viewers as if the art works presented themselves in the form of a proposition, 'This is so and so', and the viewers then behaved accordingly. Propositional statements are fundamental to everyday experience because they articulate our beliefs,

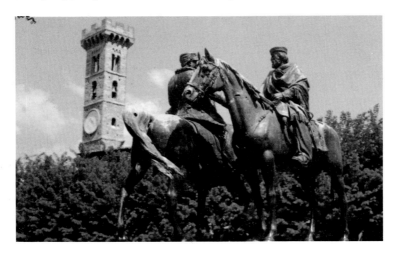

2 Oreste Calzolari, *Vittorio Emmanuele II and Garibaldi*, Fiesole, 1906

offered as the predicates of a given subject, e.g., 'This is John'. Portrait images tend to do the same because the urge to identify the subject realizes the connection between the viewers' awareness that the art works they see are portraits and their general knowledge that art works of this kind always refer to actual persons.[4] Therefore, the propositional definition of all portraits conflicts with the recognized capacity of portrait images to represent, or stand for, someone, rather than to be that someone. Because portraits require some discernible connection between the visible image and the person portrayed in order to legitimize the analogy, some degree of resemblance is normally posited, however imagined. That purported resemblance, a restriction on the image's freedom of reference, has brought about the use of the term 'likeness' as a synonym for 'portrait'. Despite the frequency of its use, the term has its problems, as demonstrated by the 1863 case of *Barnes* v. *Ingalls*, involving the work of a portrait photographer. As Judge R. W. Walker opined:[5]

> A most important requisite of a good portrait is, that it shall be a correct likeness of the original; and although only 'experts' may be competent to decide whether it is well executed in other respects, the question whether a portrait is like the person for whom it was intended is one which it requires no special skill in, or knowledge of, the art of painting to determine. The immediate family of the person represented, or his most intimate friends, are, indeed, as a general rule, the best judges as to whether the artist has succeeded in achieving a faithful likeness. To eyes sharpened by constant and intimate association with the original, defects will be visible, and points of resemblance will appear, which would escape the observation of the practised critic . . . The fact of likeness, or resemblance, is one open to the observation of the senses, and no peculiar skill is requisite to qualify one to testify to it.

Even the notion of likeness assumes some degree of difference between the portrait image and the person, otherwise they would be identical and no question of likeness would arise. Therefore, the degree of resemblance sufficient to establish a likeness is open to dispute not only about how much, but also about how little, can be permitted and the image still

claimed as a portrait. Since the correspondence between the original and the portrait must necessarily be incomplete, then the discrepancy has to be false with respect to likeness but, nevertheless, justified by the interpretive value of the portrait as a distinct work of art. The more a portrait resembles its human counterpart, the more obvious and destructive of the illusion of comparability are the substantial differences between them.[6] The degree of likeness required of a portrait may vary greatly, affected by changing views about what constitutes 'resemblance' and whether it can ever be measured on an objective basis.

Portraits, like all images, have privileged properties of representation that affect recognition. This is partly because the images themselves establish coherent structures of information that, as art works, can be taken as self-evident.[7] For Roger Fry, however, the incorporation of such information in a descriptive likeness was an impediment to his knowing the subject, when he said of Sargent's portrait of General Sir Ian Hamilton, 'I cannot see the man for his likeness'.[8] Whatever the mimetic quality of a portrait, the work remains a representation of the subject whose value as an approximation is less determined by its descriptive character than by the coincidence of the perceptions shared by the portrait artist and the viewer. Portraits also incorporate various indexical properties whose primary function is to signal an individual's presence by symbolic means, often highly concentrated, so long as the image has a proper name. Thus, according to Roger Scruton,[9]

> if we assume paintings, like words, to be signs, then portraits stand to their subjects in the same relation as proper names stand to the objects denoted by them. Hence, representation and denotation are the same relation . . . Denotation is the special case of reference exemplified by proper names and portraits – that case where a symbol labels one individual.

Two very different paintings, one attributed to Botticelli (illus. 5), the other by John Frederick Peto (illus. 3), exemplify the signal aspects of portraiture and the respective artists' conscious interpretation of their attitudes towards portraiture itself.

The late-fifteenth-century *Portrait of a Young Man with the Medal of Cosimo de' Medici* in the Uffizi (illus. 5) bears the

marks of Botticelli's distinctive linear style and exhibits his usual preference for representing young men with strong chins and somewhat irregular features. Although the subject has not been identified, there seems little reason to doubt that the painting is a portrait because of its descriptive specificity and contemporary air, and because the work is neither mythological nor religious in subject matter. That the youth must have been a historical person is also signalled by the gilded gesso copy of the medal which he holds so prominently. The actual medal, of which the gesso is an exact copy, was cast in 1465 to commemorate Cosimo de' Medici who had died the year before. In holding out the replica, the youth seems to be asserting both that Cosimo was still remembered as he was and that he, himself, was of the Medici party.[10] This Renaissance painting is also about portraiture, its conventions, the motifs used by artists of the time in making portraits, and the relation between the person portrayed, or more correctly his image, and the spectator. The youth appears in a nearly half-length bust – a familiar, if noble, portrait motif, well established at the time; the bust is set slightly obliquely but the psychological distance between the youth and the viewer has been closed by the directness of his outward, frontal gaze towards the viewer, to whom he openly displays Cosimo's medal as a token. The carefully replicated medal, in turn, shows how much information can be packed into a very small frame. Even the reduced profile manages to maintain the recognizability of Cosimo's distinctively craggy, aged face, so well preserved in his numismatic portraits after his death. Finally, the artist's choice of frontal and profile modes of presentation effectively distinguished between the portrayal of the living and of the dead. The youth directly addresses the viewer in the first person and shares his psychological space with him so that both can refer to the dead Cosimo in the third person, and with due respect.[11]

Peto's *Reminiscences of 1865* (illus. 3) was painted shortly after 1900 and exhibits his highly realistic, superbly finished style of *trompe l'oeil* painting.[12] The work is indirectly a portrait, although its imagery in fact includes two portraits, one apparently a meticulously reproduced popular lithograph of Abraham Lincoln, suitably and familiarly identified, the other an unknown man on a partly concealed twenty-five-cent banknote. Lincoln's presidential portrait was so well-known

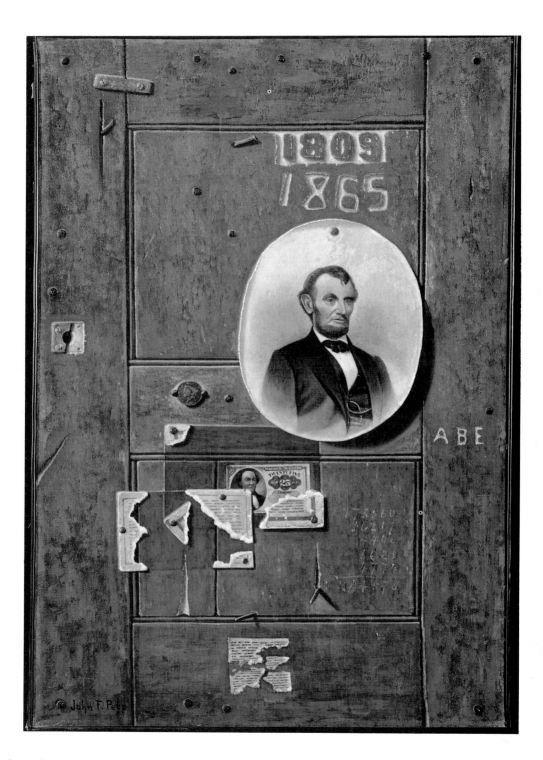

and so physically distinctive that recognition by any American would have been instantaneous, even without the label 'Abe'. But Peto has adopted an elegiac mood towards Lincoln, as if representing him took on the character of a memento mori once the viewer considered the implication of Lincoln's dates of birth and death, carved into the wood in the manner of an epitaph. Peto, however, had used Lincoln as a surrogate for his father who died in 1895, perhaps because he could not bear to portray him directly as a dead man. In effect, then, Peto converted Lincoln's portrait from a public image to a private symbol, thereby achieving a controlled transference of his feelings that enabled the artist to represent his father not in his own likeness but under the masking cover of a much honoured parental model.

These two paintings encompass many fundamental aspects of portraiture, beginning with the problematic identification of the principal subject. In the *Portrait of a Young Man* (illus. 5) the youth is unknown but sufficient clues are provided by the work and its format for one to classify the painting as a portrait in the context of Italian Renaissance art and to pursue the consequences of that determination when interpreting its imagery. In Peto's *Reminiscences of 1865* (illus. 3), despite the overt inclusion of portrait images, the work cannot be readily classified as a portrait: it only takes on aspects of commemorative portraiture when knowledge about the special circumstances of its creation becomes available to the viewer. Unless one knows better, Lincoln's portrait could be considered as a highly-charged, realistic item in a traditional *trompe l'oeil* painting, subservient to the demands of that genre, although an important part of the mental world of the artist. In both works, public (Cosimo and Lincoln) and private elements of portraiture come together, the content enriched by the public images' high degree of recognition and their attendant associations. In both works, also, the public images appear as if they were accurate reproductions of portraits in other media, appropriate to the public domain; these images have been displaced from the public context and converted to private use without, however, losing either their public character or their identity as portraits.

Both paintings call into question the importance and function of names, usually considered an essential aspect of portraiture because names so precisely identify the reference

at the core of the genre. In these paintings, not all the persons portrayed are identified but some are, and quite explicitly, to ensure proper identification, e.g., the legend on Cosimo's medal and the carved 'Abe'. These names are historically correct, as correct as the portrait images they accompany, but the naming inscriptions themselves are also ambivalent, serving either as a proclamation of political allegiance in the Renaissance painting or as a potential alias in Peto's covert invocation of his father's memory. Furthermore, real and apparent differences in scale and medium in both paintings force a responsible viewer to confront the artist's choice of genre and the effect of that choice on the work, when the artist's intention to portray is just as fundamental to the constitution of the portrait as its occasionality. Peto, however, never represents his father directly but only inferentially, thus raising the issue of whether his painting is a portrait at all.

These questions and issues properly belong to the consideration of works that are, or might be, portraits because they address the nature of portraiture as a complex genre. They do not ordinarily appear in the study of portraits, which has been overwhelmingly preoccupied with the naming of subjects and the identification of portrait artists and the devices they use. Naming focuses on the imputed resemblance of the art work to the individual or individuals portrayed, although anyone who analyses the imagery of the portrait in Western art soon discovers that portraits are not merely recognizable faces and bodies, nor even likenesses in any common sense of the term. After all, no one considers a collection of fruit, glasses, and bottles on a table to be a 'still life' without the intervention of an artist, and neither is the mere likeness of these objects a still life; rather, a still life is an artificially constructed genre with a long history of representation that goes beyond immediate observation, realistic depiction, and schematic models of composition to convey certain meanings about the world.[13] Yet, the critical and descriptive writing on portraits continues to emphasize the referential character of a portrait, amateurs and collectors hunt for names – the bigger, the better – and art historians increasingly turn to considerations of patronage, the definition of portrait conventions, and the isolation of distinct programmes of display and their reception.[14]

These worthy considerations properly direct attention to

the objects themselves and to the circumstances of their making; in other words, to portraits but not to portraiture whose history and character as a genre influences the specific instances of portrayal. The agenda of such studies reflects once again the traditional emphasis on the person portrayed as the centre of empathetic and aesthetic response, although the latter is often compromised by the rapidity of the transfer of interest from the image to the person. Alternatively, attention may be directed to the role of the portrait artist in creating a work shaped by his talent and craft, by the perspicacity of his interpretation, and by the affective relationship between himself and his subject, both as responsive human beings and as 'artist' and 'sitter'. The resulting portrait may resemble a battlefield, documenting the struggle for dominance between the artist's conception and the sitter's will.[15]

Whether formed in conflict or in a more collaborative manner, any portrait represents some compromise at the time of making, a compromise that may be neither understood nor accepted by a third party, a viewer not privy to the intimate psychological exchange between the artist and the person portrayed but whose view often determines the significance of the work, or of the subject. In nineteenth-century novels by writers such as Walter Scott or Gustave Flaubert, the principal characters are made to appear especially significant because we get to see them at key moments when, at the author's discretion, they reveal themselves to the reader.[16] Such artful characterizations have their basis in life, particularly in the ways certain public figures, or celebrities, create a public persona; Samuel Clemens so successfully invented 'Mark Twain' that the latter came to constitute his acknowledged identity, because he made every effort in public to behave and look like the Mark Twain of people's expectations.[17] Every portrait makes the subject look like something, however confected that something may be, and the very act of making a portrait confirms, even in some small way, the reality of the historical person according to the standards of the time. But the portrait as an art object lives on and the individual portrayed either runs the risk of losing his former prominence (illus. 4), or it might be maintained (illus. 2), or renewed in unexpected ways (illus. 5).

More than eighty years ago Wilhelm Waetzoldt observed that a portrait gives rise to three distinct psychological

responses: one stimulated by the actual appearance of the human original, the second by its artistic treatment, and the third by the attitude of a disinterested viewer.[18] The last, unfortunately, is an almost unlimited variable (e.g., illus. 5, 3) that can undermine the often-stated importance of the 'intention to portray', unless the relationship between the original and the art work is so manifest that recognition of the existence of the former by means of the latter is inevitable (illus. 3). Ernst Buschor addressed this vexing problem of intention by expanding the concept of the portrait beyond its fixation on the unique original; he included the representation of the model as one of an established type, defined by its historical, cultural, and artistic setting, a contextualization of the portrait still followed by Dülberg and Campbell in their recent studies of Renaissance portraits.[19] Perhaps it is easier to recognize the individual in the type than the type in the individual, given the importance of deduction in our daily encounters with others. This emphasis on the externalities of reference, as manipulated by the artist, leaves little room for the opposite view that the key to any study of portraiture lies in the history and variation of the concept of personality, because it is personality that gives individuality to the type and human worth to the subject.[20]

To say that 'portraiture is the depiction of the individual in his own character' is to ignore the even greater difficulty of describing the personality of an individual through the visual rather than the verbal image, especially when the very definition of personality or character is itself so socially and culturally determined.[21] The difficulties apparent in this simple assumption about the nature of portraiture have been beautifully stated by Marcel Proust:[22]

> We are not a materially constituted whole, identical for everyone, which each of us can examine like a list of specifications or a testament; our social personality is a creation of other people's thought.

Such a creation of other people's thought subtly affects the characterization of the subject in Anne-Louis Girodet-Trioson's *Portrait of Jean-Baptiste Belley*, c.1797 (illus. 7).[23] Belley, born in Senegal, was a leader of the Santo Domingo uprising against France and had been sent from Santo Domingo as a deputy to the National Convention in Paris where

4 S. Merkusov, *Stalin*; remnant of a concrete statue in Yerevan destroyed in 1950

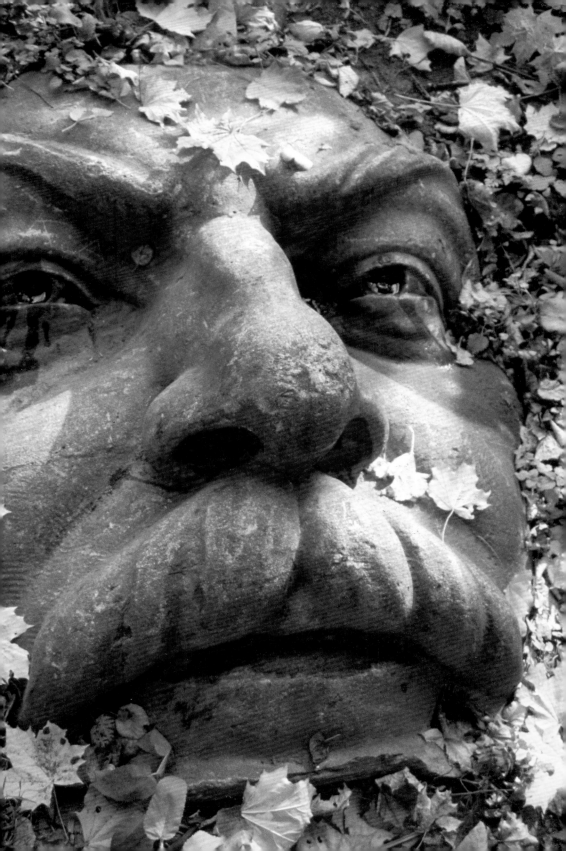

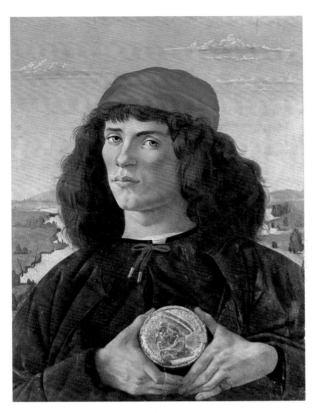

5 Sandro
Botticelli, *Portrait
of a Young Man with
a Medal of Cosimo
de' Medici, c.* 1465

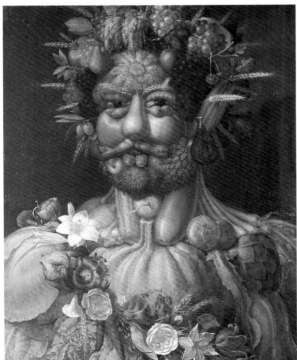

6 Giuseppe
Arcimboldo,
*Rudolph II as
Vertumnus,
c.* 1570

he enjoyed a brief political career and some notoriety in the 1790s. The artist portrayed Belley as an elegantly dressed black man, casually leaning against a podium which supports what appears to be a marble bust portrait, carved in the old Roman fashion, and bearing the identifying inscription, 'T. Raynal'. Guillaume-Thomas-François Raynal (1713–96), historian and philosopher, was a renowned anti-colonialist, an enemy of the Inquisition, an opponent of the mistreatment of blacks, and an activist in the Revolution. His presence in Belley's portrait is particularly appropriate, a noble and severe counterpoint to Belley's casual, contemporary image, and a fitting symbol of Raynal's republican principles and their practical demonstration. His character-laden bust would seem to exemplify the contemporary physiognomist J. C. Lavater's understanding of portraiture:

> What is the art of *Portrait Painting*? It is the representation of a real individual, or part of his body only; it is the reproduction of an image; it is the art of presenting, on the first glance of an eye, the form of a man by traits, which it would be impossible to convey by words.[24]

But what about Belley, the principal subject of this portrait? Towards Belley the artist reveals a prejudiced attitude, governed by typological preconceptions about him that operate beneath a veneer of civilization and employ classical references of a very different order of meaning. Raynal's portrait-within-the-portrait takes the prestigious form of a classical bust, overtly proclaiming its suitability as an image of a white, European intellectual, even though Raynal, who died only the year before, was a figure of contemporary history. Despite the stylishness of his clothing, Belley is portrayed as an outsider whose pose recapitulates that of the *Capitoline Satyr*, a famous Roman copy of a statue by Praxiteles, well-known to the artist's public and traditionally interpreted as the image of an uncivilized being.[25] Belley's relaxed pose, small head, and sloping profile more than hint at the moralizing basis of this racial and ethnic characterization with its negative implications.

Portraiture is such a calculating art of (mis)representation that no beholder can be completely innocent. Girodet-Trioson's impartiality as an observer vanishes in the face of the invidious comparisons he has set up between Raynal and

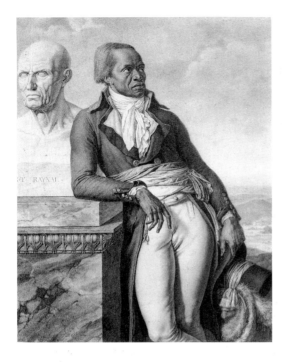

7 Anne-Louis
Girodet-Trioson,
Portrait of Jean-Baptiste Belley, c. 1797

Belley as historic personages, and between their respective 'characters'. The artist has followed the programme of an old portrait tradition that specified the degrees of resemblance that portraits should strive to achieve: to depict the external features of the model; to reveal the model's special features and to make them stand out from those features that are commonly recognizable; and to generalize the artist's observations by suggesting in a face not only a person but also his heredity, race and, above all, what this transitory being has in common with humanity.[26] In following this tradition, Girodet-Trioson has so obviously differentiated his subjects that a contemporary viewer would have had no difficulty in reading their distinct characters and histories from their images. To a modern viewer, however, the painting displays the Eurocentric concept of man typical of an artist of the time, who saw his subjects with a high degree of cultural chauvinism and so interpreted their lives and their personalities within the framework of the aesthetic and moral conventions he shared with his audience. What else should one expect of a late-eighteenth-century work that is biographical in its ambition and prejudicial in its execution?

A portrait is a sort of general history of the life of the person it represents, not only to him who is acquainted with it, but to many others, who upon seeing it are frequently told of what is most material concerning them, or their general character at least; the face; and figure is also described and as much of the character as appears by these, which oftentimes is here seen in a very great degree.[27]

The social conventions of the day conditioned Girodet-Trioson's attitude towards his subjects, but he consciously employed the artistic conventions of his time to convey his interpretation of their looks and character to viewers so that they would recognize Raynal and Belley and come to know them through his eyes. The consolidation of these socio-artistic conventions into specific verbal-visual images allows both the artist and the viewer to categorize the person portrayed in general terms. Each term, derived from the distillation of common experience and subsequently loaded with significance, is called a schema, perhaps the basic representational tool of the portrait artist. According to E. H. Gombrich, it is possible for the sensitive observer to look at a portrait as a schema of a head modified by the distinctive features about which the artist wishes to convey information.[28] The schema may adhere very closely to literal representation or take the form of a composite derived from the observation of human beings in like condition. Such are the characteristic facial types formulated by Aristotle's pupil, Theophrastus, in his *Characters*, which associate states of emotion (e.g., anger) or character (e.g., meanness) with specific types of physical appearance. The schema recognized as a sign of uprightness of character was contained within the highly realistic depiction of mature men and women, typical of Roman Republican portraiture (illus. 17); in this regard they all look so much alike that their uniform appearance is a mark either of absolute social conformity – and it is unlikely that everybody looked the same – or of a social ideal that was signified by the use of this schema for the portraits of people who wanted to look like this.[29] But if the realistic depiction of worthy Romans were to be taken at face value, the schema's existence would not be recognized and that important aspect of Roman portraiture misunderstood.

Physiognomic portraits, popular in Roman antiquity, the

Renaissance, and again in the eighteenth and early nineteenth centuries, have had a similar fate.[30] Physiognomics is the pseudo-science of face-reading, derived from the Aristotelian tradition; it asserted a belief that the signs of a person's character were manifested in the face and that with the proper method of analysis one could learn to read those signs and from them know the character of the person actually addressed or portrayed, since portrait artists could also learn the method and represent the signs as the basis of their interpretive characterizations. Although physiognomics is an unreliable science, its very popularity led to the creation of numerous portraits whose composition and iconography were profoundly influenced by invented schema (illus. 28–30). Failure to recognize the many physiognomic indicators compromises the viewer's response to the portrait.

Schema define the general categories into which all humanity falls, at least as 'humanity' is conceived of at any given time (illus. 7). When employed by artists, schema identify the membership of the individual within some known category, or categories, and therefore effect a construction of the person in relation to others in like circumstances. That construction, or analytic interpretation, may be at variance with common belief. When someone as unique as Mrs Thatcher is shown seeing herself as General de Gaulle (illus. 8), a person also considered *sui generis*, then the artist either wishes the viewer to find the common denominator or category to which both properly belong – the indomitable national leader – or is suggesting, rather archly, that Thatcher's imaginative examination of herself in the mirror is a severe case of mistaken identity.[31] It is sometimes alleged that schema interfere with the direct observation of a person, as if it were possible to see anyone in total isolation. Portrait artists have no such illusion because portraiture is not the transcription of people 'as they are'; 'as they are' is neither subject to replication nor can it be understood except in terms of 'as they are like'. Artists, therefore, represent people in portraits by means of the established or invented schema whose recognizable content shapes the identity of the subject and conveys it to the beholder. In the complex interaction between schema and literal description, the aesthetic concept of 'correctness' enters into the judgement of the portrait's quality.

In *Art and Illusion* Gombrich stated that the 'correct portrait

8 Kevin Kallaugher, *Thatcher/De Gaulle*, from the cover of *The Economist*, 19–25 November 1983

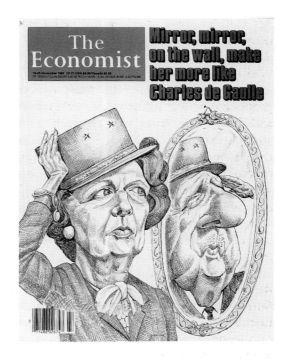

. . . is an end product on a long road through schema and correction. It is not a faithful record of a visual experience but a faithful construction of a relational model.'[32] This statement aestheticizes Gombrich's continued insistence on making and matching as the active process whereby nature and art come together through representation. But long ago Wittgenstein criticized the very concept of 'correctness' in these terms, defining it simply as the expression of an aesthetic judgement about a thing according to learned rules, rules that are themselves an expression of what certain people want as they learn them and, in the process, change them.[33] If 'correctness' can only be determined in accordance with the aesthetic criteria of a given period, then one might argue that those criteria must be established at the time of the portrait's making and distinguished from the aesthetic criteria in effect at some later period of viewing.

But portraits are not quite like other works of art for which such standards of aesthetic validation might apply. Portraits are always intentionally tied to the representation of actual persons in some potentially discernible way. Therefore, the notion of 'correctness', when applied to portraits, subsumes

39

two distinct values; one is usually expressed in terms of 'the most faithful portrait', that is, to the original, as in the question, 'Which portrait is most like Benjamin Franklin?' (illus. 64, 65); the other is presented in terms of 'the best portrait', as in the statement, 'The best portrait of Gertrude Stein was painted by Picasso' (illus. 72). Faithfulness can never be established in any ordinary sense after the death of the person portrayed because there would be no visible basis of comparison, although for historic personages the abundance of extant portraits might seem to move us in that direction (e.g., illus. 63). But we have already said that no portrait could ever replicate the original, so the concept of 'faithfulness to the original' cannot quite mean what it says, unless faithfulness is understood as a satisfying approximation, mediated by some acceptable relationship between the original in the world of nature and the portrait image, the latter a product of artistic (re)presentation.[34] The catch here is the common assumption, perhaps most strongly engendered by portraits, that there is some substratum of mimetic representation underlying the purported resemblance between the original and the work of art, especially because the sign function of the portrait is so strong that it seems to be some form of substitution for the original. Likeness has its limits, however, as we have seen. Then so, too, must the concept 'faithfulness', for many of the same reasons, despite the claim that portraits make such specific reference to particular persons that they affirm their existence.[35]

Any determination of the 'best portrait' involves the establishment of the criterion or criteria, 'Best for what?'. In certain cases, programme may be the only condition open to historical and critical analysis that can be verified objectively. In portraits, programme is the relation between the intention to portray and the application of that intention to a particular mode of use or display. Making portraits is a very purposeful activity; it is undertaken with the viewer in mind, whether that be the patron-sitter or someone else, even a stranger. Since the portrait, in effect, presents a person to the viewer, the portraitist always has to keep someone other than the subject in mind.

The complexities of programme and the information it provides about the intention to portray and the reception of its product are completely exemplified by the banal require-

ments of the United States Immigration and Naturalization Service, which stipulates precisely what is, and what is not, acceptable as a portrait photograph for *purposes of identification* (illus. 9). The photographs must be in colour and the right size; only a three-quarter short frontal bust is acceptable; neither earrings nor a hat can be worn, and the right ear must be exposed; the photograph must be recent and the image solitary; and the person's name has to be printed on the back. Certainly the Service intends to use this portrait as a document to record this person's actual existence in the United States and as an index suitable for identification, should some future question arise about the subject's status. This is also the banal photograph of a private person, in her private capacity as an alien, like other aliens, which becomes a public record for all interested parties to see; except for physiognomic details, her photograph is like all the other photographs collected for this purpose by the Immigration Service.

And yet, she is a prime subject, not because she is under suspicion but because she is presumed to be unique. Her photograph, therefore, is a prime object of representation. Consciously or not, the Immigration Service has made a number of choices about the way the portrait photograph should be taken, recognizing both the conventions of portraiture and the effectiveness of its imagery. The assumption that the photographic medium was especially reliable and accurate certainly entered into the Service's considerations, although the taking of the photograph itself was defined by very precise conditions; and few people, these days, can afford to have their portrait taken by an artist in a costlier medium, especially to give to the Immigration Service.

A close scrutiny of the Service's requirements reveals the complex nature of their specifications, even when imposed on what might seem to be the most commonplace of portrait commissions. The sharply truncated bust, long honoured as a preferred format for portraits because it so concentrated attention on the face, was deemed sufficiently indicative of the person's likeness to serve as its overt sign; thus, the rest of the body could be omitted. The oblique view of the bust presents the face three-dimensionally and therefore provides more substantive information than a profile, unaccompanied by a frontal view; its orientation towards the right is an artificial convention, imposed on all the submissions to the

U.S. IMMIGRATION & NATURALIZATION SERVICE

COLOR PHOTOGRAPH
SPECIFICATIONS

◄ SAMPLE PHOTOGRAPH

HEAD SIZE(INCLUDING HAIR)
MUST FIT INSIDE OVAL ►

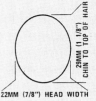

29MM (1 1/8")
CHIN TO TOP OF HAIR

22MM (7/8") HEAD WIDTH

● PHOTOGRAPH MUST SHOW THE SUBJECT IN A ³/₄ FRONTAL PORTRAIT AS SHOWN ABOVE (WITHOUT EARRING)

● RIGHT EAR MUST BE EXPOSED IN PHOTOGRAPH FOR ALL APPLICANTS, HATS MUST NOT BE WORN

● PHOTOGRAPH OUTER DIMENSION \underline{MUST} BE LARGER THAN 1 ¹/₄W x 1 ³/₄H, BUT HEAD SIZE (INCLUDING HAIR) \underline{MUST} FIT WITHIN THE ILLUSTRATED OVAL (OUTER DIMENSION DOES NOT INCLUDE BORDER IF ONE IS USED)

● PHOTOGRAPH MUST BE COLOR WITH A WHITE BACKGROUND EQUAL IN REFLECTANCE TO BOND TYPING PAPER

● SURFACE OF THE PHOTOGRAPH $\underline{MUST BE GLOSSY}$

● PHOTOGRAPH MUST NOT BE STAINED, CRACKED, OR MUTILATED, AND MUST LIE FLAT

● PHOTOGRAPHIC IMAGE MUST BE SHARP AND CORRECTLY EXPOSED, PHOTOGRAPH MUST BE UN-RETOUCHED

● PHOTOGRAPH MUST NOT BE PASTED ON CARDS OR MOUNTED IN ANY WAY
 TWO (2)
● $\underline{FOUR(4)}$ PHOTOGRAPHS OF EVERY APPLICANT, REGARDLESS OF AGE, MUST BE SUBMITTED

● PHOTOGRAPHS MUST BE TAKEN WITHIN THIRTY (30) DAYS OF APPLICATION DATE

● SNAPSHOTS, GROUP PICTURES, OR FULL LENGTH PORTRAITS $\underline{WILL NOT}$ BE ACCEPTED

● USING CRAYON OR FELT PEN, TO AVOID MUTILATION OF THE PHOTOGRAPHS, $\underline{LIGHTLY}$ PRINT YOUR NAME (AND ALIEN REGISTRATION RECEIPT NUMBER IF KNOWN) ON THE BACK OF ALL PHOTOGRAPHS

● $\underline{IMPORTANT NOTE}$ - FAILURE TO SUBMIT PHOTOGRAPHS IN COMPLIANCE WITH THESE SPECIFICATIONS WILL DELAY THE PROCESSING OF YOUR APPLICATION

SAMPLES OF UNACCEPTABLE PHOTOGRAPHS

FACING WRONG WAY

HEAD SIZE TOO LARGE

HEAD SIZE TOO SMALL

DARK BACKGROUND

TOO DARK

TOO LIGHT

Service for the sake of uniformity. And this is no mug shot (cf. illus. 85). Despite the official nature of this portrait photograph as a permanent document, the subject's pose, even her slight smile has a casual, almost incidental air; her image seems more 'natural' this way, despite the formality of its use. The greater lifelike quality of the photograph, concentrated in a single image, would make her more easily recognized in the street, if an Immigration agent had to go looking for the person who looked just like that. Although her face is the repository of the primary signals of identity, she does not present herself in a fully frontal pose, not just because the three-quarter view (including her right ear) is more informative but because her psychological engagement with an Immigration Service agent is not part of the programme. When it is, as Louis Marin noted, the interactive dynamic changes:

> It has been observed that a full-face portrait functions like the 'I–You' relation which characterizes the discursive enunciation, but with an interesting difference . . .; the sitter of the portrait appears only to be the *represented* enunciative 'ego' who nonetheless defines the viewer's position as a 'Tu' he addresses. The sitter portrayed in the painting is the representative of enunciation in the utterance, its inscription on the canvas screen, as if the sitter here and now were speaking by looking at the viewer: 'Looking at me, you look at me looking at you. Here and now, from the painting locus, I posit you as the viewer of the painting.'[36]

Great portrait paintings and sculptures are unquestionably far removed from the humble Immigration Service photograph in the scope of their ambition and in the quality of their imagery. They are not so different, however, in presenting the fundamental assertion that their images have a legitimate, intentional, and purposeful connection with the persons represented. They also share something else that further differentiates portraiture from all other artistic genres: while the artist represents the persons 'out there', those persons also represent themselves to themselves, to their contemporaries, and to those who take their portraits. One can never tell who is looking!

e Masks Fool the Bengal Tigers

RLISE SIMONS

:d carnivores
ey is coming,
ig.

ROME

2 moment, the Bengal
as met its match in the
:ed human.
 finding was a matter
ath in an experiment
ed in the Ganges Delta
re tigers living under
t reserve had been kill-
·ople a year.
t this predator only at-
rom behind, workers in
 forests started wear-
s on the backs of their
ur the trick appears to

.st three years, no one
ask has been killed,"
:kson, chairman of the
group of the World Con-
on. "Tigers have been
g people wearing the
' have not attacked."
 29 people who were not
1asks were killed there
nonths, officials report-

l, who was in Rome for
1e conservation union's
ival Commission last
ht an example of the
led the tiger: an inex-
·r mask of a pale-faced
thin mustache. He said
Forestry Service has
than 2,500 masks to
re among the 8,000 who
' go into the Sundarban

ay
: in the reserve of man-
i, cut by rivers and
 border of Bangladesh
tid Mr. Jackson, who
ea well. But people on
in to collect fish, wild
'd in the tigers' habitat.
.rst stop to pray for pro-
e shrines that rim the
the large Bengal tigers

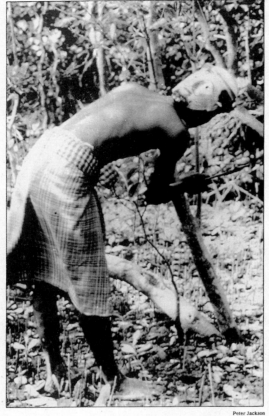

Peter Jackson

A woodcutter in the Ganges Delta of India wearing a mask to confuse Bengal tigers, which only attack from the back. In the past three years, no one wearing a mask has been killed by a tiger.

10 *'Woodcutter in the Ganges Delta Wearing a Mask on the Back of his Head'*, from *The New York Times*, 5 September 1989

The New York Times of 5 September 1989 carried a news item from the Ganges Delta in India, where Bengal tigers have been attacking and killing many woodcutters each year in the forest. Since the tigers only attack people from behind, the woodcutters started wearing human face-masks on the backs of their heads (illus. 10). Tigers have been seen following people wearing the mask but for the past three years no one wearing a mask has been killed, while many others, not wearing the face-mask, have been. One woodcutter was attacked from behind by a tiger when he took off his mask for lunch.

There is power in the likeness that even a hungry tiger can recognize.

11 Fashioning the Self

*Nothing in the whole circle of human vanities takes stronger hold
of the imagination than this affair of having a portrait painted.
Yet why should it be so? The looking-glass, the polished globes of
the andirons, the mirror-like water, and all other reflecting
surfaces continually present us with portraits, or rather ghosts, of
ourselves which we glance at and straightway forget them. But
we forget them only because they vanish. It is the idea of duration
– or earthly immortality – that gives such a mysterious interest
to our portraits.*

NATHANIEL HAWTHORNE *'The Prophetic Pictures'*[1]

Beautiful Narcissus was enamoured of his own reflection in
the pool of water, caught by his likeness in a prison of com-
plete self-absorption. Once seen, he did not wish to distance
himself from that beloved image, which he now knew as
'Narcissus'. But who was Narcissus if not himself, and how
could he, the original of the reflected image, a form of natural
portrait, be less real in his own body than in this alter ego,
so powerfully attractive as an object of love? The image had
given Narcissus access to an apparent 'other', an outsider
who bore his own name, moved when he moved, and had
no independent existence though was not identical with him.
Yet the image was so like its source that Narcissus was lost
in the schizophrenic contemplation of his doubled presence
for ever. R. G. Collingwood caught the particular nature of
Narcissus' dilemma when he wrote, 'When a portrait is said
to be like the sitter, what is meant is that the spectator, when
he looks at the portrait, "feels as if" he were in the sitter's
presence.'[2] Narcissus certainly knew this at first glance and
so, usually, do we.

When the viewer acknowledges the portrait artist's signifi-
cant role as an intermediary between the original and his
image, the exchange is more complex. The careful exami-
nation of a portrait of oneself, or of another, should expose
the particular dialectic of portraiture most acutely, as the
viewer confronts the purposeful relationship between the
original, who presents himself or herself in the world, and

the portrait, as a subsequent representation of that person. Thus, self-representation and artistic representation come together in the singular portrait image, but often uneasily.

Wendy Steiner suggested that portraits are unique among art works because they always make specific reference to an existing element of reality – that is, to a real person.[3] To real persons we tend to give names, and to portraits we also try to give names. A real, named person seems to exist somewhere within or behind the portrait; therefore, any portrait is essentially denotative, that is to say, it refers specifically to a human being, that human being has or had a name, and that name, a proper name, identifies that individual and distinguishes him or her from all others. It is a general condition to have a personal name, whether public or private, but the persons named are every one of them individual and singular.[4] The connection between names and persons is not natural but arbitrary, yet it is usually assumed that a name has a fixed or limited meaning. However, names too have their own properties of (mis)representation, just as the persons who bear them; Zelda, a modern Israeli poet, conveyed these multiple properties of representation in her declaration that:

> Each man has a name, given him by God, and given him by his father and mother. Each man has a name given him by his stature and his way of smiling, and given him by his clothes. Each man has a name given him by the mountains and given him by his walls. Each man has a name given him by the planets and given him by his neighbours. Each man has a name given him by his sins and given him by his longing. Each man has a name given him by his enemies and given him by his love. Each man has a name given him by his feast days and given him by his craft. Each man has a name given him by the seasons of the year and given him by his blindness. Each man has a name given him by the sea and given him by his death.[5]

Not all these names are proper names. Some define a person's roles in society, his character, his appearance, his reputation and reception, his fate and his fame, all those accretions of the self that constitute 'a life', for many the only true subject of a portrait.

Complementing its denotative function, a portrait designates not only the presentational imagery self-generated by

the original but, also, the established repertoires of artistic
representation out of which the portrait, as a work of art, is
made. The latter help the viewer to gain greater knowledge
of the person portrayed and of the artist's particular concep-
tion of his task.[6] By the very nature of their dual function,
portraits often reveal a tension between the demands of deno-
tation and designation that determine the relative prominence
of personal identity within the overall content of the work.
The colossal portrait of Lenin, painted on a wall in Leningrad
(illus. 11), stands for all those monumental, public, and poli-
ticized images of 'leaders of the people' that are so familiar
in the twentieth century. Here the identification of 'Lenin' is
not a matter of fortuitous discovery but is a foregone con-
clusion, so deeply has this association of name and image
been embedded in the people's consciousness through con-
stant reiteration. The transfer is so forceful that the individu-
ality of the man himself, once known as Vladimir Ilyich
Ulyanov, has been transcended by the historical entity –
LENIN – he has become. In some societies the passage from
reverence to rejection can be very quick, and so it was for
Stalin (illus. 4). But portraits of this kind raise the question as
to whether this image of Lenin could ever be a matter of
simple denotation, even if the readily identified portrait, in
effect, embodied what all the symbols that signified 'Lenin'
to the people of the Soviet Union had in common.[7]

Lenin, Stalin, Mao, Hitler, Mussolini, Eva Peron, and so
many others needed no labels to identify their portraits, but
their artists were not the first to discover how effective was
the deliberate replication of a singular image for wide public
distribution. Ancient Egypt and Imperial Rome had long ago
developed the technique of displaying a specific portrait type
of an important public figure so insistently and frequently
that it became the ostensible sign of the great person so por-
trayed. Viewers could see many examples of the same con-
solidated portrait type everywhere they looked and could
reconfirm the correctness of their perception of the original
at every turn. And so it was for Lenin (illus. 11) and for the
others, a matter of imprinting their consolidated image on the
minds of their people.

The same process is at work in modern times in the por-
trayal of 'celebrities', especially film stars. The effective com-
bination of mechanical or electronic reproduction and

11 *Colossal Portrait of Lenin*, Leningrad, 1970s

tendentious redundancy has been deliberately exploited by Andy Warhol in a number of Pop portraits of the 1960s, such as his huge *Marilyn Diptych* in the Tate Gallery (illus. 63). Fifty identical images of the actress-celebrity, Marilyn Monroe, slightly modified by colour and tone, are deliberately shown together in a single work, almost fourteen feet wide, to make a statement about the banality of popular imagery, about the insistent stereotyping of such images, about figural and non-figural pattern formation, about mechanical printing – but very little about Marilyn Monroe (itself an alias). Warhol's *Marilyn* is about image-making rather than portraiture because the work so clearly emphasizes the mechanism of popular representation in the modern age but not the person represented.[8]

Here, and elsewhere, Warhol seems to deprive the portrait of much of its deeper referential content in order to suggest both the artificial confection of her public personality and the relative invisibility of the person behind the public image, the latter offered as a commodity for the viewer's consumption. Yet his *Marilyn* (illus. 63) retains her identity in the public consciousness despite the fact that her image has been reduced to her smiling face with its crown of blond hair, unsupported by the voluptuous figure that was no less an essential part of her persona. Warhol's concentration upon Marilyn's image-sign, and his replication of it, forces the viewer to connect this art work with the broader phenomenon of mechanical reproduction that inevitably erodes the status of an original, even *the* original in the portrait. Yet, the viewer has no difficulty in providing the name of that original because the artist has retained enough of her synthetic image to make identification certain. So familiar have her features become through repetition that the denotative power of her image is absolutely firm, even without a label.[9]

Warhol's *Marilyn* is composed of smaller units, multiplied over and over again, almost as if they were a sheet of postage stamps, that other familiar locus of serialized portrait images. Functionally, it matters little whether the subject is well-known or not (illus. 12). Printed on large sheets and in vast numbers, postage stamps can be used individually or in clusters, but except for the philatelist the sight of these small images usually fails to arouse the interest of the general public in the person portrayed. Instead, one soon becomes aware of

the trivialization of the portrait because legitimacy of the issue is much more important than the capacity of the image to refer to a specific person, however recognizable and clearly identified it may be.

The legend printed on the stamp proclaims the authority of the issue and provides the name of the one honoured; that name serves also as the title of the portrait, fulfilling the role of ascription given to all such titles and alerting the few who might take an interest in the subject to do so. Her name, 'Lillian M. Gilbreth', as the title of the work, identifies the image as a portrait and directs the viewer's interpretation of it to that end.[10] Of course, names as titles and as labels[11] can assume a very great importance in group portraits, such as Frans Hals' *Officers and Sergeants of the St George Civic Guard c.*1639 (illus. 15), where both the corporate body of the guard and the individual patrons, who are members of that body, have to be identified.[12] Consistent with the conception of the Dutch group portrait in the seventeenth century, Hals portrayed the corporate body and its members in a single

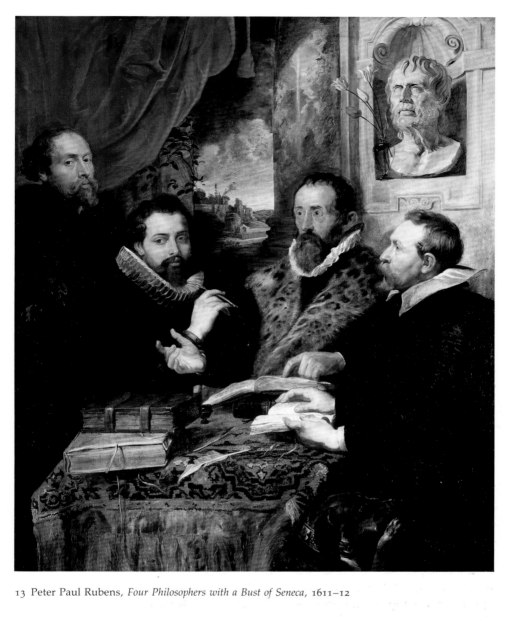

13 Peter Paul Rubens, *Four Philosophers with a Bust of Seneca*, 1611–12

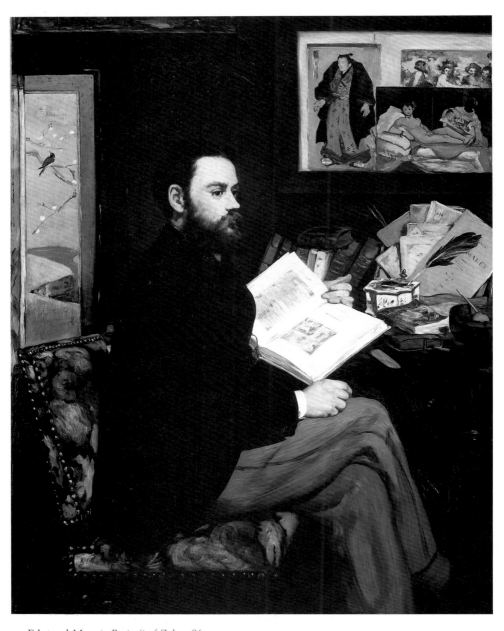

14 Edouard Manet, *Portrait of Zola*, 1867

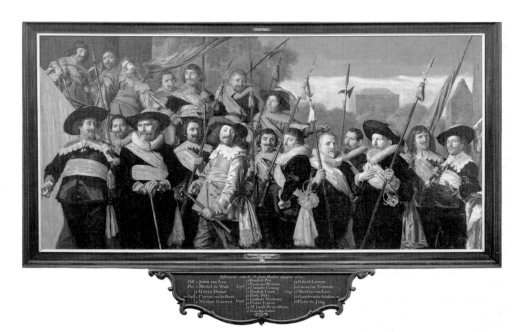

15 Frans Hals, *Officers and Sergeants of the St George Civic Guard*, c. 1639

work that presents each participant (including himself) as a typical member and as a specific, recognizable human being.

Given the operating conventions of Dutch group portraiture, so nobly practised by Hals and Rembrandt, their contemporaries would have expected to find in the ensemble the portraits of the real persons whom the artists intended to represent as such – the historical beings who, in the first place, commissioned these artists to paint their portraits as members of the group. Under the circumstances, that expectation was reasonable. It might even appear reasonable to a viewer from a later age who is not fully aware of this convention but observes the artist's effort to individuate each person in the group and the apparently historical nature of the representation. Such a viewer proceeds by abduction from the close observation and interpretation of the images in the painting to the development of an interpretive hypothesis that he is, in fact, looking at a group portrait. Such a hypothesis has its risks, especially when the convention is effectively unknown and there are no labels.

Walker Evans' *Penny Picture Display, Savannah 1936* (illus. 16) is a composite photograph of 225 portrait photos – unquestionably portrait pictures of the most commonplace

16 Walker Evans,
*Penny Picture
Display, Savannah,*
1936

sort – that does not constitute an ensemble in the sense of
Hals' group portrait (illus. 15), nor does it offer the reiteration
of a single image as in Warhol's *Marilyn* (illus. 63) or the sheet
of stamps (illus. 12), although it shares some of their overt
features. Evans' photograph seems to be about popular por-
trait photography of the 1930s and its banality in insensitive
hands; it is also about the photographers who take such
photos and the advertisement of their products.

The word 'Studio' spread across the front expresses Evans'
disregard for the integrity of the pictures as portraits, but
not as objects of representation, thus anticipating Warhol's
attitude towards Marilyn Monroe (illus. 63). The individuals
presented to the viewer in miniature are truly anonymous
and their identification is irrelevant to the meaning of the
work despite the candid factuality of their images. Here Evans
has deliberately challenged the importance of that aspect of
mimetic representation so painstakingly itemized in each of
the 225 snapshots that someone consciously assembled and
displayed as a portrait gallery. When Evans photographed
them he changed their character as one-time portraits, rob-
bing them of their identity and their names.

Real faces without names, when naming was no longer a

necessity, should not be considered portraits in the context
of Evans' photograph, even if once they were. There are
works of art, however, that have been accepted as portraits
because their faces appear so idiosyncratic within a well-
known artistic convention that they are assumed to be por-
traits for whom good, appropriate names must be provided.
The *Capitoline Brutus* (illus. 17) is a famous instance of this
impulse; it is now thought to be a Romano–Italian sculpture
of the third or second century BC, made at least three hundred
years after the death of the great Roman regicide whose name
it bears.[13] This magnificently grim bronze head, so character-
istic of contemporary portraits of distinguished leaders,
seems to manifest an artist's realization of a distinct person-
ality, so distinct that viewers since the Renaissance have
found satisfaction in naming the ancient sculpture 'Brutus'
because it corresponded so exactly with the mental image
of him which they had formed in their reading of Roman
history.

These viewers found the portrait they were looking for in
this splendid work of art. The name 'Brutus' confirmed the
aptness of their discovery, an appellation psychologically jus-
tified by the intensely personal nature of the encounter

between themselves and the sculpture, seen as a portrait. The temptation of such an identification can be overwhelming[14] given the desire to embody great persons – great names of the past – in great works of portraiture.

> But what type of man these busts figure forth can only be deciphered by those who have made up their minds on the subjects beforehand. Long years will elapse before serious psychological deductions can be drawn from the date of iconography.

Norman Douglas was thinking of busts of the Roman emperor Tiberius when he wrote these lines, but he could have had the *Capitoline Brutus* in mind.[15] And he was not alone. Joseph Brodsky has written:

> That sweet incoherent mumbling inside the toga! So we have a bust that stands for the essential independence of brain from body: a) one's own, b) one that is Imperial. Should you be carving your own likeness, you'd produce gray twisted matter.[16]

The *Capitoline Brutus* is one outstanding example of the imputed portrait whose identification is the object of intensely personal reactions on the part of the viewer. Another is Southworth and Hawes' daguerrotype of *Daniel Webster, 22 April 1851* (illus. 18) which visualizes an extraordinary concurrence of self-representation, artistic interpretation, and viewer expectation, appropriate to the portrayal of such a great American.[17] Ralph Waldo Emerson called Daniel Webster 'a natural Emperor of Men' and in this photograph he looks it. Surely this Daniel Webster is '*the* Daniel Webster', an icon of American political history and a most satisfying portrait image.

The image corresponds to his reputation and, being a photograph, we imagine it to be true. Here is a character likeness: the stocky torso of a middle-aged man, forthright, erect, dressed in contemporary, formal costume, and nobly bald. But here also is an elaborate portrait iconography: the large cranium, indicative of the great mind within (cf. illus. 30); the powerful and proper stance of a mid-nineteenth-century gentleman; the grim, serious expression, reminiscent of Roman Republican portraits (e.g., illus. 17), reflecting the patriotic dedication of this distinguished citizen of the Ameri-

can Republic; the column with its reference to the neoclassical architecture of Washington, where Webster served in the Senate, and its invocation of the noble portrait conventions developed in European art of the seventeenth century; the light from on high as a sign of divine revelation; and so forth. In sum, this 'honest', surely neutral photograph offers up a composite portrait of the *public* Daniel Webster as 'a virtuous statesman, a defender of the Republic, a great Senator . . . *himself'*.

Given the length of exposure required by this photographic process, Daniel Webster had the time and the motive to reconstitute himself before the camera, to portray himself to the lens and to posterity, and in willing collaboration with

the photographers Webster consented in the propagation of this self-defining image.[18] He must have known the result in advance. The peculiar mirror-surface of the daguerrotype would make his otherwise transient appearance seem permanent, replete in all its fine physical details, yet floating like a silver shadow, an immanent presence. Daguerrotypes had the look of 'natural' portraits despite their manufactured character, and they reminded the viewer of seeing an image reflected in a pool of water, or in a mirror, or in a polished sphere. The very complex, artificial, time-consuming, yet seemingly realistic nature of this daguerrotype, at the very beginning of portrait photography, breaks down the distinction that some, like Roger Scruton, would make between painted and photographic portraits.

> One of the most important differences between photography and portraiture as traditionally practiced lies in the relation of each to time. It is characteristic of photography that, being understood in terms of a casual relation to its subject, it is thought of as revealing something momentary about its subject – how the subject looked at a particular moment. And that sense of the moment is seldom lost in photography . . . Portrait painting, however, aims to capture the sense of time and to represent its subject as extended in time, even in the process of displaying a particular moment of its existence. Portraiture is not an art of the momentary, and its aim is not merely to capture fleeting appearances. The aim of painting is to give insight, and the creation of an appearance is important only as an expression of thought.[19]

Webster, the man of the moment (22 April 1851), transcends that moment by the force of his iconic dignity, so beautifully played by Webster, so artistically staged by the photographers, Southworth and Hawes. For those familiar with the great figures of American history, this 'Webster' is instantly recognizable; for those who are not, and do not know the title of the daguerrotype, this is the portrait of a 'somebody' who once bore a distinguished name.

Heidegger wrote, 'The self reflects itself to itself from out of that to which it has given itself over.'[20] Daniel Webster achieved that coincidence of self-awareness and self-making through a lifetime of appearances on the public stage, where

after many years he made himself into the 'Great Senator from Massachusetts'. He was, in effect, able to look himself in the eye and compose himself satisfactorily with respect to his own expectations and to the expectations of others. This was an evolutionary process, encouraged by public opinion and his own sense of self-worth. Webster did not become '*the* Daniel Webster' right away, and the icon we recognize so easily, the historic identity he assumed, did not become his until later in life. Therefore, the Daniel Webster in the photograph (illus. 18) did not always exist, although some changeable being bore this name and eventually became the person we know.

Personal identity is an ambiguous constant in a human life, unlike names, which can be changed by marriage, adoption, politics, immigration, and prejudice. But just as the body, the mind, and the reputation of a person change over the years, so identity is not fixed either, except, perhaps, in the memories of others after death and in those special portraits that have the authority to make predicative statements: This is (or was) Daniel Webster. At the very least, the assertion of identity, by whatever means, is an affirmation of existence itself.[21] If identity is a flexible concept, then defining the relationship between the original and his portrait is surely problematic. Daumier's lithograph from the 1864 series, *The Public at the Exhibition* (illus. 19), addresses this problem directly, if satirically keyed by the inscription:[22]

> There is no doubt of it, it certainly is my profile; but I shall always regret that the artist had the obstinacy to omit my spectacles.

Daumier presents no immediate reference to actuality, but through illusion he suggests that there is a meaningful distinction between the subject, regarding himself as portrayed, and the 'sculpted' bust, the object of his disapproving gaze, an art work removed from life by its artefactual nature. This dramatic confrontation between the supposed original and his replica immediately reveals how different the replica is from himself, as both he and the external viewer see it. Daumier was no philosopher but here he has raised the issue of whether the bust is a faithful representation of the sitter's identity. Typically, the artist takes pleasure in poking fun at our too simple ideas of what constitutes veracity in a portrait,

93 DAUMIER, 'There's no doubt about it, it certainly is my profile; but I shall always regret that the artist had the obstinacy to omit my spectacles.' *The Public at the Exhibition*, 1864. D.3316

as the naïve patron finds fault with his likeness because of the inadequacy of its denotative reference.

Daumier's print has a narrative content that exploits the possibilities of portraiture through the medium of the patron's reaction – the patron, of course, who is a pseudo-original. This patron has forgotten that even he takes off his spectacles at night, but he would have been terribly surprised if, in fact, the bust needed them when it appeared in public. Daumier, however, remembered something even more

important: that the bust is a highly confected art work, not to be judged exclusively by denotative criteria, especially when the very existence of the bust (and the patron) depended on the artist's imagination. To make this point, Daumier employed two profiles: the bust displays the right profile, the pseudo-original the left, and together they seem to constitute the entire face. Both are visible to the external viewer only because the bust and the pseudo-original appear to be looking at each other, thereby combining one self and the 'other'. Whether or not the two profiles constitute a face, the lithograph's inscription is at odds with reality, since the pseudo-original's knowledge of his profile is not available to him when he is standing in front of his bust, unless he is using the word 'profile' metonymically to mean 'face'. If he does mean profile, we may wonder how he can be sure, since the only way to determine one's natural profile is to arrange a set of mirrors to create multiple reflections of one's head that could be seen at the same time, or to rely on the apparently unreliable artist's taking of a profile. Daumier's composition cleverly implies this condition of self-examination as the source of the memory-image upon which the pseudo-original's negative opinion of the result is based.

To continue with the possibilities of Daumier's implied narrative, let us imagine that the pseudo-original moved to look at his bust profile from the side and found it 'correct', despite the practical difficulty of knowing what his profile 'really looked like'. He believes that the bust profile makes a true statement because it is consistent with the image of himself that he has previously acquired, but he is still mistaken. The accuracy of the profile, as the depiction of a person, can be fully evident only to another viewer and, even then, incompletely so, since the right and left profiles are never identical and, therefore, neither one, by itself, could be 'correct' in relation to the whole head. Daumier does seem to be playing with the concept 'profile', drawing attention to the artistic convention of the profile itself both as a distinctive device in the art of portraiture and as a form of reductive sign. Daumier also knew the physiognomist tradition that singled out the profile as the most effective way to characterize the subject – to make visible the interior life of a human being and the substance of his or her true nature or personality.[23] A profile, taken by an artist, could then substitute for the whole and, by implication, both the profile and the

self within could best be known to another person, not to one-self except through a work of art.[24]

It has already been stated that works of art are not prop-ositions, subject to true or false judgements derived from the real world, but that the referentiality of portraits subjects them, perhaps unfairly, to an evaluation of their relative veracity.[25] In the Daumier print (illus. 19), true and false statements have been made both in the inscription and in the image, forcing the viewer to confront the portrait's arti-ficiality. The print also compounds the issue of denotation and representation, as the viewer observes the pseudo-original's contemplation of his portrait and then proceeds to consider the validity of the judgement he utters at its failure to replicate the spurious original.

One can dismiss the pseudo-original in Daumier's print as a purely fictive invention, possessing no natural identity, unlike *Daniel Webster* (illus. 18), but only its potentiality within the implied narrative. As a character in that narrative, how-ever, he both represents himself and is fully represented by the artist. Sometimes works of art, originally conceived as portraits, lose their faces and their names and with them their effective referentiality. The observer cannot identify the subject, although the surviving relic may preserve the original intention to portray an actual person in the still visible appa-ratus of representation. The *Faceless Roman Female Statue* from Cyprus (illus. 20) falls into this category; her draped, matronly body is a standard item in the Roman portrait reper-toire, produced in large numbers as props, awaiting the addition of a face to become an identifiable person. Function-ally, the statue resembles the scenic flats in photographers' seaside studios with their empty face-holes waiting for the tourists to come and fill them in, while their portraits are taken. Without those missing faces, personhood can be inferred from the context, but not established, as if the self were waiting for the right circumstances to make itself visible.

Sometimes, of course, individuals deliberately assume a public identity (and name) different from their private iden-tity (and name). Paul Wunderlich explored this ambivalent situation in his recent lithograph, *George Sand* (illus. 21), which takes advantage of the missing face, the hidden per-sona, to comment on the bifurcated identity of his subject.[26] Wunderlich played with the dominance of the face as a deno-

20 *Faceless Roman Female Statue*, 2nd century AD, in Cyprus

tative key in a display of the nuances of concealment: arcane symbols alternate with obvious references, such as the fragment of the piano keyboard and Chopin; there are visual puns, such as the sand dollar in the shape of a heart that hovers between the keyboard and George Sand's androgynous, disembodied face; and the 'portrait' bust is itself defaced, separated into its discrete components, reminiscent of the paper dolls once popular with young girls, and suggestive of George Sand's delight in children's games, especially play with puppets. The physically decontextualized face does indeed portray George Sand, née Aurore Dupin, later Madame Dudevant – mother, grandmother, lover, and always female, as revealed by the curve of her breast. It also represents the fictional alter ego of an author who presented herself to the world as another, with a man's name.

A faceless bust fills the visual field at the right, the conventional foundation from which George Sand had departed. This bust is easily recognized as a reference to the *Mona Lisa*,

21 Paul Wunderlich,
George Sand, c. 1983

an association reconfirmed by the Leonardesque mirror-writing beside her head. Mona Lisa, as an image, carries a reputation for inscrutability and concealment, potentially an art historical and psychological paraphrase for the detached head of George Sand herself, who was, of course, not what she presented herself to be in public. The repetition of the inscription 'La cause du peuple', first written below the head, in the normal way, asserts Sand's political commitment as a pervasive element in her character. The second inscription, in mirror-writing, suggests the potential coalescence or integration of head and bust and simultaneously calls that combination into question, because the disembodied head looks too large to fit into the blank opening in the bust. Wunderlich has thus defined the schizophrenic character of her personality, while portraying George Sand in her totality, as a historical figure.

George Sand explored the presentation of oneself as another, an identity assumed under a different name, and the idea that identity and naming are inextricably bound together in the art of portraiture. Wunderlich's separation of head and

face expresses the separation of one identity from another; philosophically, the picture implies a dialectic, turning on the name, that logically requires the viewer to be far more cautious about taking portraits, any portraits, at 'face' value. We are so used to recognizing people from their faces that we feel disoriented when they are absent (illus. 20), or delusive (illus. 21), or otherwise insufficient (illus. 22).

How specific such facial indicators must be has been put to the test by Magritte's etching, *Paysage de Baucis* (illus. 22), which is considered to be a form of self-portrait because of its resemblance to portrait photographs of the artist and because it includes the bowler hat that Magritte always wore.[27] Without this prior knowledge, however, a viewer would have difficulty recognizing the image as a portrait, let alone a portrait of the artist. Unlike the faceless Roman statue (illus. 20), there is nothing about this image that calls for such a specific classification among the genres of art. The viewer must integrate the typical features of the human face into the shape of a human head and provide the enclosing outline, thus defining the image for himself mentally; he also has to find some reason for believing that the image refers to some-

22 René Magritte,
Paysage de Baucis,
1966

one in particular. The artist's metaphysical concept addresses the process of becoming a person rather than the attainment of a fixed state of being. This allows Magritte to comment on the way in which identity is given to a person from the outside and to modify the conception of a visible likeness, so long tied to the idea of portraiture.

Paul Klee has explored the challenge to personal identity perhaps more than any other modern artist. He has also used the mask to investigate its potential for concealment and revelation. The masks in his work express his uncertainty as to whether visible faces have any continuous and true connection to their bearers and whether there is any core of self to which specific faces might be legitimately attached. His 1932 watercolour, *Ein neue Gesicht* (*A New Face*) (illus. 23), shows two ghostly intersecting forms – vague visages – in the process of change, a theme repeatedly explored by Klee in his ironic response to the world's masquerade.[28] The concept of individuality was then receding in art and literature, and perhaps the vagueness of this image was Klee's metaphor for that changing attitude. With this erosion of the sense of self, only the vestigial autonomy of the person – the dark shapes within the lighter shapes in the watercolour – could survive, if namelessly.[29] In Robert Musil's words:

23 Paul Klee, *A New Face*, 1932

The center of gravity no longer lies in the individual but in the relations between things.[30]

Historically, portrait artists have often sought to discover some central core of personhood as the proper object of their representation. They have done so not because they doubted its existence, as did Klee, but because they wanted to capture, unmistakably, the special quality or qualities of their subject. That invisible core of self was always hard to grasp and even harder to portray, so various solutions were invented that would extend the metaphorical nature of the portrait in a manner consistent with the subject's own behaviour or patterns of self-representation. This mode of portrayal has, as its ruling principle, the presentation of the individual in some special, personal capacity, however extreme that might appear.

The superb portraits of the third-century Roman emperor, Commodus, as *Commodus–Hercules* (illus. 24), and of *Rudolph II as Vertumnus* (1591) by Arcimboldo (illus. 6), are classic instances of this revelatory mode of portraiture. Commodus, shown with the attributes of Hercules – the knotted club, the lionskin helmet, and the apples of the Hesperides in his left hand – is not only playing the part of Hercules. In his mind, in his propaganda, in his portrait images he had become the Roman Hercules, and could and would be portrayed as the conflated, compound being he truly was, so that his Herculean nature could be fully revealed.[31] The Roman audience was not ready for this conceit and soon after the portrait was completed Commodus was murdered. Arcimboldo went further than the Roman sculptor in his departure from a physical likeness of his patron in this vegetal fantasy on Rudolph's beneficent power over nature and the fruitful passage of the seasons. Arcimboldo utterly transformed Rudolph's face, converting his features into their fruity counterparts without, however, fully submerging the general appearance of his subject so that Rudolph's image could retain both its character as a portrait and its identification.[32] Essentially the same compositional technique was used by Paul Outerbridge in his photographic *Self-Portrait* of 1927 (illus. 25), in which he appears as a fully masked 'invisible man', with only his mouth exposed. There is an offputting quality in this image, perhaps reflecting Outerbridge's flir-

tation with Surrealism or his memory of the seriously
wounded of World War I living on as disfigured veterans,
but his portrait follows the same pattern of partial conceal-
ment and tantalizing revelation of character adopted by his
illustrious predecessors.

From Magritte (illus. 22) to Outerbridge (illus. 25) we have
seen that not every configuration that the viewer can legiti-
mately interpret as a human face sets the stage for personaliz-
ing the image. Certainly, the viewer has to deal with the
rudimentary elements of a face in order to extract from them
some sense of the presence of an individual, however
defined, even if that definition has to be provided from with-
out. Indeed, highly individualistic, descriptive images can
also become depersonalized through constant repetition
because they come to possess some other, and greater, sym-
bolic value. Such is the fate of Franklin Roosevelt's jaunty
photograph of the 1930s (illus. 26). Often reproduced, this
portrait became a vital symbol of hope in a troubled time, one
in which the character appears so 'upbeat' that the familiar
image took on some of the exaggerations of caricature,

25 Paul
Outerbridge,
Self-Portrait, 1927

although the mood was consciously and deliberately pro-
jected by Roosevelt himself as an expression of his own opti-
mistic nature. Here, a tendentious form of self-representation
met the special need of the audience, a need satisfied by the
photographer's careful selection of just the right moment to
make such a positive statement about the American Presi-
dent. Despite the exaggeration, or because of it, this portrait
effectively displays Roosevelt's likeness and his likeability,
but is no less a public, highly-charged political icon for being
so.

Caricaturing oneself, especially for positive effect, is very
different from the caricaturing of others, given the usual sati-
rical or hostile nature of this sub-genre of portraiture, when
the artist's commentary on the subject expresses itself in the
deformation of the likeness. Purposeful deformation of the
appearance of the original is the métier of the caricaturist,
witness Philipon's famous depiction of Louis-Philippe of
France in *Les Poires* (illus. 27).[33] The progressive transforma-
tion of the King's face endows the final, devastatingly
reduced image with the power to conjure up a particular,

unflattering interpretation of Louis-Philippe, but the joke is all the better for the preparation. The three previous stages in the degradation of the King's image were necessary so that there would be no lapse in recognition, since recognition of the person portrayed is essential to caricature. Unlike Rudolph II who did not look like fruit, although a collection of fruit was made to look like him (illus. 6), Philipon relied on the development of certain salient physical features in Louis-Philippe's face as the point of departure for his caricature. To be successful, hence recognized, the caricature depends on the viewer's prior knowledge of the original and on the deformation of those facial features thought to be most typical of the subject – like Roosevelt's upward tilt of the head and big smile (illus. 26). In caricature, as in the entire genre of portraiture, likeness as a concept is a variable criterion, bounded on one side by considerable, but not unlimited, indeterminacy and on the other by highly descriptive detail.

But if it (a portrait) does not present a convincing likeness of the sitter, it is not a successful portrait. In this way a portrait is like a caricature – it is a picture whose unique subject matter is a resemblance. This resemblance is not in any way the complete image of a man. It is obtained, like

caricature, by looking at the man from a special point of view. To get it, a peculiar state of sympathy of a mysterious and almost magical nature must be established and maintained between the painter and his sitter . . . This state of sympathy, this psychological nearness, which constitutes the difference between a portrait and any other sort of painting, depends directly on the actual physical interval . . . between the painter and his model. And a portrait can be defined as a picture painted at a distance of four to eight feet of a person who is not paid to sit. A picture painted

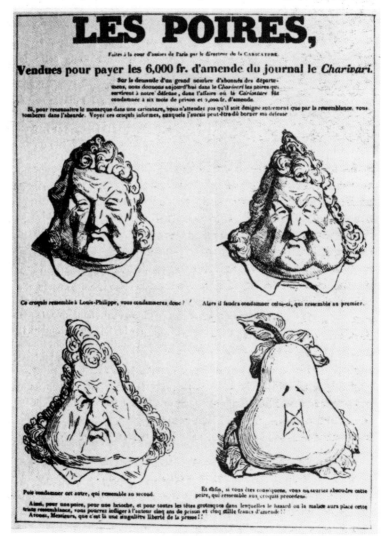

27 Philipon, *Louis-Philippe/Les Poires*, from *Le Charivari*, 17 January 1831

71

from nearer or farther away is often a recognizable likeness. It can seldom, however, be properly called a portrait. The characteristic quality of a portrait is the peculiar sort of communication, almost a conversation, that the person who looks at the picture is able to hold with the person painted there. This depends on there being depicted on the canvas at the same time the sitter's soul – or how he feels to himself – and his character – or the part he plays in the outside world . . .[34]

In this passage, Maurice Grosser has not just placed caricature and portraiture on the bridge of resemblance, he has also argued for the comparability of the psychological relationship between artist and subject and between portrait and viewer. For him, access, intimacy, and the feeling of closeness are all essential ingredients in this personal transaction between oneself and another, although what constitutes 'resemblance', sufficient to establish that transaction, is not clear. In Grosser's view, poignant and traditional as it is, the congruence of 'soul' and 'character' should be the standard of judgement, if one knew what they were and agreed on the substance of their representation by the sitter and in the work. If each person could reveal these same elements to different portrait artists, perhaps the viewer might then know what the original was truly like.

To see how the identity of a famous subject could be captured in a portrait we can turn to two portraits of a well-known model that have long been recognized as canonical examples of the genre – Dürer's and Holbein's portraits of *Erasmus* (illus. 28, 29).

If a man makes an image of a friend, of course he does not suppose that the friend is in it or that parts of his body are included in the various parts of the representation. Honor is shown toward the friend by means of the image.[35]

Holbein's portrait of Erasmus in his study, painted in about 1523 and now in the Louvre, and Dürer's engraved portrait, made some three years later, both present Erasmus in his familiar role as a humanist-scholar, a role made familiar by these same artists and by Erasmus' own self-fashioning, supported in this effort by his contemporaries.[36] Holbein's portrait has primacy; his vision of the great scholar became

28 Albrecht Dürer, *Erasmus*, 1526

29 Hans Holbein the Younger, *Erasmus*, 1523

authoritative, despite the inscription in Dürer's print which states explicitly that Erasmus' image was taken from life by the artist. We should understand this to mean 'pre-formed life' as determined by Holbein's imaginative portrayal, so readily accepted as the *correct* representation. This powerful, synthetic image stands for ever for the person 'Erasmus', whom we recognize and whom we know: a distinguished humanist-scholar, a modestly dressed, sharp-featured, middle-aged man, who lived the life of the mind and communicated his thoughts and feelings to others in his many public and private writings.

> A painter may well succeed in rendering the fundamental humanity of a person by a synthesis of observations in an artistic idea; but none the less the recognition of his achievement will often not come before that strange moment after the death of the portrayed when visual recollections have grown dim enough to be replaced in the mind of the survivors by the likeness itself.[37]

Holbein, and then Dürer, chose not to represent a significant moment in Erasmus' life but to construct one, characterizing his customary attitude and behaviour and consolidating that perception in a synthetic image which presents Erasmus most completely *as himself* to posterity. Despite the evident differences between Holbein and Dürer in personal style, medium, and composition, their consistent treatment of the subject indicates the practical validity of Grosser's test. Their 'Erasmus' was quickly taken up as an acceptable visual impersonation, the fictive portrait through which Erasmus would be seen and remembered. This composite portrait lived on through history as the true likeness of this great man, as if these artists had played no role in its creation.

Through synthetic concentration and analytic vision, Dürer had arrived at a proper likeness of his subject – a most difficult task. Erasmus was, after all, not merely a creature of the flesh but primarily a man of the mind, if not of one mind. He had written a series of works over the years that revealed his changing state of mind, each fixed at the time of writing, a true reflection of his soul's development. Their author's appearance changed constantly, as Erasmus himself recognized, but not his identity as a thinking being – that never changed.

VIVENTIS·POTVIT·DVRERIVS·ORA·PHILIPPI
MENTEM·NON·POTVIT·PINGERE·DOCTA
MANVS

Dürer attempted to represent another such complex and creative person in his portrait of *Philip Melanchthon* of 1526 (illus. 30) but found a different way to characterize his subject.[38] In the inscription, the artist claims that he was able to depict Melanchthon's features 'as if he were alive' but that even his skilled hand could not portray Melanchthon's soul (*mentem*). This statement recognizes that the appearance of an individual may bear only a casual, even coincidental relation to his nature, his interior personal life, and that, therefore, his features do not necessarily portray that inner quality which identifies the individual in his essence. Despite his disclaimer, Dürer made an interesting attempt to achieve this goal by placing Melanchthon's head against the open sky

– not Erasmus' cloistered study – permitting the apparent expansion of his large, bony cranium as a sign of the lofty spirit and great intelligence of this celebrated Protestant theologian. Thus Melanchthon's intellectuality, the very core of his being, was given a physical and visual presence in this portrait.

Of course, a portrait may represent the fact that the subject has a mind, and is devoted to the life of the mind, but it cannot describe or define what goes on in that mind. The problem here is not just the great difficulty of knowing what goes on in another's mind; it also lies in the Renaissance artist's obligation to establish the identity of his subject and to represent his knowledge of that individual, *qua* individual, in a visually accessible manner. In order to establish and characterize the mental activity for which Melanchthon was justly famous, Dürer used the distinctive size and shape of his head as a key to revealing the intimate correspondence between Melanchthon's corporeal self and his otherwise unrepresentable soul. It may well be that Dürer even exaggerated the physical properties of Melanchthon's head to achieve that goal, thereby contradicting Duncan's observations about the Thane of Cawdor that, 'There's no art to find the mind's construction in the face' (*Macbeth*).

Apart from this powerful invention, Dürer relied on an old tradition, long used for the symbolic representation of character – physiognomics. According to this pseudo-Aristotelian tradition, the personality of the subject can be grasped through the precise interpretation of somatic clues which manifest the spiritual qualities of the person portrayed.[39] Artists developed a formal repertoire of such visual clues to use in depicting the subject's character, even when such physical features did not, in fact, correspond with the model. The tautologous nature of this process merely confirmed the need of the subject, the artist, and the viewing public to share in this way their information about character (Grosser's 'soul'), the true criterion of identification.

Perhaps the most influential practitioner of this pseudo-science was Johann Caspar Lavater, a Swiss theologian active in the late eighteenth century, who sought thereby to improve the human race. His work on physiognomy was translated into many European languages, accompanied by diagnostic illustrations which could readily serve as models

31 *Socrates*, from
J. C. Lavater,
Physiognomie, 1
(Vienna, 1829)

for portraitists.[40] Representations of Socrates (illus. 31) pro-
vided Lavater with an excellent test case for his theories,
because the ancient sources gave the philosopher the coun-
tenance of Silenos, with coarse, brutish features, yet artists
had to uncover the noble soul within this unrepresentative
corporeal envelope. They did so by adjusting his physiog-
nomy, making 'ennobling' corrections to his cranium, nose,
ears, chin, and beard – everything – in an effort to capture
the real personality of the man who lives in Plato's
dialogues.[41] Cicero himself imagined a noble Socrates from
his encounter with the man in Plato:

> In point of fact, when reading the admirable volumes of
> Plato, almost all of them containing a picture of Socrates,
> there is not one of us who, although they are works of
> genius, yet does not imagine something on a larger scale
> in regard to the personality that is their subject.[42]

The denotational content of the proper name 'Socrates', with

all that it implies, outweighed the accidents of physical appearance which, artists felt, were superficial and misleading, failing to convey his true nature to the observer. Accordingly, such physiognomically sensitive portraits of Socrates (illus. 31) or Melanchthon (illus. 30) are primarily statements about being 'Socrates' or 'Melanchthon', as a form of visual predicate rather than a description – a metaphysical rather than a physical portrait.

> Each perfect portrait is an important painting, since it displays the human mind with the peculiarities of personal character. In such we contemplate a being in which understanding, inclinations, sensations, passions, good and bad qualities of mind and heart, are mingled in a manner peculiar to itself. We here see them better, frequently, than in nature herself; since in nature nothing is fixed, all is swift, all transient. In nature, also, we seldom behold the features under that propitious aspect in which they will be transmitted by an able painter.[43]

'Under that propitious aspect', in J. C. Lavater's words, seems to allow the artist extraordinary leeway in fashioning the subject's core identity – the self – when his interpretation of that identity does not correspond to the reality of physical appearance. *Philip Melanchthon* (illus. 30) and *Socrates* (illus. 31) were made to 'look better' than they actually appeared because, to the artist and to the admiring public as well, neither subject looked as good or as distinguished as he should have done. Under these circumstances it is quite conceivable that a portrait could bear the subject's name but have a face not wholly his own, or even someone else's face, and still retain some slight resemblance to the original, or at least to the viewer's mental image of that original. A portrait that has become widely accepted as the image of a well-known historical subject may, it seems, function very usefully as a portrait of that person even if the features actually belong to someone else.

A fascinating and successful instance of such a counterfeit, passing itself off as an original – albeit unintentionally – is Rubens' *Four Philosophers with a Bust of Seneca* (1611–12) in the Pitti Palace in Florence (illus. 13).[44] The four philosophers have been identified, beginning with Rubens himself at the left, then his deceased brother, then the great classical scholar

and Neostoic, Justus Lipsius (also dead), and, at the far right, his pupil Woverius. In combining living and dead subjects, Rubens expressed the continuity of living memory, made possible by affection and by art, which imbues the dead with the freshness of life. This imagery requires interpretation in terms of the context within which Rubens worked, that of Dutch and Flemish seventeenth-century group portraiture, but only the illusionistic 'bust portrait' of the Roman Stoic philosopher, Seneca, in the wall niche above, interests us here. Seneca's bust appears in the background of the painting as an emblem of his philosophy and manner of living which Lipsius greatly admired and which he helped to disseminate through his authoritative edition of the Senecan corpus. (cf. illus. 1).

So much is self-evident in the painting and would have been readily understood by Rubens' cultivated contemporaries. But this ancient bust – one of many circulating among humanists of the period – is not a portrait of Seneca at all. This portrait represents some other ancient worthy, variously and contentiously identified by scholars today; meanwhile, the highly recognizable image, of which there are more replicas than any private portrait surviving from classical antiquity, passes under the no-name title of the Pseudo-Seneca, an imputed identity based on past errors.[45]

The Pseudo-Seneca is a false index – that is to say, it conveys an untruth to an unsuspecting, gullible audience. More than a century later the physiognomist Lavater refused to be taken in, not because his iconographical methods were scientific but because his intuition of Seneca's appearance led him to contest the attribution:

> This head cannot possibly be that of Seneca, if he is the author of the works which bear his name. The forehead indeed suggests the richness of the imagination, and the energy of the Latin philosopher, but so far from harmony with his delicacy and ingenious manner, it is harsh, inflexible, intractable . . . Everything in it (the physiognomy) is full of force and impetuosity; everything announces violent passions, easily roused, but calmed with difficulty. There is in each part separately, and in their union, a shocking coarseness and vulgarity.[46]

For Lipsius and his friends, however, the search for Seneca marked their desire to discover the likeness of an admired

person, Seneca, and to 'read into' the portrait those values which they associated with Seneca's life and writings. With their willing help, the ancient portrait makes a false denotation and therefore, one might argue, all those values – moral, spiritual, psychological – which have been imputed to this image, the products of misreading, are either erroneous or irrelevant.

That would be an oversimplification. The name given to this portrait type (and all believe it to be a portrait of someone) is both true and false: false in that it does not represent Seneca, and true in that it presents the appearance of a person whom many could and did take to be him. What is in such a name? If we call this image the 'Pseudo-Seneca', we understand that it represents all those traits of character that people are prepared to accept as 'being Seneca'; it is a portrait of someone we have envisioned Seneca to be like. The association between Seneca and the Pseudo-Seneca is formed by projection, involving the relationship between *reading into* and *reading out of* a portrait. Reading into a portrait provides us with the sense that this could be Seneca (or could have been), because Seneca was a man who did such-and-such things, and this recognizable portrait still exists today as a likeness for the kind of person we imagine Seneca to have been, even if we know that the portrait is of someone else. Despite the mistaken identification, the Pseudo-Seneca must be understood historically as a form of simile, where likeness as an *as* has been validated, although untrue.[47] In this way, the Pseudo-Seneca image legitimately served Lipsius' need for a portrait in which the characteristics and activities of the great Stoic could be clustered under the name 'Seneca'. For Lipsius, this was Seneca (illus. 13) and he could 'read out' of the image all the qualities of the individual whom he admired. When the supposed connection between the original living subject and his/her portrait is broken, then acceptance of the art work as a portrait seems to depend ultimately on the viewer's opinion.

Rembrandt's portrait of *Aristotle Contemplating a Bust of Homer* (1653) in the Metropolitan Museum, New York, poses a similar dilemma (illus. 32).[48] Freed from any dependency on an original subject, the artist has created an imaginary Aristotle, or what passes for Aristotle, looking at a bust of Homer, derived from a Hellenistic portrait type of Homer,

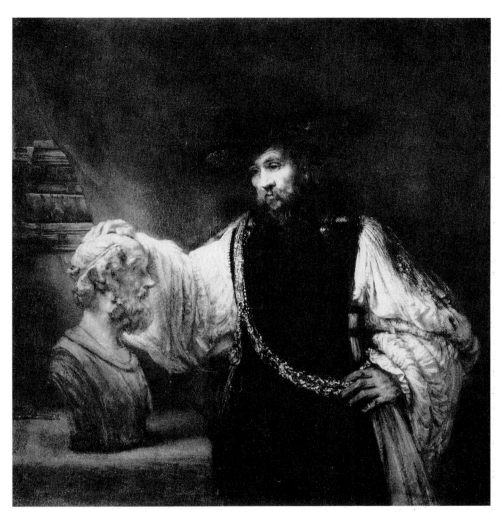

32 Rembrandt,
*Aristotle
Contemplating a
Bust of Homer*, 1653

and thinking about him, just as Rubens used the bust of
Seneca to suggest the direction of Justus Lipsius' thoughts
(illus. 13). It is usually assumed that the *Aristotle* exemplifies
a kind of Rembrandtian make-believe in which the artist cov-
ertly intervenes to create a deliberately ambiguous portrait of
the Greek philosopher, perhaps because portraiture itself as
a subject is not preeminent in this work. In one set of mental
circumstances, Aristotle appears; in another, the figure may
be identified as Rembrandt's 'Aristotle', his sombre, bearded
likeness moving between the ancient models of philosopher
portraits and the melancholic image of a pensive contem-
porary.

Again, we know something Rembrandt did not: the sculpted bust of Homer which receives Aristotle's gaze and touch is also a fiction, having many of the characteristics of the Pseudo-Seneca but without the possibility of representing anyone else. The bust does indeed portray 'Homer', but a physically blind image of Homer that was invented in the Hellenistic period, dependent on a mental image that emphasized the poet's inward-turning vision as a seer.[49] This Hellenistic 'Homer' came to stand for Homer the poet, serving as his recognized likeness and as a sign of his presence, the 'Homer' for all who, like Aristotle or Rembrandt, wished to make contact with the master.

Rembrandt does more than depict two great figures of the Classical past in silent communion. In this painting he visualizes the magical power that portraits have to bring the viewer – wherever present – into a personal, even intimate connection with another being, however remote from him in time that subject might be. Rembrandt has formalized an intensely personal relationship between his 'Aristotle' and his 'Homer', thereby transcending the separations of time and medium. In addition, by implying that the desire to know one another makes possible the knowledge of oneself, Rembrandt has included himself in the work, mediating between Aristotle and the viewer as Aristotle mediates between Homer, the poet-creator, and Rembrandt, the artist-creator.

Aristotle Contemplating a Bust of Homer can be taken as an expression of the artist's selfhood, a characterization lacking any visible reference to the external appearance of himself, Rembrandt, as that subject. To quote Oscar Wilde,

> . . . Every portrait that is painted with feeling is a portrait of the artist, not of the sitter. The sitter is merely an accident, the occasion. It is not he who is revealed by the painter; it is rather the painter who, on the coloured canvas, reveals himself.[50]

Appropriately, Richard Shiff echoed these remarks when he observed of Manet's *Portrait of Zola* (1867) in the Louvre (illus. 14) that, 'The Portrait of Zola . . . becomes Manet's self-expression, his own vision and his own portrait.'[51]

Manet's *Portrait of Zola* makes the presence of the artist felt even more forcefully than Rembrandt. Setting the famous author in his studio, furnished with prints and sketches

owned or made by Manet himself, the painter has made Zola seem almost incidental, his presence redefined by his relationship to the painter, whose aura fills the canvas. When the artist is so manifest in the work, providing the viewer with repeated clues to his identity and to his genius,[52] the ostensible subject (Zola), descriptively realized, becomes to some degree subservient to the implicit portrayal of Manet as an artist who paints distinctive pictures, including this one. Thus, designation and denotation may refer to different subjects in such a work, the tension between them limiting the effect of the sitter's centrality in the composition.

Manet's ego occupies the visual field, perhaps because he contends with Zola for prime consideration as an artist on grounds of his own choosing. Consistent with his nature, the painter wished to make 'explicit for himself that which he is, and generally, whatever is'.[53] Zola, however, remains a contestant for attention because of his position in the painting and because of his intrinsic worth as a subject. But, as any sitter would expect in such circumstances, Zola can only be seen through Manet's selfish eyes. Manet's painting has been complicated by the double agenda of representation undertaken by the artist in the evocation of his own presence through the portrayal of Zola. In doing so, Manet has fashioned an abstract, non-descriptive, but pertinent characterization of himself in the very process of fashioning an image of a distinguished 'other' who naturally comports himself in the painting as the renowned author-critic that he *is* and wanted to be known *as*.

The artificiality of portraiture as a method of packaging individuals in neat containers of personhood is often much more obvious in less agreeable instances of representation. Jean George Vibert's *In the Image of the Emperor* (illus. 33), a late-nineteenth-century painting auctioned off in New York in 1975, depicts the composite, derivative, and misleading character of self-fashioning which attempts to submerge the self in the guise of another.[54] A man, dressed in clerical costume – already a cover – carefully combs his hair in the manner of Napoleon, using a bust of the Emperor as his model; on the wall behind is a painted portrait of Napoleon and various Imperial mementos are scattered about the room. Although the reflections in the hand-held mirror are invisible to us, we can imagine the subject's effort to reshape himself

in the Emperor's pervasive image, at least in that part of his body, the face, still open to such visible transformation. Although this is far from being a distinguished work of art, Vibert has been very successful in ringing the changes on portraiture as an art of deception in which artist and subject are accomplices.

33 Jean-George Vibert, *In the Image of the Emperor*, late 19th century

Vibert's painting displays the cheaper devices of self-fashioning and its models, making it possible for the viewer to appreciate this unknown cleric's drive to (re)make himself in the image of a famous 'other'. To look like Napoleon is, of course, not to be like him, because his persona cannot be so readily assumed; the cleric remains the cleric in his soutane. One person's desire to resemble another is both a sign of admiration and, in the extreme, a mark of self-delusion. In the theatre, however, it expresses the metaphorical nature of all impersonations, even more so in the portrayal of a famous actress assuming a role. Thus Joshua Reynolds' portrait of *Sarah Siddons as the Tragic Muse* (illus. 34) exposes the whole concept of being 'like' another in the representation of 'as-ness', according to F. E. Sparshott:[55]

> . . . (whereby) Reynolds paints Mrs Siddons as the Tragic Muse. The metaphor is Reynolds', and not ours. But is it his alone, or is it Mrs Siddons' as well? Was she posing as the Tragic Muse, or did she merely pose and leave the Muse bit to the artist? And, if she was posing as the Muse, did she merely dress for the part, or did she throw herself into the role? We are encouraged to ask this because we know she was an actress. And because we know that she was the foremost tragic actress of her time we go on to ask: is this a picture of an actress acting, or of an actress not merely seen as, but thought to be, the inspiration of the stage? And is it the portrait of a woman trying to help dear Joshua out by looking Muse-ish as she knows how, or of a celebrity dreaming of her own apotheosis? That depends on what we think of her doing – on what we think of her as a model.

Reynolds has raised our natural suspicions by confronting the problem of calculated self-fashioning with such cunning in Mrs Siddons' portrait. We are less wary in the encounter with the person in a photographic portrait because we tend to assume it is the 'real thing', that the image seen bears an immediate and direct relation to its subject, innocent of the pretensions of the photographer, if not of the subject. Yet, Southworth and Hawes' daguerrotype of *Daniel Webster* (illus. 18) is no less a product of calculated and calculating artifice than Reynolds' *Mrs Siddons* (illus. 34). Still, the photographic image seems so real, so like Narcissus in its natural reflection

34 Joshua
Reynolds, *Sarah
Siddons as the Tragic
Muse*, 1784

of the man, that we can readily accept the 'Webster' we have
been given, just as we have accepted Holbein's 'Erasmus'
(illus. 29), Dürer's 'Melanchthon' (illus. 30), and the Pseudo-
Seneca, so precious to Justus Lipsius and his friends (illus.
13, 1).

M. C. Escher's Surrealist lithograph, *Hand with Reflecting
Sphere* (1935), is a self-portrait with many of the illusionistic
qualities of a photograph (illus. 35).[56] It is a brilliant work that
sums up the relationships fundamental to the act of portrayal.
Escher revealed himself in the reflecting sphere, a world
within a world, brought into association with the 'outside' by
the details of the room, appearing on the convex surface, and
by the hand which holds up the sphere for contemplation.
But by whom? Unlike Manet's *Portrait of Zola* (illus. 14),
Escher is present both as the performing artist and as the
visible subject, the very immediacy and centrality of his image

in confrontation with the viewer. He exists unequivocally as the 'I' in the work, in visual dialogue with the viewer who appears, however, to be Escher himself, if the sphere's reflection is valid and the supporting hand is his own. Escher seems to be manipulating the spectator, fooling him into believing that the lithograph is like a mirror, then denying that possibility by presenting his own image *instead*.

Escher's figure in the spherical reflection seems to reach out with his right hand, extending it, apparently, into the spectator's visual and psychological space, where it meets the

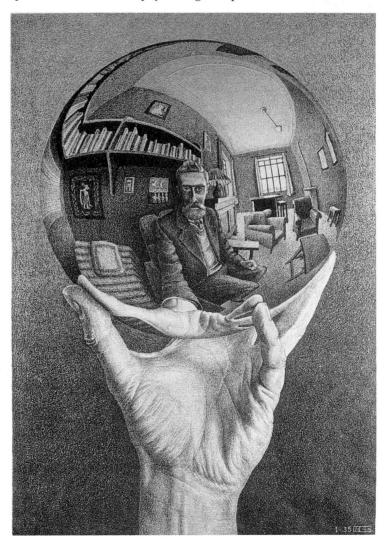

35 Maurits Cornelis Escher, *Hand with Reflecting Sphere*, 1935

(be)holder's hand on the 'outside'. But wait! Considering the position of the thumb, that external hand must be the holder's left; and if it is the left hand, then Escher's hand in the spherical reflection must also be his left, given the well-known reversion from right to left effected by mirror images. This 'outside' hand could only be a right hand if Escher and the spectator were different persons and the sphere did not reflect the holder's image but rather displayed some prior portrait of Escher placed on its surface. Yet Escher and the spectator are different persons under the special conditions of this vision. The spectator can have access to this private, seemingly hermetic self-portrait *by* the artist only by accepting the portrait for what it is, a portrait *of* the artist and an independent work of art, and thus denying the illusion. Representation, therefore, asserts its customary authority over presentation.

In the lithograph Escher has presented himself as the artist who made the work, as the subject of the portrait, as the self-conscious portraitist, and as the being in the work who has, in effect, made himself what he is – *homo-artifex-faber*. We too can look upon this challenging image as a statement about the fabrication of identity and accept this as the specific task of any portraitist who responds to the human presence in time and place and desires to preserve it for others. This has been well expressed by the French phenomenologist, Merleau-Ponty:

> If the other is truly for himself alone, beyond his being for me, and if we are for each other and not both for God, we must necessarily have some appearance for each other. He must and I must have an outer appearance, and there must be, besides the perspective of the For Oneself – my view of myself and the other's view of himself – a perspective of For Others – my view of others and theirs of me . . . I must be the exterior that I present to others, and the body of the other must be the other himself I discover by reflection not only my presence to myself, but also the possibility of an 'outside spectator'.[57]

III Fabricated Identities: Placements

In fact, those who most seem to be themselves appear to me people impersonating what they think they might like to be, believe they ought to be, or wish to be taken by, whoever is setting standards.

PHILIP ROTH *The Counterlife*

The novelist Philip Roth has succinctly described the rhetorical character of self-fashioning and its deference to the expectations of others. Surely, putting people in their 'rightful' place within a social context always requires a high degree of cooperation and collusion among the participants in a social encounter. Cooperation is found in the exchange of the meaningful, but not necessarily true, indications of status and role that establish the social identity manifested by one person and so understood by another. Collusion is the end result of the tacit agreement that whatever a person represents himself or herself to be, or to be like, will be taken as face value, at least at the beginning of the exchange.

Apparently, people impersonate as a normal condition of their social existence, but their impersonations have limits. Unfortunately, both the cooperative spirit and the collusive social contract often break down in disillusionment, when the representation of the social self does not correspond to reasonable expectations or has been grossly misinterpreted. What might be considered a reasonable expectation – or reading – when the artificiality and other-directedness of self-representation are readily acknowledged, is a matter for ironic speculation and occasional regret.

The portrait artist's intervention in this already complicated relationship adds another participant whose views must be taken into account. The very ambiguity of impersonation complicates the proper evaluation of the portrait artist's performance in interpreting (or concealing) the impersonating subject, when impersonating something is such an essential feature of the subject's social identity. To take someone for a 'something' – an artist, or leader, or member of a family, or

a 'beauty', or an engineering or scientific genius, etc. – is to place that person within the categories established by consensus to locate members of a society in the familiar roles by which they are particularly presentable and knowable. The denotation of someone as 'the person who is a something' adopts the metalanguage of the social act in defining identity, equivalent in its value to the person's name. A few years ago, Harold Rosenberg wrote: 'Portraiture involves a consensual ritual encounter which is both trusting and wary: the subject submits to the artist's interpretation while hoping to retain some control over what that interpretation will be. The history of portraiture is a gallery of poses, an array of types and styles which codifies the assumptions, biases, and aspirations of the society.'[1] I would add to that the artist's collusive involvement in the fabrication of an identity for the subject that may, or may not, correspond to the subject's own representation of self, even at the time of portrayal.

Sometimes, the impersonation shown does not suit the programme of artistic representation, although it may be difficult to determine whether it is the subject or the artist who is principally at fault. A classic instance of this failure to comprehend the objective of representation undermined the effort of the American politician, Michael Dukakis, to present himself properly as a presidential candidate in the *Dukakis Family Portrait* (illus. 36), issued in countless numbers to advance his campaign in the autumn of 1988. The private and public needs were at odds, so that Dukakis, the presidential candidate, disappears in favour of a rather self-effacing family member whose body is the least conspicuous in the entire ensemble. Candidates in American politics have often demonstrated their allegiance to traditional values by showing themselves with their families, and Dukakis is no exception. Rather, the failure in representation, and probably in self-representation as well, lies in his or the photographer's insensitivity to the implications of the candidate's relative invisibility in the family portrait; it could be interpreted by anyone, let alone a political opponent, as a sign of Dukakis' inability to take a leadership role even within the context of his own family, and if not in the family, then how in the nation? This misguided intention to present himself as a truly modest Democrat bore with it the seriously negative connotation that betrayed his posture as the presidential candidate

36 *Michael Dukakis Family Portrait,* 1988 presidential campaign photograph

37 Henry F. Darby, *The Reverend John Atwood and his Family,* 1845

90

for whose election that photograph had been taken and distributed in the first place.[2]

What made the Dukakis photograph even more counterproductive was the long-standing portrait tradition of representing the family as a cohesive group, led by a dominant male. Families that can, and want to, commission artists to portray their members in a group are a special breed to begin with. Inevitably, such family-group portraits carry with their collective imagery the connotation of a positive self-evaluation, shared by the family members, and they often display gentilic identity as a matter of pride and as a sign of their confidence in the family's future.

Henry F. Darby's *The Reverend John Atwood and his Family* (1845) is a fine example of a well-structured American family portrait (illus. 37). The two parents and their six children are shown assembled in the family parlour, reading the Bible together and led, appropriately, by the Reverend Atwood. As the *paterfamilias*, Atwood's authority and his compositional weight are only slightly greater than his wife's, because the private nature of this representation of an upstanding mid-nineteenth-century New England minister's family is unmistakable. A tight structure also establishes the hierarchical composition of the Tudor family portrait of *William Brooke, Earl of Cobham, and his Family* (1567), formerly attributed to the Flemish artist, Hans Eworth (illus. 38).[3] The arrangement is hardly democratic, with the family members clearly stratified by generation, but everyone appears close together in this red-headed clan, sharing that overt physical characteristic. Furthermore, the setting of the group around the table suggests a degree of domestic intimacy that was becoming increasingly typical of the late-sixteenth-century noble household in England. Certainly, the historical and sociological implications of family-group portraits as indicators of social change cannot be overestimated.[4] From the eighteenth century onwards these portraits mark the embourgeoisement of their participants as well as the progressive decline of parental authority and prominence. The process leads eventually to the social dynamic of the *Dukakis Family Portrait* (illus. 36), which is completely understandable as a private portrait, conceived in the terms of late-twentieth-century American culture, but thoroughly unsuitable for public consumption.

Group portraits are not random collections of persons but

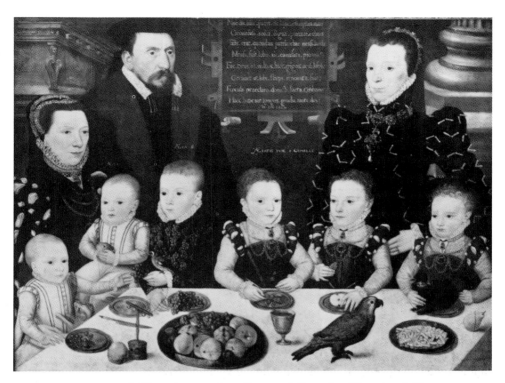

38 Hans
Eworth(?), *William
Brooke, Earl of
Cobham, and his
Family*, 1567

deliberate constructions of the significant relations among
them, as Frans Hals showed so well in his *St George Civic
Guard* (illus. 15). In Dutch group pictures, the integrated
ensemble may prevail over the independent individual, but in
them the strong emphasis on the realistic depiction of specific
individuals permitted each person's portrait to compete for
close, if momentary, visual and psychological attention. The
Dutch artists seemed to compel the viewer's eye to move from
face to face, never losing sight of the others in the contem-
plation of the one. Such works are peculiarly cooperative and
collusive in their nature, because each person in the group
contributes to, and draws from, the presentational dynamic
of the whole. Some conformity to the norms of the group,
whatever these might be, affects all members, forcing each
person to evince some significant degree of participation as a
way of manifesting the alleged coherence of the group, as
represented in the work of art.

Portraits of husband and wife, especially when the pair
have been married for a long time, are often the most mutu-
ally responsive and cohesive of group portraits, perhaps

93

because after a while many husbands and wives begin to look alike.[5] Dutch seventeenth-century portraits of married couples are rarely joyous in expression, but their customary reticence was frequently mitigated by the artificially casual disposition of their figures in a comfortable domestic environment. And sometimes, as in the very conventional Van der Neer, *A Dutch Interior* in Boston (illus. 39), the portrait displays symbols of marital bliss or erotic love at considerable variance with the couple's apparent sobriety.[6] Or perhaps the purported resemblance of husband and wife to each other reflects more the artist's expressive style than a fact of nature, as in Kokoschka's portrait of the art historians, *Hans Tietze and Erica Tietze-Conrat* (1909), one of his finest works in this genre (illus. 40). Their portrait seems filled to overflowing with the subjects' presence and with their intense consciousness of themselves and of each other, the latter reinforced by their gestures. Kokoschka concentrated on the couple,

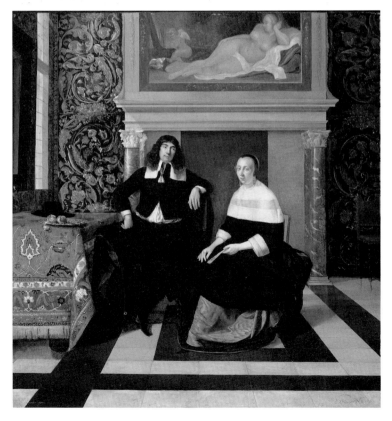

39 Eglon Hendrick van der Neer, *A Dutch Interior*, mid-17th century

94

excluding almost all references to a setting, unlike the Dutch
pair (illus. 39), and he covered the ground of the painting
with vibrant, agitated passages of paint to express the inner
power and energy of these people, singly and together . . .
yet he complained about Tietze's 'boring head'.[7] As an inter-
venor in this personal transaction between the Tietzes, and
between them and the viewer, Kokoschka's 'Tietzes' is what
we have, no less an artifice of representation and no less a
portrayal of their on-living selves than Picasso's almost con-
temporary portrait of Gertrude Stein.[8]

The compositional glue that holds groups together need not
depend on family ties or on joint membership of established
institutions, although the great Dutch group portraits prob-
ably established the model for representing the corporate per-
sonality in a single, all-encompassing image. In an artist's
conception of the Dutch group portrait as a corporate body,
class membership and its visual analogue, classified imagery,
provided a common denominator to the portraits of the indi-
vidual members. It is the participation in the group and the
devices used by the artist to visualize that participation that
have such a high degree of significance in establishing any
member's identity. Definitions of the group itself must be
manifested in the group portrait, if the work is to have any
meaning, and if the individual subject within it is to display
the desired identity as a participant – that is, to appear to be
like the others.

Many such groups come to mind in the repertoire of Dutch
seventeenth-century art, but there are other well-established
groups that have neither familial nor formal institutional con-

nections. These groups, or group portraits, assert, as the basis of association, a coherency of manners and activities, such as 'poets', 'philosophers', 'mathematicians', and 'artists'; the *locus classicus* for such an assembly of cultural and intellectual giants would be, of course, Raphael's *School of Athens* in the Vatican.[9] This type of voluntary association took on additional importance in the nineteenth century, when 'to be an artist' carried with it a belief in the assumption of a special vocation with an attendant behaviour pattern, which effected at least the partial separation of artists, as a self-defining élite, from the rest of society. Perhaps Courbet's *L'Atelier d'Artiste* in the Musée d'Orsay is the most famous example of this type of group portrait, but it is egocentric in its conception and thus diminishes the importance of the group and its members in favour of Courbet's dominance, as artist-king, over the ensemble. Much more representative of the ethos of the group portrait is Fantin-Latour's *L'Atelier aux Batignoles* (1870) which portrays Manet at the easel, accompanied by Astruc, Scholderer, Renoir, Zola, Edmond Maitre, Bazille, and Monet, but not by Fantin-Latour himself (illus. 41).[10] It is the company of artists, writers, and their friends that constitutes this group; all of them are creative persons who associate with one another under the auspices of Minerva whose statuette can be seen at the left, reminiscent of Rubens' use of the Pseudo-Seneca in his *Four Philosophers* (illus. 13), painted more than two centuries earlier.

The Rubens, the Frans Hals (illus. 15), and the Fantin-Latour (illus. 41) all establish the relationship between the actors, the locus of their characteristic actions, and the worthy consequences of these actions. In doing so, the artists have revealed the outward expression of each actor's personhood by virtue of his participation in the group, the very participation that gives meaning to his life as an individual and offers to him a part of his identity that he shares, willingly, with others. Such groups make ideological statements about the values, attitudes, and practices shared by their members, and by the portrait painter as well. In effect, that shared ideology binds the individuals together in some transcendent association, while also constituting each of them as the 'concrete subject' – in Althusser's sense – who holds these values and attitudes.[11] Group portraits of this kind reveal the mutuality of the transaction between the individual and the group

41 Henri Fantin-Latour, *L'Atelier aux Batignoles*, 1870

42 William Hogarth, *Conversation Piece with Lord Hervey*, 1737

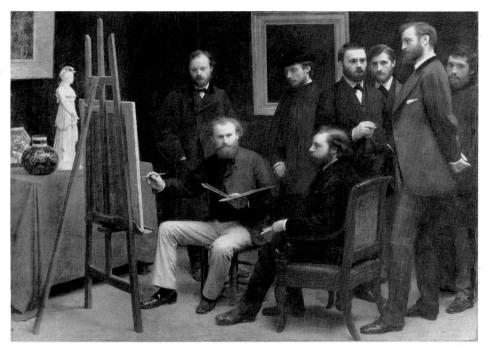

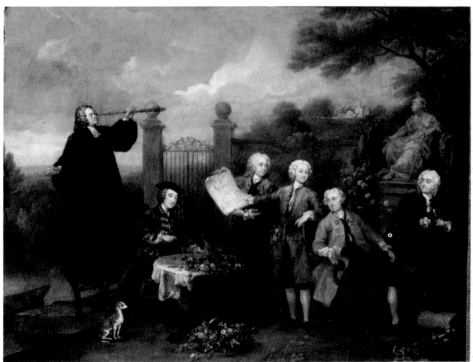

that balances the unique and typological characteristics of personhood.

Fantin-Latour's *L'Atelier aux Batignoles* (illus. 41) portrays a well-defined group of friends, but its composition is open, inviting others, including the spectator, to join the company, if like-minded. The apparent informality of this work may have its origins in the 'conversation picture' whose heyday was in the eighteenth century, when polite conversation in the drawing-room or garden was both a social and intimate occasion for the assembly of friends, and their engagement in conversation. Artists painted 'conversation pictures', as a form of group portrait, to represent these occasions for the very persons who enjoyed them, as if to confirm by their art the value of this civilized, domestic ritual.[12] Conversation pictures might include family members, but in the hands of Zoffany or Hogarth these pictures could include a group of friends, drawn from the same social class and sharing the easy, but courteous, intimacy of all well-mannered persons. Such is the company portrayed by Hogarth in *Conversation Piece with Lord Hervey* (1737), a portrait of a group of learned friends, not unmindful of the implied spectator – perhaps, one of them – who is welcome to participate in their discourse (illus. 42).[13] Conversation pictures of this type are potentially unrestricted, in the sense that they seem to incorporate the unrepresented class member, because the implied or potential spectator is assumed to look, and behave, like them. These pictures, possibly Fantin-Latour's *Atelier* as well, seem to be generic rather than historical, representing typologically accurate rather than actual gatherings, despite the details that Hogarth introduced into Lord Hervey's company to individuate the interests of the parties.[14]

Lord Hervey and his friends belong to a group, partly predetermined by their social standing and partly formed by their intellectual pretensions, although Hervey himself was more a 'wit' than an intellectual. Fantin-Latour and his friends constitute a different kind of group, determined by the quality of their individual talents and by their achievements, even if these achievements are implied rather than represented. Perhaps in response to the dynamic nature of modern society, the identity of a person in the nineteenth century was more and more established on the basis of what he or she did, or had done, than by birth. The achievements themselves – the

work done – formed an extrinsic projection of the person that, nevertheless, remained an integral part of his or her being – and therefore a legitimate element in any portrayal.

Manet's *Zola* (illus. 14) offers a particular response to this impulse to characterize someone by externals – the products of the person portrayed that bear the mark of that person's character or genius. Manet portrayed Zola together with the pamphlet, entitled *Manet*, that Zola had written, while he portrayed himself, or indirectly suggested his own presence, by reproducing an oil sketch of the infamous *Olympia* by which he, Manet, had become famous.[15] One might imagine that Manet's portrait of *Zola* could just as well have been entitled 'Manet Makes Himself' because that is so much the spirit informing the entire work. Manet was not alone in doing this, although only an artist could control all the aspects of this covert self-portrait.

A similar concept informs the superb photograph, taken in November 1857 by Robert Howlett, known as the *Portrait of Isambard Kingdom Brunel Standing before the Launching Chains of the 'Leviathan' (the 'Great Eastern')* (illus. 43). Brunel, one of the greatest and most original of nineteenth-century engineers, appears in all his shabby glory like some splendid Dickensian figure, his boots and trousers stained with mud; behind him rise the iron chains of the *Great Eastern*, the largest ship built up to that time and the forerunner of the great transatlantic vessels, launched later in the century. The apparent verisimilitude of Brunel's appearance against the background of the iron chains confirms our expectations of such a person, much as Daniel Webster's photograph did (illus. 18). However, it is no less an ideologically determined convention for representing the self-made engineering genius at the height of his powers and reputation, standing in the presence of one of the great products of the genius on which that reputation was based. In this regard, Brunel appears like an actor playing a part, the part of the 'great engineer'. But this is not a part he puts on and takes off like an actor on the stage; rather, the part is a permanent aspect of his being, of his identity, from which he cannot and, if properly portrayed, should not be parted. In this portrait of Brunel, the engineer, the impersonation is so complete that there is no other 'Brunel'.

Perhaps Brunel plays his part so well that, in effect, it is no part at all, but some parts are so closely tied to the player,

43 Robert Howlett, *Portrait of Isambard Kingdom Brunel Standing before the
Launching Chains of the 'Leviathan' (the 'Great Eastern')*, November 1857

like an alter ego, that they cannot readily be separated from the person who plays them. So it is with Thomas Phillips' rather vapid portrait of *George Gordon, 6th Lord Byron* (1813), a superficial realization of the romantic, Byronic hero, at least somewhere present in the dashing oriental costume he wears (illus. 44). This pallid attempt to fabricate Byron's identity hardly satisfies because, unlike Howlett's photograph of Brunel 'in context', there is nothing in this portrait of Byron to connect the passionate poet and adventurer with his own splendid achievements, or with the persona he was so actively creating at the time, except the token of exotic dress.[16] One senses in Phillips' portrait the player in the part rather than the part in the player. Certainly, for some parts there are distinctive players, although one cannot be sure what part or parts Reynolds' *Sarah Siddons* (illus. 34) is playing. Yet it is clear that, as a great actress, playing parts is what she does best, so part-playing is essential to her identity as a performer and that can be captured by a perceptive artist.

When the roles played by actors and actresses do not define their own characters but displace them, then the player may seem to be so submerged in the role that he or she almost disappears from view. This would seem to be the fate of the opera singer, L., in Paul Klee's *Die Sängerin L. als Fiordiligi*

44 Thomas Phillips, *George Gordon, 6th Lord Byron*, 1813

(1923–39) in Mozart's *Cosi fan tutte* (illus. 50). The puppet-like figure with the masked face, looking more like a doll than a human being, presents herself at the moment in the opera when the character Fiordiligi assumes a disguise so complete that, in the language of the libretto (scene XII), she hardly knows or recognizes herself.[17] The viewer might be tempted to dismiss Klee's image as a brilliant, abstract meditation on Mozart's opera and on the character of Fiordiligi, rather than as a portrait of the singer, L., whom he much admired. If so, the viewer might well be misinterpreting the complexity of Klee's intention, because for him to portray L. descriptively, or to represent Fiordiligi exclusively, would have been a failure to reckon with L.'s abandonment of herself to the role of Fiordiligi, the most complete realization possible of her being as an opera singer in performance. On the contrary, Klee showed a particular insight in portraying L. in this supreme moment of self-realization, when she was, figuratively speaking, 'out of herself', being so fully absorbed in the role she was playing, in the role she was making her own. As an artist of the operatic stage, L. thus internalized her own art of deception no less expressively and no less honourably than did her portraitist, Paul Klee.

Some roles, on a different stage, are equally absorbing, especially when played by royalty. Kings and queens, in effect, possess two bodies, one their own, the other belonging to the State over which they rule. It is the latter that interests portrait artists worthy of their royal commission; even in the twentieth century, one such artist, Henry Mee, decided that it was better to paint Queen Elizabeth II as the Queen rather than 'as a person'.[18] In an earlier age of real sovereignty, the reigning monarch would have appeared fully encased in the trappings of royalty because that was the body worthy of portrayal. Then the portrait types representing 'king' and 'queen' were developed, drawing on a rich repertoire of roles, manifested visually through the medium of symbolically charged masques, costumes, and attributes of the kind envisioned in Spenser's allegorical portrait of Elizabeth I of England as the 'Faerie Queene'.[19] All this and more is revealed in her engraved portrait of c.1596, attributed to Crispin van de Passe, senior, and grandiloquently entitled *Elizabeta D. G. Angliae. Franciae. Hiberniae. et Verginiae. Regina Christianae Fidei Unicum Propugnaculum* (illus. 45).[20]

ELIZABETA D. G. ANGLIÆ. FRANCIÆ. HIBERNIÆ. ET VERGINIÆ.
REGINA CHRISTIANAE FIDEI VNICVM PROPVGNACVLVM.

Immortalis honor Regum, cui non tulit ætas
Villa prior, venient nec feret vlla parem.
Sospite qui nunquam terras habitare Britannas
Desinet alma Quies, lucitius atque Fides.

Quem spoil tantum superans reliqua omnia regna,
Quæritur tu maior Regibus et reliquis.
Viue precor felix tanti in moderamine regni,
Tum tibi Rex Regum cælia regna paret.

For Queen Elizabeth, the masque (or mask) is all. No other access to her exists, not just because majesty keeps its distance but as if to suggest that in her the ruler's two bodies – one temporary, the other temporal – have joined together in this image of the untouchable Virgin Queen. Recognition of her comes through externals, while her face, almost insignificant in the visual field, appears as a reductive, nearly impersonal sign comparable in its abstraction to that of Fiordiligi–L. (illus. 50). The question 'Where is she?', that is asked of portraits in expectation of the reply, 'Here!', is answered by this engraving of Elizabeth the Queen, 'There, and everywhere!' Of course, allegorical portraiture of royalty can be made less

remote, but public figures are always defined to some degree by the distance necessary to stage the roles they play for a sizeable audience. Allegorical portraiture, by its very nature, tends to make observation abstract, to displace perception from its objects, and to engender emblematic images which transmute the substance of a person into ideas, words, and conceits, gathered around a named persona. Knowledge of the 'what' about someone here supersedes knowledge of the 'who', if indeed there can ever be truly separate forms of knowledge about the identity of any person.

For kings and queens, identity was tied to their work, and artists portrayed them in their roles as personifications of the ruling power, and only incidentally as persons of flesh and blood. In this swift passage from the physical body to the metaphysical king, the typological representation of royalty predetermined the viewer's cognitive response to the individual ruler portrayed. Thus the general propositional attitude took precedence over the particular, even if the king or queen had a face and a name that could be recognized.

Now that royalty has become less powerful and its appearance less awesome, celebrities of the cinema, of popular music, of sport, and of politics have taken their visual place as numinous, greater-than-life figures in the public eye.[21] Film stars are, perhaps, the most widely represented of non-political celebrities, because their existence is so tied to the visual medium which defines their very being and the dimensions of its authority. Film stars assume a fictive cinematic persona and fancifully invented names – Rock Hudson, Greta Garbo, Marilyn Monroe (illus. 63) – which their fans usually know about and disregard. They maintain a flexible relationship between familiarity and distance, between image and illusion, between their 'natural selves' and their film roles that often leads to the conflation of their various identities in the public mind.[22] In the period of silent films, the persona of the film star was fabricated visually – black-and-white images, and voiceless figures endowed with apparent movement. Nothing impeded the flow of an unnatural visual imagery, including the subtitles, while the absence of the actor's voice encouraged the viewer to concentrate on his immaterial appearance on the screen as the true sign of his presence. Indeed, when motion pictures took on sound, many silent film stars were rejected because their voices were deemed

'insufficient' for the parts they played. Significantly, many of them failed because their voices did not meet the audience's expectations, as if too much actual knowledge interfered with the viewers' preconceived attitudes about the stars, attitudes formed by their response to the artificial screen image and to the fictitious persona thereby created.

In this way, royalty and film stars have something in common: they both appear subject to stereotyping, to the projection upon them of the audience's cognitive representation of what such persons, even the person before them, should be like. That mental representation of another in these circumstances is effected by prior exposure, by the controlled nature of the exposure that limits access, and by the general tendency to categorize all persons encountered, especially those whom we do not know well, in order to place them in context, often in clear disregard of observed idiosyncrasies or in spite of them.[23] The *Portrait of Jean-Baptiste Belley*, discussed earlier (illus. 7), displays such wilful projection as an example of cognitive dissonance in two respects: the first in relation to the representation of Belley as a 'French revolutionary gentleman', which he was not; the second in denying the validity of that representation by physiognomic characterization and by the employment of the disfunctional imagery of the *Capitoline Satyr* as an artistic model for Belley's figure.[24] Both of these dissonant elements are products of a primary ethnographic designation of Belley because of his race, the most rigid stereotype of all.

Just as Belley was contrasted with the Abbé Raynal in his portrait, so too did Benjamin West distinguish between the Mohawk Indian in the background and Colonel Guy Johnson, the subject of West's fine portrait of 1776 (illus. 46). Johnson, a British soldier active in the Anglo-French colonial wars in upper New York State, owed his reputation to his close friendship with the Mohawks, who adopted him into their tribe, and his ability to lead them to fight with the British against their enemies. In the portrait Johnson wears the scarlet coat of a British officer, but he also prominently displays an elaborately decorated Mohawk robe to indicate his divided nature (cf. *Commodus–Hercules*, illus. 24). The robe further documents the Mohawk connection as a uniquely distinctive element in Johnson's professional biography as a British soldier on active service in the American colonies.[25]

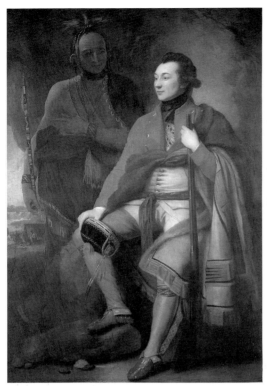

46 Benjamin West,
*Colonel Guy
Johnson*, 1776

The Mohawk Indian, however, standing to one side of the picture – probably a chief, in view of his costume – remains anonymous as a type, an *ancilla* to Johnson's persona, in a deferential position unacceptable to a modern sensibility but readily comprehended in the eighteenth century. He exemplifies ethnographic stereotyping, all too common in the difficult encounter between Europeans and those exotic others for whom the artist and the beholder have formed only the most general categories of differentiation and classification.[26] These categories depend heavily on the externals of appearance, especially costume, and on other visible forms of ethnographic notation, including the Indian village on the left side of the Johnson portrait, all manifested to indicate the strangeness of the place and its native inhabitants. Of course, in West's portrait (illus. 46) Colonel Johnson appears to be in that strange place and simultaneously to come from another place, a place he shares with the audience for this work.

So-called 'ethnographic portraits' seem to cause some critical difficulty in assessing their worth as portraits because the

subjects are so often ignored as subjects of portraiture or they are strongly subordinated to other agendas of representation. Collections of American–Indian portraits were popular in the nineteenth century; notable among these are Karl Bodmer's paintings of Plains Indians, now in the Joslyn Art Museum in Omaha, and the magnificent series published by Thomas L. McKenney and James Hall in their *History of the Indian Tribes of North America with Biographical Sketches and Anecdotes of the Principal Chiefs, embellished with one hundred and twenty portraits from the Indian Gallery, Department of War.*[27] Splendid as the McKenney and Hall images are, however, from a present perspective the portraits exhibit a very narrow range of physiognomic variation; they conform to a limited repertoire of types, particularized by details of ethnic costume and hair treatment, even though each person represented is named. If we mean by the term 'ethnographic portrait' the portrayal of exotic non-Westerners by Western artists for Western audiences, in which the exoticism of the person portrayed is intentionally represented as the principal subject, and that exoticism is manifested through careful attention to details of costume, personal appearance, and 'race', then such ethnographic portraiture is both anthropologically defined and culturally biased. But if ethnography, as a social science, involves the scientific description of men and women, their customs, habits, and differences, then most portraits would qualify for ethnographic analysis, and most would be exotic to some ethnographers. Of course, portrait artists working in their own culture rarely think like ethnographers, nor is it customary to apply anthropological techniques to the portraits of those with whom one shares a common culture.

It is quite possible, then, to dispense with traditional iconographic pursuits and view a picture of *Ladislaus of Fraunberg, Count of Haag* (1557) by Hans Mielich as an ethnographic portrait (illus. 51). The richly embroidered costume covers the Count's body but exposes his legs; his beard is neatly trimmed, but his head is small; gold on black seems special to the Count and to the haltered leopard he does not even bother to hold; there is a confusing assemblage of attributes that includes weapons, a skull, an hourglass, and religious symbols in strange juxtaposition; there are explicit references to place (the castle in the window) and to rank and name (inscribed on the stained-glass window with its coat-of-arms);

and the pose is awkward and stiff – all these features bespeak a complex culture with an elaborate symbolic language, open to cultural analysis, including the Count himself. Of course, a traditionally trained Western art historian might prefer to interpret this portrait iconographically, according to the conventions of sixteenth-century German princely portraiture, before passing on to consider the *vanitas* imagery and its implications.[28] One could then miss the magical splendour of the whole work and the strange association of man and beast within it, elements that might first capture the attention of an outsider who was not privy to the secrets of this culture and to its traditional ways of representing chiefs.

Queen Elizabeth's numinous portrait (illus. 45) would be a ready subject for this different kind of interpretation, and so too would Ingres' superb painting of the *Princesse de Broglie* (1853), although Ingres is much less explicit in his presentation of culturally relevant material than Mielich. Neither Queen Elizabeth I nor the Count of Haag (illus. 51), nor the Princesse de Broglie are shown playing parts in the sense that L., as Fiordiligi, is (illus. 50). To be fully engaged in one's cultural milieu involves playing a role, or the role permitted

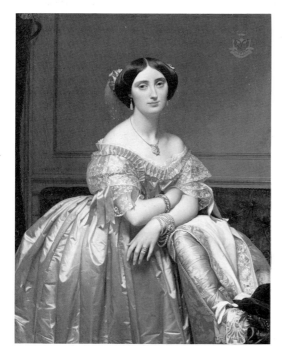

47 Jean Auguste Dominique Ingres, *Princess de Broglie*, 1853

by society. Not one of these characters is in disguise, that is, being something other than what they represent themselves to be, their roles defined by the social conventions of the day and without artifice – at least, without more than would be appropriate for them and their class at that time. Therefore, the full dimension of their social existence would be invisible to all who are members of the same society, including themselves. This does not mean that Elizabeth I does not appear as 'the Queen', Colonel Johnson as 'the Mohawks' friend', the Count of Haag as 'the noble soldier', or the Princesse de Broglie as 'a great lady', the kind who conducts salons in mid-nineteenth-century Paris. All are roles that place each of these persons in society and, in so placing them, constitute an essential part of their identity.

From an outsider's point of view, these roles are barely distinguishable from one another within a larger category of the élite and the culture that diminishes their individuality, even as role-players. Any society can have many vocational and status categories whose members' appearance, behaviour, and modes of self-representation seem so similar that they look alike, as exotics do to strangers. If we are to go beyond the cultural apparatus that holds each person and his/her constituent role in its grasp and, thus, defines personal identity and its artistic representation, then it is fair to ask whether there can ever be particularity in portraiture, some finite and unique quality that cannot be reduced to a social norm. If the habit, manners, and customs of a society establish all the possible roles for its members and all the factors by which anyone is known, what is left to portray but some specific application of a general proposition? Perhaps only the face remains as the true foundation of portraiture, not as a product of genetic chance nor as a cultural artefact – although it is both – but in some transcendent manner of willed composition (cf. Klee, *A New Face,* illus. 23).[29]

Yet the faces of Elizabeth I, of Colonel Johnson and his Mohawk friend, of the Count of Haag, and the Princesse de Broglie are all opaque in some way and, as a result, difficult to read. It is a truism that every human being shares the same basic range of physical features but differs in the peculiar combination of nature, experience, custom, and chance that affects each person's life and face.[30] The end product is what we recognize, and in each stage of its becoming. Modern

psychology has demonstrated how people approach face recognition by concentrating on those fragments of faces that have particular value for the observer and which lead to pattern recognition and, subsequently, to identification.[31] Police departments rely on photo-montage synthesizers, 'Identikits', and well-trained artists to recreate the appearance of suspected criminals from the verbal testimony of witnesses, who tend to recall this same limited repertoire of salient elements as the key to recognition.[32] If detail is not essential for recognition in daily life, then one should imagine that it is also unnecessary for recognizing faces in portraits, even if detail is largely constituted by the special residue of personal experience.

Of course, portraiture is not limited to recognition and faces are not blank composites of salient, distinguishing features, but are active surfaces and shapes which constitute the expression or 'look' of a person. 'You look like a real thug,' Alberto Giacometti told the writer James Lord. 'If I could paint you as I see you, and a policeman saw the picture, he'd arrest you immediately.'[33] Expression is such a complex product of nature and nurture, of the voluntary and involuntary translation of states of mind or feeling into physical form, that the successful interpretation of anyone's expression is very difficult to attain, even if the expression is genuine and not contrived.

> Nobody knows what he looks like. He knows what he feels like inside and that is all. Even when he looks at himself in a mirror, he arranges his face to fit his inside feelings, or else carefully refrains from seeing it.

Maurice Grosser put his finger (or brush) on the intentional confection of an expression,[34] but the relation between facial movements and emotional states is not such a simple matter. Expression is now believed to be physiologically determined from the exterior muscular activity of the face, which affects mood, rather than the other way round. Indeed, the so-called basic emotions of surprise, disgust, sadness, anger, fear, and happiness, with their associated expressions, seem to be universally recognizable without regard to culture.[35] These basic expressions do not reveal character or personality unless the basic emotion no longer depends on immediate circumstances but has been transformed into a perennial character

trait. In addition, most facial expressions – in reality, or in art – represent subtle variations, combinations, and projections of the six basic emotions that may become difficult to interpret if they substantially modify the physical character of the natural repertoire. In a particular individual, as the modern Japanese novelist Kobo Abe noted, facial expression itself 'comes like the annual growth rings in a tree trunk',[36] leaving their trace in habitual muscular response and in wrinkles, a historical record of the repeatable past. Because that record is specific to the person, the observer can recognize him and respond by marking the particular variation in the norms of expression and feature, typical of the faces commonly encountered in daily life, and then automatically cancelling out the effects of age and momentary emotion, unless either appears to be extreme. Thus, recognition seems to depend on establishing some relationship between the norm and its instant variation, so that, even in faces, individuality is contained within the boundaries of the familiar type.

Guillaume Duchenne de Boulogne, in his *Mécanisme de la Physionomie Humaine ou Analyse Electro-Physiologique de l'Expression des Passions* (Paris 1862), tabulated the anatomy of emotions and illustrated them with a large number of expressive photographs which do not seem to have resonated in the art world. Recent work on his theories has indicated that thousands of variants exist in the basic system of facial expression and are generally recognized in action.[37] No consistent application to portraiture of Duchenne's categories of emotional expression seems to have been undertaken by artists, who may either not have known about them or were resistant to the science of expression after physiognomics and phrenology had been so fully discredited earlier in the nineteenth century. However, some periods in Western art have exploited the representation of purified states of emotion – pain, tension, anxiety – especially in the late phases of a style, or culture, e.g., Hellenistic art, Roman Imperial art, Medieval art in northern Europe, Baroque art, and twentieth-century Expressionism. Despite this, the appearance of an intense emotional state in portraits of these late periods is rarely a specific characterization of the individual subject but, instead, reveals the current *Zeitgeist* or spirit of the age, shared by many at the time. Of course, if it is stylish to look anxious, then sentient individuals, subject to being portrayed by

observant artists, will also look anxious, as do many Romans of the second and third centuries, or Kokoschka's subjects (illus. 40). Yet, when 'looking anxious' reflects a shared style of life, expressing this characteristic in a portrait does not serve to differentiate one subject from another. Such an individual psychological state, however specific in facial expression, then relates to a style of behaviour (or representation) that asserts the group identity over that of the individual and becomes acceptable precisely because it is so common.

On the whole, portrait artists eschew the representation of strong expressions of feeling because traditionally they are thought to reflect transitory states of being and are therefore an obstacle to the artist who seeks to capture the essential stability of the self, existing beneath the flux of emotions. In their own self-interest, portraitists also tend to avoid 'unpleasant' expressions because of their negative connotations, unless their very negativity is exploited in caricature. But they do use a number of formulaic expressions, whose content is diluted by propriety, to signify (for example) noble, pensive, intelligent, determined, strong, or assertive 'looks' in formal situations, or more relaxed, affectionate, friendly, or spirited 'looks' in informal or private settings. This sanitizing of facial expression, and the resulting imposition of conformist attitudes on the presentation of the subject, allows the successful portraitist to encase his subjects within the masks of convention. Then, even faces and the expressions on them are established typologically as significant images. And personhood, so strongly attached to names, faces, bodies, and roles, can be understood as a metaphor for a particular intersection in the network of social relations.[38] What is left to the individual in representing himself, or to the artist portraying him, is a matter of choice, perhaps an attempt to foster the pleasing deception that either of them is free. For this, the mask is best.

In primitive societies, where masks are discrete, physical objects used in ritual, they 'serve the purpose of and are used for the isolation of the wearer from the external social and cultural environment'.[39] In so-called civilized societies, masks are not used for ritual, nor are they discrete objects, but they are used, and used frequently, for dealing with the world more effectively than the wearer can without them. Here,

masks seem to be self-imposed disguises allowing the wearer to impersonate someone, even himself, in a favourable guise; that is, to manifest some aspect of the wearer not otherwise visible, whether or not that representation is wholly imaginary, delusional, self-serving, or meets the expectations of others.[40] Real masks are hollow, but the masks that civilized people put on have no physical existence separate from their own flesh, their 'own' face, although what lies behind them may be impossible to know. They are both transparent and opaque, because such masks conceal the being within from others, blocking their access to it, while simultaneously making a social commitment to these same others by presenting some visible, comprehensible form of the self that might be recognized. The complexity of the dual function of the mask, to conceal and to reveal, is fully conveyed in the layering effected by Clarence John Laughlin's 1947 photograph, *The Masks Grow to Us* (illus. 48), a visual complement, as it were, to Rilke's superb rumination on faces:

(Faces)

Have I said it before? I am learning to see. Yes, I am beginning. It is still going badly. But I intend to make the most of my time.

For example, it never occurred to me before how many faces there are. There are multitudes of people, but there are many more faces, because each person has several of them. There are people who wear the same face for years; naturally it wears out, gets dirty, splits at the seams, stretches like gloves worn during a long journey. They are thrifty, uncomplicated people; they never change it, never even have it cleaned. It's good enough, they say, and who can convince them of the contrary? Of course, since they have several faces, you might wonder what they do with the other ones. They keep them in storage. Their children will wear them. But sometimes it also happens that their dogs go out wearing them. And why not? A face is a face. Other people change faces incredibly fast, put one on after another, and wear them out. At first they think they have an unlimited supply; but when they are barely forty years old they come to their last one. There is, to be sure, something tragic about this. They are not accustomed to taking care of faces; their last one is worn through in a week, has

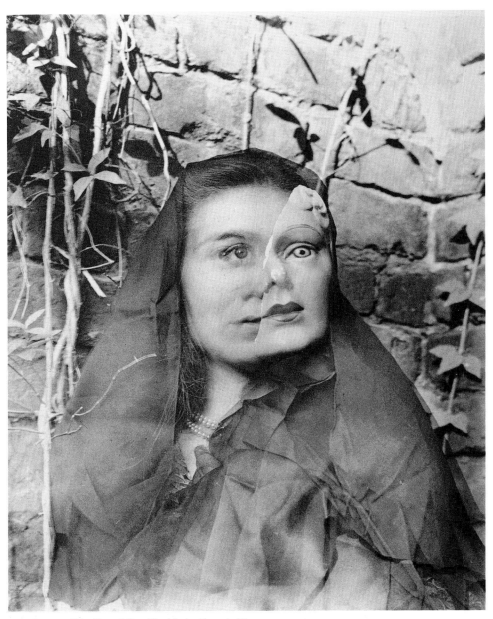

48 Clarence John Laughlin, *The Masks Grow to Us*, 1947

holes in it, is in many places as thin as paper, and then, little by little, the lining shows through, the non-face, and they walk around with that on.[41]

Laughlin's *The Masks Grow to Us* (illus. 48) at first glance suggests the presence of a real person beneath the mask, a mask that coincidentally resembles the protective mask adopted by the tiger-wary woodcutters of the Ganges Delta (illus. 10). At a second look, however, the revelation that even the 'real person beneath' is herself subjected to a double exposure hints at the artificiality even of this third layer. Laughlin warns the viewer to take nothing at face value, especially when there are three closely related faces, all of them partially visible at one time. As a commentary of self-representation and on photographic portraiture, this picture deliberately exposes the duplicity of the mask as a problem in visual interpretation and interpersonal relations.

Portraits partake of the artifical nature of masks because they always impersonate the subject with some degree of conviction. What, if anything, lies behind the mask can only be inferred by the viewer from the clues provided by the mask, which may mislead as well as inform through the use of conventions of representation. Ultimately, the emergence of the subject revealed in the portrait must take into account the fact that self-effacement behind the mask is consistent with the social nature of men and women, of all who (re) present themselves in public. The relationship between personal identity and the face-mask, which stands for its appearance, would seem to be the point of Inge Morath's *Portrait of Artist-Celebrities Wearing their own Masks* (illus. 49). The detachment of face from body is striking, arguing visually for the sufficiency of the face in establishing the identity of these 'celebrities', even when masked and slightly deformed by caricature. Inge Morath is a modern photographer who specialized in photographing well-known artist-celebrities throughout her career, and therefore her authorship of the photograph sets up certain expectations in the mind of the viewer. The masks in Morath's photograph function as a special codified sign of 'faciality', a flat, abstract meeting ground of significance and subjectification, that characterizes the arbitrary nature of portraiture itself.[42]

Not every mask looks like one. Indeed, it should not, so

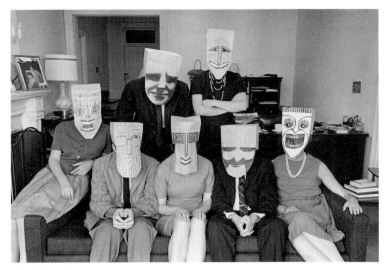

49 Inge Morath,
*Portrait of
Artist-Celebrities
Wearing their Own
Masks*, 1961 (masks
by Saul Steinberg)

habituated have we become to their use in public and private intercourse, and by extension in portraits as well. 'William Shakespeare', whose very authorship of the works attributed to him is disputed, appears in all his now familiar glory on the front of the First Folio (1623) in Martin Droeshout's engraving (illus. 52). Although Ben Jonson complimented this portrait in verse, there is every reason to believe that Droeshout's portrait was not taken from life, since Shakespeare died in 1616.[43] However, it served to memorialize Shakespeare, together with the works published in the First Folio, in a manner apparently satisfactory to those who knew him personally and to those who did not. The artist might have relied on some earlier portrait of Shakespeare, no longer extant, but this famous and much reproduced portrait must be considered an invention, well within the tradition of creating appropriately 'noble' portraits of great poets like the 'Homer' represented in Rembrandt's *Aristotle* (illus. 32). As a poet and dramatist of extraordinary intellectual range and depth, sharp-eyed Shakespeare should appear big-headed, not because Droeshout was inept or imprisoned in a contemporary portrait mode, but because the large volume of his cranium signified the very same quality of intellectual power celebrated by Dürer in his portrait of *Melanchthon* (illus. 30).

Shakespeare's great balding head not only dominates the portrait, it also physically overwhelms the thin, flat body from which it is separated by the meagre ruff, as if laid on a platter.

50 Paul Klee,
*Die Sängerin L.
als Fiordiligi*,
c. 1923–39

52 Martin
Droeshout,
*William
Shakespeare*, from
the First Folio of
the *Works*, 1623

Mʀ. WILLIAM
SHAKESPEARES
COMEDIES,
HISTORIES, &
TRAGEDIES.

Publiſhed according to the True Originall Copies.

LONDON
Printed by Iſaac Iaggard, and Ed. Blount. 1623.

The strong detachment of the head from the body, too slight
to bear its weight, reveals the priority given by the artist to
the representation of the intelligent head and alert face. At
the same time, the separation of the head from the body,
which serves as a fashionable prop, resembles the analogous
construction of the masked artist-celebrities, presented in
Inge Morath's photograph, taken more than three centuries
later and, perhaps, similarly motivated (illus. 49).

Shakespeare also appears in the sober clothing of a Tudor
gentleman. For the subject to have the 'look of a gentleman'
was also important, if the artist wished to endow Shake-
speare's portrait with the gloss of true merit in contemporary
terms, because this class was thought to have a monopoly on
all of the virtues. In a different age, Tischbein would not
hesitate to portray Goethe as the extraordinary being he was,
the unique member of a class of one – and still a gentleman
(illus. 54). In the early seventeenth century, however, to

51 Hans Mielich,
*Ladislaus of
Fraunberg, Count
of Haag*, 1557

incorporate Shakespeare within an acceptable contemporary type is to mask him, to make him play the role that all others, similarly represented, play, to bury his physiognomic likeness (whatever that actually might have been) beneath a supervening imagery that demanded the sentient viewer's primary attention.

Portraits of important thinkers, in various fields of activity, suitably dressed, often appear in books of the seventeenth and early eighteenth centuries. These portraits follow a similar pattern of fashionable concealment, seeming almost to make persons of genius interchangeable except for a few individuating facial traits and, of course, the well-published name.[44] But then costumes, wigs, make-up, attributes, and other paraphernalia of disguise have always been used to create artificial categories of identity. However, 'thinkers' constitute an uncertain, loosely defined category. Their identity cannot be easily fixed by class or occupation, nor does their thinking manifest itself in the same creative ways. The Greeks in the fifth century BC invented the image of the 'creative thinker' as a positive stereotype; the figure of the bearded, reflective man, no longer young, soon became a distinctive motif of portraiture, one that endured for millennia.[45] It established an important precedent for the selective portrayal, by private vocation, of persons whose creativity merited public acclaim and the preservation of their images. So prevalent was the type that to look like them was to be like them, and statues of this genre filled the Greco-Roman world.

An interesting variant of the Classical type of creative thinker is the double herm, two busts fused dorsally, a form popular in cultivated Roman circles where the dual nature of Greco–Roman culture was a fact of life. Pairing Greeks and Romans in such a way served this presumption very well because it brought together those whose intellectual or artistic style seemed to display the strongest similarity, such as the classic Roman and Greek writers of comedy, *Aristophanes and Terence*, on a double herm in Naples (illus. 53).[46] Whether or not the resemblance was forced by the critical perception that inspired the sculptor or his patron, each double portrait presupposed the presence of its (co)respondent, either actually or potentially, in the viewer's eye. Thus, the identity of one inevitably became enriched or contaminated by that of the

53 *Aristophanes/
Terence*, Roman
double herm, First
century AD

other. The herm itself, as an abbreviated sign of the whole
person, accelerated this transference or partial exchange of
identity from one to the other, as if the Roman could mask
himself with the face of the Greek in order to assert more
firmly his own categorical existence as a creative artist in the
tradition established by his Greek counterpart. Double herms
are both complementary and competitive, in that the Roman
member not only establishes his categorical identity but also
asserts his own individual merit.

The Greek and Roman public knew what creative thinkers
looked like because their world was filled with images of
them; they also knew what such persons should look like
because there were so many prestigious portraits around that
creative persons could use as models in representing them-
selves. To be a poet, or playwright, or philosopher, or any
kind of creative thinker, and to look the part, could be crucial
to one's success in being so taken by others, especially in the
nineteenth century when to belong to such groups of creative
persons marked the individual as someone special.
Nineteenth-century portraiture abounds in such formulaic

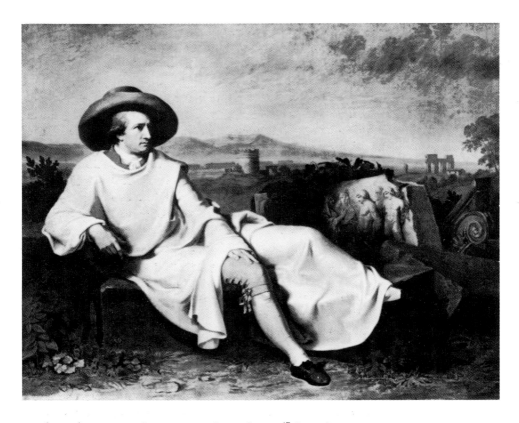

modes of presentation, as we have been,[47] but there were
masterful heroic types who rose above such competition early
in the Romantic period. Tischbein's *Goethe in the Campagna*
(1786–7) reflects the painter's admiration for his subject and
Goethe's own special sense of himself as a Modern who is
heir to the great Classical tradition (illus. 54).[48] Posed like
some graceful but substantial figure derived from the Par-
thenon pediments (at the time unfamiliar), Goethe's figure
seems to redefine the Italian landscape, just as his creative
imagination reworked ancient texts into modern dramatic
form. In this painting, both artist and subject – compatible
friends rather than friendly antagonists – contributed to
Goethe's fashioning of himself as a cultural monument whose
stature loomed larger than the living man.

Time and high repute have reconfirmed this figurative esti-
mation of Goethe, endorsing Tischbein's portrait as a memo-
rable image of the protean artist, more powerful in this form
than Shakespeare (illus. 52) with whom Goethe is so often

54 J. H. W.
Tischbein, *Goethe
in the Campagna*,
1786–87

compared. Tischbein's *Goethe* departs radically from the stereotype of the creative thinker, separated from the ordinary world, because in portraying him in, but apart from, the landscape, the artist has revealed the poet's subjectivity, that special quality of his Romantic genius. The painting presents the otherwise invisible self of Goethe as it incorporates the world outside – the present world of the Roman Campagna that delighted his senses, the associations of the landscape with the Classical past that engaged his imagination – as part of his own consciousness.[49] Tischbein's portrait offers the beholder access to the poet's mind, that richly inventive mind in the act of contemplating itself and its relation to the world, a form of intimate knowledge about Goethe as a creative thinker rarely equalled in the history of Western art. Tischbein seemed to know Goethe as Goethe knew himself, and shared that knowledge with the viewer. Since Goethe is so self-aware, he could be wholly himself, unmasked, unlike others, playing his own part to perfection, awaiting the contemplation of others as he presents himself, quietly in profile, to their view.

Tischbein portrayed a great man housed in a partly concealed body as if to suggest the priority of the former and the necessity of the latter in the composition of his subject in its entirety. One without the other was insufficient for Tischbein and for Goethe, but could the body alone be enough to portray genius?[50] Jeremy Bentham apparently thought so.

Bentham's alter ego, or *autoicon*, is virtually unique (illus. 55), although he hoped others would be made to preserve (not portray) other geniuses for posterity. Upon his death in 1832, and in accordance with his instructions, Bentham's body was dissected, the dismembered skeleton reconstructed and supplied with a wax head to replace the original which had been mummified; the ensemble was then dressed in Bentham's own clothes and seated upright in a glass cage, where it – not he – remains on permanent display in University College, London. The figure is not a statue, although it has some of the properties of a sculpture; it is not wholly a wax replica of Bentham *à la* Madame Tussaud, but the head is artificially produced by modelling and colouring to look lifelike; and it is not a mummified corpse despite the real, if invisible, bones concealed within. In sum, the *autoicon* of Bentham has many of the properties of a fetish for the neo-

55 *Autoicon of Jeremy Bentham,* 1832

Benthamites who revere it. Perhaps this hybrid figure should be seen as a surrogate for Bentham himself: like all effigies, it strives to maintain the great thinker's physical presence after death as an inspiration for future generations. Just as a mummy is not a portrait, although it may be accompanied by one, so Bentham's *autoicon* is not a true portrait, which is wholly artificial, although it contains elements of portraiture as well as pieces of Bentham himself. It resembles, instead, a death-mask, commonly taken from famous people – like Dante – and preserved, with modifications, to deny the inevitable corruption of the flesh.[51] Bentham's *autoicon* meets the same objective which Erasmus sought to achieve when he sent a portrait of himself to Thomas More in 1517 and wrote:[52]

> I am sending you the portrait in order that we may always be with you, even when death shall have annihilated us.

Bentham's *autoicon* preserves an authentic, highly realistic replica of the great economist, his final appearance, as it were, extended without limit of time. Unlike Erasmus' painted portrait (cf. illus. 29) that is completely distinguishable from the

subject to which it refers, the *autoicon* incorporates it. Referentiality, and not corporeal integration, is a basic requirement of portraits, even if the portrait should be so realistic, in the descriptive sense, that it appears to replicate the original, to (re)place it once more in the world.

Three-dimensional sculpture lends itself more readily to this task because its resemblance to the physical existence of the original can be made much more convincing. Indeed, the very substantial nature of sculpture helps to strengthen the distinction between the illusionistic thrust towards replication, effected by the *autoicon*, and the evident departure from the original, effected by any portrait painter depicting that original. Funeral effigies, and funeral sculpture in general, often elevate this desire for immediacy of contact into high art, as if to enhance thereby the once-living quality of the original, to place him or her in the world of the living again, at least for the benefit of family and friends.[53] Roman sepulchral monuments, furnished with explicit lifelike portraits, exemplify this tendency to manifest the physical nature of human existence and then recapture it in a portrait.

Looking at such a monument (illus. 56), a sympathetic

56 *Grave Altar of Tullius Diotimus and Brittia*, *c*. AD 100, in the Borghese Gardens, Rome

57 Donatello, *San Rossore*, 1422–7

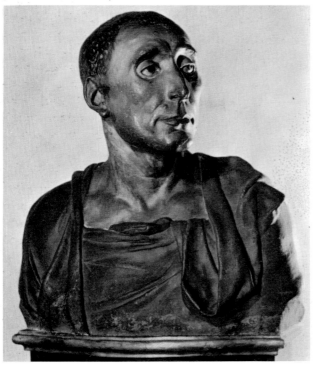

58 Donatello(?), *Niccolò da Uzzano*, mid 15th century

observer makes the quick shift from here to there, convinced, one imagines, that the original subjects must have been immediately recognizable on the Roman street. No contemporary observer survives to justify that belief; no one lives who knew this man and woman by sight or can say that the inscription is, in fact, correct in its statement of their names (Tullius Diotimus and Brittia) and position (a court officer and his wife). Although one may reasonably assume that the monument describes a Roman married couple of about 100 AD, its legitimacy as a work of art is no proof of the accuracy or reliability of its representation as an honest transcription of the original. Therefore, despite the graphic realism of the portraits, for the modern viewer the busts and the inscription are ultimately self-referential, entitled images, and their greatest value is as an index of Roman social history and art.

The study of Renaissance portraiture has similarly suffered from this misplaced confidence in the reliability of the portrait, even though such works of art have always been considered expressions of post-medieval modernity and humanist individualism.[54] From Petrarch onwards, the representation of 'famous men' formed an important topos in art, emphasizing virtue and moral instruction.[55] Early Renaissance portraits were often designed to reveal the virtue of their subjects, visualizing (in this respect) the early sixteenth-century ethos, as expressed in Castiglione's *Courtier*.[56] Despite the ethical burden borne by Renaissance portraits almost from the beginning, it is their apparent realism that strikes the observer (illus. 57 and 58), as if the original might have been encountered and recognized in the streets of Florence.

It is generally assumed that Donatello invented the modern portrait bust, combining antique models and the traditional medieval reliquary used to house the physical relics of saints in containers made to look like complete versions of the surviving anatomical parts. Donatello's *San Rossore* in Pisa (1422–7) may be the first instance of that invention; it is a gilded, life-size, bronze sculpture that contained the bones of the saint in a reliquary shaped like the bust portrait known from later in the fifteenth century (illus. 57). The face on the bust displays a number of physical details and a depth of characterization that strongly suggests a portrait, but since no genuine, corroborating likeness of San Rossore has been

found, some scholars believe the face to be Donatello's own.[57] This may be wishful thinking, because of a natural desire to know what Donatello looked like at this stage in his career, coupled with an assumption that the sculptor cared to represent it. Donatello might not have made such a fine choice between himself and the saint as potential subjects, and there are other possibilities. Like Bentham's *autoicon* (illus. 55), Donatello's *San Rossore* incorporated the physical remains of the dead saint (one believes) – the ostensible subject of the work if the bust is indeed a portrait of San Rossore. The individuality of the face does suggest that the work represents a specific person, but the *San Rossore* bust may not even be the likeness of the person whose name it bears, or of anyone at all. Although this bust looks so much like a 'someone' that it is presumed to be a portrait of that someone, the *San Rossore*, as a revolutionary work of art, could equally reflect Donatello's new awareness of the possibilities inherent in portraiture in the early stages of the Renaissance in Italy. Whoever or whatever the bust portrays, the *San Rossore* is also a mask, made for the protection of the relics contained within it; Donatello endowed that mask with such apparent naturalism that it gave flesh to the dry bones and brought the saint and the devout beholder closer together in a more personal relationship. And that is what portraits do.

Perhaps Donatello realized at the moment of inventing the 'Renaissance portrait bust' that the act of portrayal involves the portraitist in the formation of his ostensible subject, and that great portraits express that social relationship as part of their primary meaning. Few Renaissance busts have such a distinguished author, but even when the identities of both artist and subject are in doubt, as in the alleged portrait of *Niccolò da Uzzano* in the Bargello (illus. 58), once attributed to Donatello, the nature of that empathetic relationship comes through the veil of the past.[58] This lively terra-cotta bust of a vigorous Italian of the fifteenth century still conveys the vivid presence of the man and the artist's fresh engagement with him. The spirit of this cooperative relationship, the bond between the artist and the subject, both engaged in making the portrait what it came to be, is beautifully expressed in a letter the Venetian humanist, Claudio Tolomei, wrote to the artist Sebastiano del Piombo in 1543:

If I obtain this favor (as I hope) it will seem to me henceforth that I have acquired a mirror that I shall always call a divine mirror, because in it I shall see you and me together . . . And seeing myself vividly portrayed by your art will provide me with a continual stimulus to purge my soul of its many defects, and seeing therein the illuminating rays of your genius (*virtù*) will kindle in my soul a noble longing for glory and honour.[59]

Claudio Tolomei understood very well what Sebastiano del Piombo could do for him in providing a virtuous image that he, Claudio, would subsequently use as a model for his own life. But if life should imitate art, then the portrait was not only to be drawn from him; it was also to be imposed on him, to fix him as a moral being amid all the conflicting contingencies of existence. Through the genius of Sebastiano, Claudio hoped that the portrait would give coherence and meaning to his life, otherwise fragmented by the passage of time and the variety of experience. This hoped-for portrait would then establish him firmly and significantly as a worthy man, worthy of his own self-respect as well as of the artist's, and would forever symbolize that aspiration even if he did not always appear so in life. Such a portrait is reductive; it fixes the person irrevocably in place and time, symbolically asserting the ideal nature of his existence, of his identity, in its very singularity. The reductive concept of this type of portrait was succinctly expressed by the early-nineteenth-century German philosopher, F. W. J. Schelling, in his *Philosophy of Art* (c.1802):[60]

If . . . one understands under portraiture a portrayal that, by imitating nature, simultaneously becomes the translator of its significance, turns the interior of the figure toward the outside and renders it visible, then one must no doubt recognize the significant artistic value of a portrait. Portraiture as art would then admittedly have to be limited to such subjects in which symbolic significance is seen to inhere, and in which one can see that nature has followed a reasonable design and, as it were, the goal of expressing an idea. The true art of portraiture would consist in embracing the idea of a person that has dispersed into the individual gestures and moments of life, to collect the composite of this idea into *one* moment and in this way make the portrait

itself, which on the one hand is ennobled by art, on the other more like the person himself, that is, the idea of the person, than he himself is in any one of the individual moments.

To make a portrait more like the person himself and, in so doing, to translate the immanent into the permanent is no easy task, as the following newspaper anecdote makes all too clear:

> Fred Perry was a three-time Wimbledon champion and the last British player to win the men's singles title. That was in 1936. Thus, next year, Wimbledon will celebrate 50 years of British futility. A bronze statue of Perry hitting a fore-ground was unveiled on the grounds last year [illus. 59], and Perry said the sculptor looked at 700 photographs before choosing one he thought suitable as a model.
> When they unveiled it, I said, 'Oh my God, it's me,' Perry said. 'It was scary.'[61]

After he recovered from his scare, Perry might have been curious to know what was wrong with the other 699 photographs, rejected by the sculptor, David Wynne, who had probably never seen Perry play in his prime. Perhaps they were discarded because they did not suit the sculptor's mental image of Perry in action as a champion tennis player in the 1930s. Strangely enough, Perry, living into the 1980s, was not used as the model, for by then he was not the Perry of Wimbledon fame, but someone or something else. Neither the actual Perry, a relic living in the body of the person he once was, nor the 699 photographed Perrys were acceptable models for this portrait of the British champion, which concealed or denied both his lost youth and the remoteness of his victory.

Commemorative portraiture must often reject the present in favour of a fictive image, selected for its appropriateness to the portrait commission. We can assume that the sculptor of the Perry monument recognized, despite the continuity of Perry's own body from young manhood to old age, that Perry *now* lacked the requisite expressive or significant features of Perry *then* – the Perry who was the tennis champion in 1936 – the real subject of this bronze statue. Because the monument revealed the conclusive interaction between his enduring

59 David Wynne,
Fred Perry, 1985

name and his temporary classification in the figure of 'Fred Perry, Wimbledon Champion', the artist must have imagined some newly conflated image, paring away all those Fred Perrys known to his friends and relatives for decades. Artistic success depended on David Wynne's ability to make the visual significance of his statue conform to the requirements of his commission. The resulting bronze portrait statue of 'Fred Perry' at Wimbledon, the site of his long-ago triumphs, therefore represents a type of meta-imagery, which in the end persuaded even the aged Perry himself. At the unveiling of the work, he exclaimed, 'It's me', when it could not actually be so, unless for him the statue signified the perennial nature of the 'me that once was I'.

Those 699 rejected photographs must represent the same Fred Perry; otherwise the sculptor would not have considered them at all. Let us imagine that these photographs, multiple images of Perry, were taken during his playing days, that they fairly represent his appearance and action on the court (and elsewhere), and that they all have some valid connection

to the historical subject. These images of Perry must have something in common and, in turn, they must bear some consistent relationship to the actual, if nominal, Perry of the 1980s, the ex-champion. At the very least, they preserve many fragmentary impressions of the Perry of the 1930s, although only an infinitesimal part of his total being, even then. Potentially they all have equal legitimacy, yet only one photograph fitted the sculptor's idea of a satisfactory model. Still, these old photographs, the portrait statue (illus. 59), and later photographs and portrait paintings represent the same man, or the one known by the name 'Fred Perry'. Such a profusion of images surely extends the portrait repertoire of an individual; the images challenge each other for accuracy, authenticity, and primacy, as they make permanent those otherwise evanescent changes in life from youth to old age.

When confronted with so many images, the viewer who does not know the subject personally has a problem in deciding which of them is truly Fred Perry. So many portraits of an individual provide the viewer with an opportunity to experience the character portrayed in depth and from different points of view, an experience comparable, in its way, to reading several biographies of a famous person. However, such an abundant repertoire of images may also present the viewer with a confusing range of options, destabilizing the characterization of the person portrayed and obscuring the mental image of the subject; contentious biographies can achieve a similar result, especially when compounded by a self-serving autobiography.

Biographical portraiture can preserve the fragmentary nature of human existence in a number of ways. First, this can be achieved through a series of portraits, made at different times and representing different stages in a person's life; examples abound in the portraits of the Roman emperor Marcus Aurelius, Queen Elizabeth II, the film star Elizabeth Taylor, and Rembrandt. In these cases, the portrait repertoire comes to constitute a figural record of the subject over the years, providing, in the ensemble, a sense of the whole being as a changing constant. Or, as in Perry's case, only a significant aspect of a life may be chosen for representation in portraits, because of its special saliency or great historical importance in that life; e.g., Alexander the Great, young, handsome, leonine; Napoleon, who never seemed to pass

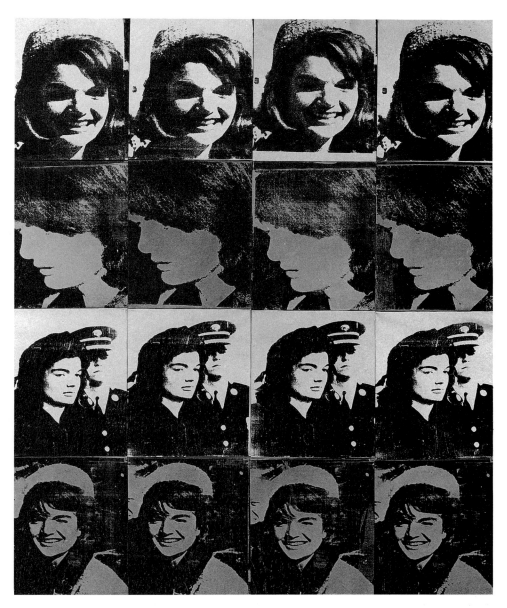

60 Andy Warhol, *Sixteen Jackies*, 1964

beyond maturity; Elizabeth I, who moved from fresh to hard-
ened virgin (illus. 45); Greta Garbo, who retired at the height
of her fame and physical beauty. Other prominent figures,
such as the emperors Trajan and Charles V, Erasmus (illus.
28 and 29), Churchill, Ronald Reagan, although portrayed by
a number of artists at various times, seem to change very little
with the passing years. And last, some portraits of public
figures, such as Lenin (illus. 11), eventually, through rep-
etition, become clichés or are so from their very inception;
these latter images never seem to change at all, but through
replication become in effect iconic. These four kinds of bio-
graphical portraits stimulate very different patterns of recep-
tion, since the first group explicitly acknowledges the fact of
change in human life, the second ignores it, the third barely
accommodates it, while the fourth denies it altogether.

Andy Warhol, with his usual acumen as an observer of the
current scene, sensitively exploited the possibilities inherent
in the multiplicity of biographical portraits. He combined sev-
eral of these modes in his *Sixteen Jackies* of 1964 (illus. 60), one
of a number of sympathetic representations of Jackie Kennedy
that he made after the assassination of President Kennedy.[62]
Like the celebrated *Marilyn Monroe* (illus. 63), Jackie is a media
person and Warhol's sensitivity to her public persona informs
the work completely. This vast assemblage of sixteen panels
contains four sets of identical images, each set taken from
news photos and television shots of Jackie Kennedy: as the
stylish, happy wife of the young President, as the shocked,
grief-stricken participant in the tragedy of his assassination,
and as the grieving widow at his funeral. Unlike the emphatic
banality of his *Marilyn Diptych*, Warhol's use of four different
images of Jackie Kennedy in this composite, biographical por-
trait draws attention to her as an actual, sentient individual,
deeply affected by the swift change in her personal condition,
and therefore less defined by her public persona, even though
she remains a public figure. The portrait's strong effect
depends on the constant interaction among the images in the
visual field, as the eye moves from one square to another,
from the elegant First Lady to the grieving widow, from the
momentary incident to the reconstituted whole.

Warhol has enriched the character of his portrayal by
mediating among contrasting images of his subject. This
elegiac portrait also contains an element of narrative, moving

135

62 Salvador Dali,
Mae West, 1933–35

63 Andy Warhol,
*#204 Marilyn
Diptych*, 1962

from 'before' the assassination to 'after'. Although the history recounted by the *Sixteen Jackies* is brief, the total effect is reminiscent of the biographical tradition in portraits that always tries to place the subject in time. Because Warhol has adopted his types of 'Jackie' from earlier representations in the popular media, their collective appearance in the work has a special private resonance in the minds of viewers who remember the Kennedy era. Looking at Warhol's composite as a model, the viewer can enjoy the private, reflective experience, available to anyone who remembers a longtime friend or looks at an extensive series of portraits of the same individual over a period of years (e.g., *Fred Perry*, illus. 59) and, from this collection of images, fashions his or her own composite of the subject. Warhol seems to have understood the implications of this process and the importance of its contribution to the fabrication of an identity, when he filled up this reservoir of visual memories and made it permanently available to the public in his *Sixteen Jackies*.

Once the portrait type of a famous figure has been accepted as definitive, even normative, portraits that do not conform to the type disturb our sense of the whole person whose image we have formed in our minds. The portraiture of Benjamin Franklin – printer, author, entrepreneur, self-made man, scientist, savant, diplomat, ladies' man, politician, sage – is a case in point. The B. Franklin whom we all know was a protean individual, but his portraits consolidate those richly varied bits and pieces, rejecting the Franklin of Boston and Philadelphia for the worldly and wise Franklin of his late maturity. The historical Franklin appears in the guise of the seasoned veteran, a conclusion about the nature of his life made by Houdon in his bust portrait of the 1770s (illus. 64) that was calculatingly displayed by Franklin himself in establishing his public persona.[63] This is the Benjamin Franklin we remember, and other images, lacking its plain manner, seem out of place in our consciousness.

The repeated presentation of the complex man, B. Franklin, in the garb of a simple person of advanced years was so influential that fifteen years after his death, in 1790, Benjamin West used it in an oil sketch in preparation for a full-length portrait (never in fact executed) of *Benjamin Franklin Drawing Electricity from the Sky* (1801).[64] West represented the old sage grandly conducting the experiments with lightning that

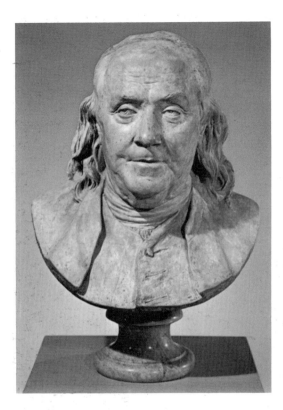

brought Franklin an international reputation (illus. 65), although Franklin actually performed these experiments in the 1740s and published them in 1752 when he was only in his forties. Yet West was not deterred from inserting this anachronistic image into his portrait because that Franklin was already 'the Franklin' for all purposes of commemoration and portrayal, a virtual icon of the great man. Evidently, this portrait type had become a complete predicate, indistinguishable from B. Franklin as a fully rounded impersonation of the Founding Father and colonial savant whom everyone knows.

The wise, old Franklin (illus. 64) represents the compression into one of all the possible images that Franklin's long and distinguished life could have produced. Combining age and strength, a mobile face and a self-composed manner, the visible effect of the portrait type is expansive, rendering the full character of this protean being in the round. No individual is ever completely identical either to himself or to his image, but this Franklin is one with all the other Franklins

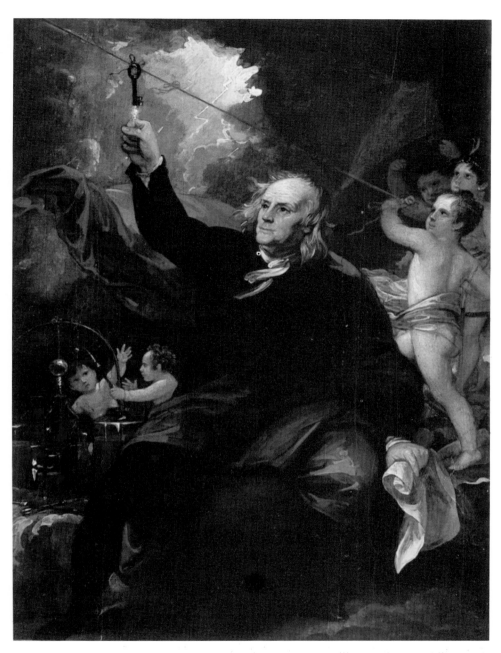

65 Benjamin West,
Benjamin Franklin
Drawing Electricity
from the Sky, 1801

that have led up to it. His image, therefore, radically differs from Wynne's *Fred Perry* (illus. 59), truly a 'flat character', readily summed up in a single moment of glory. That Perry – the only one that counted – is fully defined by a character-istic, if momentary, action on the tennis court; he is tied for ever to that place (Wimbledon) and to that time (1936) where and when he became a person worth remembering. He thus fulfils E. M. Forster's reductive characterization, that

> Flat characters were called 'humours' in the seventeenth century, and were sometimes called types, and sometimes caricatures. In their present form, they are constructed round a single idea or quality; when there is more than one factor in them, we get the beginning of a curve towards the round. The really flat character can be expressed in one sentence . . .[65]

Both fully rounded and flat characters may have their proper place in the viewer's imagination, but the former actors have greater roles than the latter, and Benjamin Frank-lin also has his place on the hundred-dollar banknote.

iv 'Here's Looking at You!'

Know thyself!
Ancient Greek proverb

By person (I understand) a thinking, intelligent being that has reason and reflection, and can consider itself as itself, the same thinking thing in different times and places.

JOHN LOCKE *Works*[1]

All portraits envisage a complex transaction between the implied viewer and the subject, an allusion as essential to the viewer's role as it is imaginary. But portraits come to the viewer's conscious mind like the magical, unsettling reflections exhibited by the trick mirrors popular in carnivals and circuses. They may reflect an image of the person standing in front of them, often with such distortions, or so unstably, that the connection between the image and its source seems uncertain, effectively complicating the relationship between the seeing 'I' and the seen 'You'. They may also confront the viewer with an image so apparently 'different' from the expected that the portrait seems to be of a stranger, yet not completely so, thus forcing the viewer, upon due reflection, to respond to the artist's interpretation. And like trick mirrors, or even conventional ones, portraits establish the conditions and circumstances of the viewer's gaze; they shape the psychological process that implicates the viewer, as a respondent, in answering the question posed by the portraitist, 'Who is "the You" that I am looking at and how may I know it?' Knowledge of others is also knowledge of oneself, and perhaps for that reason self-portraits are so important to the analysis of portraiture, for in them the patron, the subject, and the artist are often one. The eyes of all three parties to this transaction focus on a single vision, asserted by the artist's self-indulgence in the act of creation but subject to the queries of the unknown strangers (us?) who witness its result.

We have already seen how the Bengal tiger responded to the woodcutter's back-of-the-head mask (illus. 10); he would have nothing to do with its wearer, although it is likely that

the tiger had never encountered such an overtly two-faced human being before. Artists are also two-faced in regard to their own portraits, but not necessarily because they practise deceit. One image of the artist is surely to be found in all his work, recognizably manifesting his identity in the telltale signature of his personal style, in the choice of subject matter, and in its characteristic treatment.[2] Matisse represents this action, this mode of partly self-effacing self-portraiture, in *The Painter and his Model* of 1917; the painting shows the artist's faceless figure obliquely from the rear, together with his own painting of a faceless model, and the faceless model herself (illus. 61).[3] Indeed, the work offers the viewer a glimpse of the artist as well as two distinct opportunities to view his art, because it so completely implicates Matisse in the very process of making a painting. Here, Matisse seems to question the idea that a self-portrait requires anything more than the explicit representation of the artist's distinctive style and touch; his body may be present indistinctly but not its significant properties, expressed in the mark of his hand, the unique presence of his mind, and in the visualization of his gaze and its very object. After all, who else could it be but Matisse, under the circumstances?

Matisse's distinctive originality, as a significant individual, here transcends the incidentals of his physical appearance, because it is his paintings that truly embody 'Matisse, the painter'. Not only is *The Painter and his Model* recognizable as a painting by Matisse, the artist, but Matisse, as an artist, can be identified in and by the painting. The actualization of his identity realized in the special look of the work – the look of the artist translated into paint – therefore defines, or portrays, the essence of Matisse more exactly than any descriptive likeness. With his typically sardonic acumen, the cartoonist Charles Addams visualized the commonplace observation, particularly valid in this context, that 'artists put themselves into their work' (illus. 66).

By intentionally representing the subjectivity of his artistic consciousness, Matisse countered the old argument that the objectivity of a portrait is defined by the likeness of the person portrayed. He also conflated into a single image his own special view of the world and his place in it.[4] When he visually implicated his personal identity in the substance of a readily identifiable art work – in the sense that one could

legitimately say, 'This is a Matisse, and so is that' – the artist
denied the fragmentation of his persona among the large
body of works he made and, instead, asserted the wholeness
of his being in each of them.[5]

Of course, artists' self-portraits take many forms, often a
much more explicit association of persona, presence, and
product, as in Poussin's *Self-Portrait* in the Louvre (illus. 67).
Clearly inscribed 'Effigies Nicolai Poussini . . . Pictoris . . .
Roma Anno Iubilei 1650', Poussin has represented himself as
a dignified, cultivated person, holding a book – not a brush
– in his hand, as a forthright individual looking out calmly at
the world, and as a master of 'painting as an art', if the

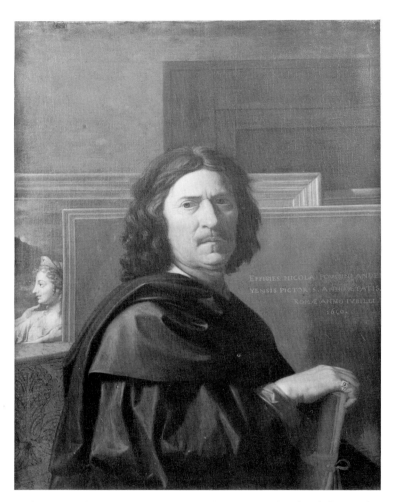

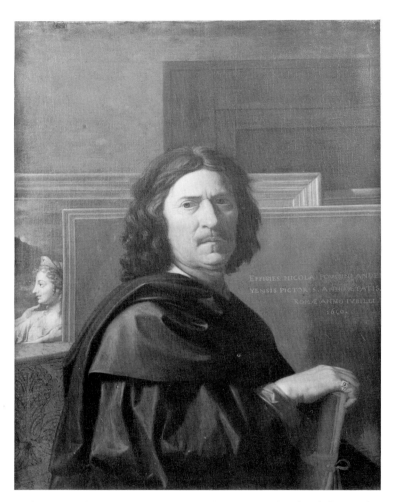

67 Nicolas
Poussin,
Self-Portrait, 1650

tantalizing fragment of a noble female at the far left can be
interpreted allegorically.[6] Because the artist's image has been
presented so directly, the beholder has two options: he may
be induced to take Poussin's place, as he saw himself (in a
mirror), and find the immanent 'I' in the work;[7] or he may
reject that imaginary barrier to his own identity and discover
the less familiar 'You', depending on which look is the more
important to the viewer.

The ambivalence of this interpersonal mode allows the
image to fluctuate not only between potential viewers but
also between states of Poussin's being and becoming. It is
strongly reminiscent of Montaigne's attitude about pre-
senting himself to himself and to a potential other reader in

writing his *Essays* in the 1580s.[8] Both Montaigne and Poussin, the latter imbued with Cartesian certitude, adopted a confessional mode of self-presentation, tinged however with pride, confident that their personal reflections would reach beyond themselves to an audience. Both writer and painter exhibited a powerful sense of self, mitigated, as it were, by the impermanent state of the moment. Yet, so strong are their respective personalities in mind and in image that the reader or the beholder has no doubt of their existence nor of their substantial identity, however much he may be on guard against the distortions evident in their ruminations and reflections. These self-portraits establish the 'I' as 'Me' and the 'I' as 'You' as reasonable objects of interpretation because the model is so fully and convincingly realized by art that its existence is beyond doubt. But what if the model for a self-portrait were itself a fiction and its mirrored reflection a delusion?

A few years ago the cartoonist Jim Stevenson exploited the interpretive possibilities inherent in an artificial self-portrait in a *New Yorker* cartoon (illus. 68). One 'Larry Hoskins' is shown looking at himself in the bathroom mirror and saying to his mirrored reflection, 'Hi, I'm Larry Hoskins as portrayed by me'. Now, if 'Larry Hoskins' is not portrayed by the person standing in front of the mirror, then who could possibly por-

68 Jim Stevenson, 'Hi. I'm Larry Hoskins as portrayed by me', cartoon from *The New Yorker*, 14 May, 1983

"Hi. I'm Larry Hoskins as portrayed by me."

tray him? Jim Stevenson? And if 'Larry Hoskins' should be portrayed by Larry Hoskins, then the Larry Hoskins we see appears to be an actor playing a role, rather self-consciously at that. The fictitious name, given to Larry Hoskins by Stevenson, specifies what Larry Hoskins represents to himself, at least by way of introduction to that stranger in the mirror, or to the viewing public at large.[9] The blank mirror in the cartoon is somewhat disconcerting, but perhaps the discovery of the 'other' in the mirror first has to be made by the fellow playing Larry Hoskins, when he sees the direct projection of his image and becomes accustomed to its accuracy. We can only guess what Larry Hoskins, fictional character, sees in the mirror, although we know from long experience that the mirror holds right and left in place in the reflection and, therefore, gives a false impression of the model, at least as the model would appear to another person, standing in front of the subject. The distortion rarely disturbs us, because we are so used to making the adjustment when we see the right side of our face on the right side of the opposing image. For this reason, our mirrored reflection seems to be distorted, separating the image of myself to me from the image of myself to others. How strange it is that the 'I' that I see in the mirror opposite may be less true to my actual appearance – my face to the world – than the 'You' that you see and know at sight.

Stevenson's cartoon questions what it is that we see when we see a reflection of ourselves and how we go about identifying it. Of course, we can try to make ourselves look like ourselves, that is, like the 'ourselves' that others in our society already know and expect to see. Or, if we are as sceptically self-aware as M. C. Escher in his *Hand with Reflecting Sphere* (illus. 35), we will notice the incomplete correspondence between the self-reflecting image and the original that so depends on who is doing the looking.

Proof of the ultimate uncertainty of recognition or of the incompatibility of different perspectives towards the self, now a topic of modernist discourse,[10] can be found in a very common experience: the shock that comes to us while walking in the street, when we catch, out of the corner of our eye, an unexpected reflection of ourself in a mirror or plate-glass window; first comes the thought, 'I know that person', and then the surprised discovery, 'It's me!' What prevents the indi-

vidual from knowing immediately that the reflection is of himself is that overriding perception of the 'other', the 'You out there', as being substantially different from the self. This response is especially strong if the mental image of oneself is not determined by transient, ever-changing reflections in window or mirror but by the more permanent images, fixed by photographs and other media of portraiture. But even the supposed authority of the recognized portrait likeness has its problems, as we saw in Chapter I.

If we were to accept the fact that I may not appear to you as I appear to myself, it may still be possible for me to appear to both of us in the same way. An artist's self-portraits over a number of years might do the trick, if we can assume that such an artist has effectively created a consistent image of himself over time, even if such an image were wholly fictional.[11] Then it would no longer be necessary to take sides in the great debate over the existence or nature of the self, or to hold that it is necessary to the concept of identity, or to determine whether the self at any time is the same as the self at an earlier or later time, especially when no one has ever seen a 'self'.[12] David Hume himself set the terms of this debate:

> For my part, when I enter most intimately into what I call *myself*, I always stumble on some particular perception or other, of heat or cold, light or shade, love or hatred, pain or pleasure. I never can catch *myself* at any time without a perception, and never can observe anything but the perception . . . If anyone, upon serious and unprejudiced reflection, thinks he has a different notion of *himself*, I must confess that I can reason no longer with him. All I can allow him is, that he may be in the right as well as I, and that we are essentially different in this particular. He may, perhaps, perceive something simple and continued, which he calls *himself*; though I am certain there is no such principle in me.[13]

Perhaps it is the constancy of his perception, rather than the constancy of the self, that gives Stanley Spencer's self-portraits of 1914, 1936, and 1959 such a sense of the connection of a single person to a single body over a lifetime (illus. 69–71).[14] These portraits have a no-nonsense quality about them, as if the artist were saying, 'Here I am! Take me as you find me.' They do not seem to make strong psychological

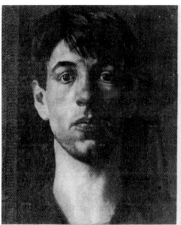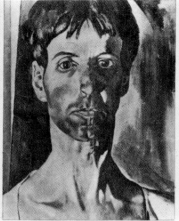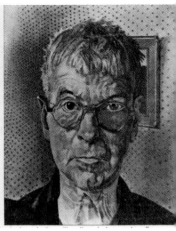

demands upon the viewer, nor does Spencer make much of an effort to control the beholder's imagination, to direct his response to the person represented. Rather, Spencer's self-portraits reflect the ambiguous possibilities of ordinary experience, those inherent in a chance encounter with a stranger, whom one might take to or ignore without it mattering much either to the viewer or to the subject. Indeed, Spencer seems not to need the viewer to exist. He did not adopt a neutral position about himself but is always careful to delineate his features and the changes in them brought about by increasing age. And he always takes himself very seriously, looking out at the world with the unflinching directness that makes these unpretentious self-portraits so arresting, so unsociable, and so defenceless.

Spencer's preoccupation with the unglossed manifestations of daily life in its basic forms may arise in part from his English working-class perspective on the world. However, this doughty artist also endows these images with the idiosyncrasies of his intensely personal style of painting, even if not wholly immune from the general tendency to flatten forms and detach colour from modelling that is typical of British modernism. Perhaps it is only a truism to insist upon the importance of personal style as a sign of the artist, yet Spencer's personal style does not seem to have been used instrumentally as a deliberate way to assert both his artistic persona and his participation in the contemporary art movement in Britain. Spencer, in fact, seems to deny the very

69, 70, 71 Stanley Spencer, *Self-Portrait*, 1914, 1936, 1959

148

'as-ness' of his portraits, concentrating on the representation of the inner core of his being, as he perceived it in each instance of self-portrayal.[15]

In these self-portraits (illus. 69–71) Spencer's life seems to be strongly lived, without reference to before and after, yet a continuous thread of obdurate personality moves forward from one stage to another in accordance with Kierkegaard's sage observation in his *Journals* for 1843, that:

> It is perfectly true, as philosophers say, that life must be understood backwards. But they forget the other proposition, that it must be lived forwards. And if one thinks over that proposition it becomes more and more evident that life can never be really understood in time simply because at no particular moment can I find the necessary resting-place from which to understand it – backwards.[16]

Spencer does not appear to look either forwards or backwards in the contemplation of his life, even though viewers may do so in their attempt to discover the historical reality of his existence as a significant artist. His self-portraits are so dense, the image saturated with his personality, as in many artists' self-portraits from the fifteenth century to the present, from Dürer to Rembrandt to Courbet to Cézanne to Beckmann to Picasso to Lucien Freud, and beyond. Great artists, such as Titian and Poussin (illus. 67), represent in their self-portraits both the personal implications of their fame and the fragility of the historical self, either in its corporeal envelope or in its externalization through works of art.[17] Just as Matisse implied his definite presence in *The Painter and his Model* (illus. 61), so an artist can infuse the portrait of another with the authority of his gaze in such a way as to create, in effect, an explicitly visible reference to himself within the closely observed form of his subject.[18]

Man Ray's 1922 photograph of Gertrude Stein sitting in front of her portrait, painted by Picasso in 1906, represents such an instance of ambivalent portraiture, a transaction between Stein and Picasso further subjected to a third party's intervention (illus. 72). The story of Picasso's *Gertrude Stein* is well-known from Alice Toklas' account: in the spring of 1906 Gertrude Stein sat some eighty times for the portrait and yet Picasso was not satisfied; that summer he went to Spain and looked at early Iberian stone sculpture, then, returning to

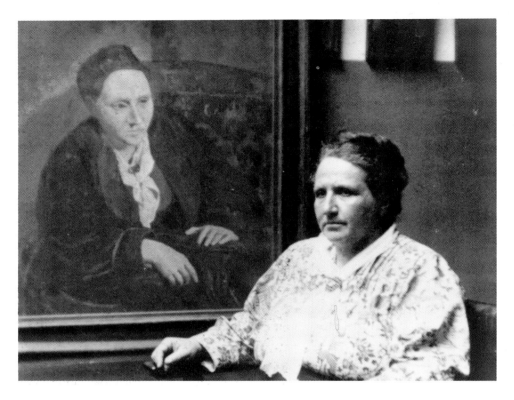

72 Man Ray,
*Gertrude Stein
Sitting in Front of
Picasso's Portrait of
Her*, 1922

Paris, he completed the portrait, adopting the blocky, stony facial and body types of Iberian art as the basis of his image of Stein; there were many objections to the result and many complaints that the portrait did not look like her. Picasso replied, 'That does not make any difference, she will.' And Gertrude Stein herself responded, 'I was and still am satisfied with my portrait, for me, it is I.' Stubborn certainly, prescient perhaps, Picasso had so imposed his vision on Stein's portrait that his perceptive 'I' and her receptive 'You' seem to have fused in a proleptic anticipation of the artistic personae they were both to become.

Man Ray's photograph deliberately contrasts Picasso's *Stein* with Stein herself, now sixteen years older, and the inanimate, but powerful, pictorial presence with the monumentality of her actual body. Picasso's portrait seems to be closer to the original Gertrude Stein than the ageing human being in the photograph, but Man Ray also wanted to demonstrate the persistence of that unique self, the self that was once and for all defined by Picasso as 'Gertrude Stein'.

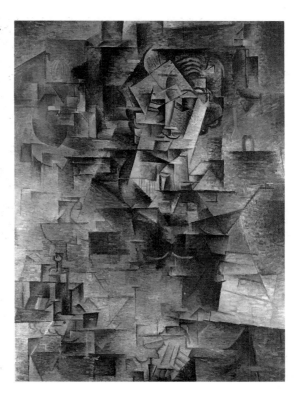

73 Pablo Picasso,
*Portrait of
Daniel-Henry
Kahnweiler*, 1910

Walter Benjamin once remarked that 'the portrait becomes after a few generations no more than a testimony to the art of the person who painted it'.[19] That hardly does justice to the richness of Man Ray's dialectical conception that represented Gertrude Stein's life with all its solidity and all its change-ability, offering in his photograph a deliberate redundancy of images that closely follows Stein's own repetitive mode of literary portraiture.[20] The persistence of the Steinian self in her written work, in her indomitable appearance, and in her portraits, confirms the existence of her powerful ego, the 'I' so often used by Stein, the author, and Stein, the talker.[21] Ego identity has a stability in Stein, rare in most individuals;[22] it existed within her, as Picasso recognized, and therefore, in meeting the criterion of resemblance, the posited relationship between the portrait image and the person portrayed, he did not draw so much upon her physique as upon her psyche, which he visualized concretely.[23]

Analytical verisimilitude is the touchstone of this artist's competence, because while her contemporaries might have

been able to see Stein as she looked, Picasso was able to see and paint her as she was and would be. By 1910, in his portrait of *Daniel-Henry Kahnweiler* (illus. 73), Picasso's analysis of the formal properties of Cubism took precedence over the manifest recognizability of the subject, and the artist's gaze was clearly the focus of representation, even though it is said that Kahnweiler sat for him twenty times or more.[24] This Cubist portrait of Kahnweiler shows him together with an African sculpture and, thus, points equally to Kahnweiler as an art dealer in such objects and to Picasso as an admirer of African tribal art. Despite the imposition of Picasso's nonconforming Cubist vision on the portrait, despite the intrusion of his aesthetic preferences into the content of the work, 'Kahnweiler' could still be recognized within the circle of his familiars. For them, the searching out of the represented 'Kahnweiler' followed directly upon a tacit acknowledgement that it was necessary to do so, if they were to discover the meaning and intention of Picasso's painting.

Confronted by Dali's portrait of *Mae West* (1933–5), even the necessity or appropriateness of that search might be in doubt (illus. 62). A viewer, not privy to the joke, might easily mistake the 'come hither' look, made famous by the bawdy actress, for some erotic abstraction; or, with an even greater flight of imagination, someone might see the work only as a typical example of Dali's bizarre fancy; or, more inventively, as a clever representation of the disconnection between a named person and her remembered image experienced by those who suffer from visual agnosia.[25] Sexuality certainly permeates Dali's portrait, a sexuality embodied in the cinematic personality of Mae West, once her identity is established, even if only a few telling physiognomic clues are presented: bleached blond hair, mascara-covered eyelashes, a pale, blank face, upturned nose, and pouting lips – in sum, a mask, and *the* mask Mae West constantly adopted. Nevertheless, Dali's *Mae West* does not provide a high degree of descriptive resemblance between his portrait image and the subject, despite his very strong characterization, verging on caricature.

Dali's *Mae West* exists within the world of Surrealist imagery that blurs the distinction between her sexually defined persona and her implicit invitation. Yet the work also falls into an old figurative mode of representing sexually

attractive women in terms of their real or potential effect on men, as if any man's erotic gaze – let alone Dali's – was an essential feature of Mae West's persona, the persona that continually and naturally elicited prurient looks from men. Dali has indeed suggested that those prurient looks constitute a resonating element of Mae West's appearance, central to her own and to others' perception of her identity. This 'Mae West' is the person everyone knew from her pictures, from her well-publicized private life, and from her public appearances. Aptly employing the Surrealist vocabulary, Dali's portrayal of Mae West implies his attitude towards the subject's visual, sexual appeal, rendering it incomplete without the responding voyeur, just as she was in real life, apparently. Whether or not Mae West was as reachable as she appeared to be is, of course, another matter, better left to the beholder's imagination.

Dali's image surely portrays Mae West, but without foreknowledge it would be difficult to know that it is a portrait, rather than some theatrical presentation or some character on a stage. But then film stars fabricate themselves, often in collusion with others, and it is the very fact of such fabrication that gives meaning to Steichen's superb photograph of *Gloria Swanson* (1924), a beautiful woman behind a dark screen, unreachable (illus. 74). The silent film star appears as a magical creature, composed of eyes and mystery, an image imprinted behind a flowered veil, as if it were the black-and-white film world in which she truly lived.[26] Her expressive eyes, aggressively frontal face, and closed mouth – silent film stars are voiceless – bring her image too close to the viewer to be ignored. This 'Gloria Swanson' demands a response, as if she were actually present in the viewer's space rather than in his sight and imagination.

Steichen has induced the viewer to project on to Swanson's image the elements of character created by her film roles and studio publicity, thereby effecting a well-crafted relationship between the star and the observer through the medium of the suspended close-up, held away from the viewer by the veil. In Steichen's screened-off portrait of the actress, the viewer could find whatever person Swanson had played in the movies that he chose to look for. Projection, however, is not limited to the camera; it is also stimulated by expectation and by yearning. Elias Canetti erroneously identified Dr Sonne as Karl Kraus when he saw him at the Café Museum

in Vienna in the 1920s; Canetti, that extraordinary observer
of observations, was satisfied by his imputation of the latter's
characteristics to the former, even though he knew he was
mistaken.[27]

Picasso's *Kahnweiler* (illus. 73), Dali's *Mae West* (illus. 62),
and Steichen's *Gloria Swanson* (illus. 74) strongly solicit the
viewer's participation in puzzling out the connection between
the portrait image and himself on the one hand, and between
the image and the original on the other. *Gloria Swanson* is the
closest to mimetic representation and *Mae West* the furthest,
but all three portraits are tied to the body of the human object
as a simulacrum of reality in varying degrees. Since none of
them argues for the equivalence of object and image, but
instead all challenge the validity of that old proposition,

theoretically a portrait can be freed from all forms of descriptive reference to physical appearance without losing its categorical status as an intentionally exclusive sign of a named individual.[28] How a given person looks at any time would then be irrelevant for the purposes of portraiture and unnecessary as a reference for the portrait image, if it is wholly the artist's vision that ultimately forms that image.

The artist's approach to portraiture as a journey of discovery may be almost infinitely varied, so long as the art work provides a name and reasonable access to the subject, sufficient to bring the person portrayed to the viewer's mind. This seems to be the active principle behind Francis Picabia's provocative *Portrait of Marie Laurencin* (1917) which dispenses with the human object as the simulacrum of reality and replaces it with an imaginary machine (illus. 75).[29] The machine parts and the legible inscriptions, including the explicit statement, 'Portrait de Marie Laurencin', communicates the artist's intention to portray her without reference to anything that can be said to look like her. From 1915 to the 1920s Picabia made a number of such non-objective portraits of friends and acquaintances without attempting to convey any hint of mimetic resemblance, as if he had rejected such

75 Francis Picabia, *Portrait of Marie Laurencin*, 1917

representation of the simulacra of these persons as fundamentally untrue.[30] The subjects were as they appeared in his mind and nowhere else, even in themselves, and they received no referential imagery except to his visions. His *Marie Laurencin* is a highly abstract, non-objective portrait, similar in nature to the experience of visual agnosia which forces the sufferer to mistake not just the identity of familiar persons but their very existence as persons.[31]

Picabia himself is not afflicted with this failure of cognition. Rather he seems to imagine in these works a new form of visionary solipsism, defined by the literary critic Charles J. Rezepka as 'that state of mind where attention is focused so exclusively on the sole self . . . and its sphere of perception that objects of perception no longer appear as objects of bodily sight, whatever their degree of correspondence to the world which is assumed to exist outside the mind'.[32] Picabia may have shared this attitude but his own poetic constructions were anticipated in the early nineteenth century by William Wordsworth:

Amid the moving pageant, I was smitten
Abruptly, with the view (a sight not rare)
Of a blind Beggar, who, with upright face,
Stood, propped against a wall, upon his chest
Wearing a written paper, to explain
His story, whence he came, and who he was.
Caught by the spectacle my mind turned round
As with the might of waters; an apt type
This label seemed of the utmost we can know,
Both of ourselves and of the universe; . . .[33]

If the portrait subject's resemblance to himself is conceptually insignificant, modern artists who reject mimetic reference may adopt other strategies of presentation in which their own intrusive presence, rather than any issue of personal style, colours all portraits from their hand. Francis Bacon's portraits of popes, friends, patrons, of himself, all seem to look alike, as if he were seeking to express himself through their contorted images.[34] To the degree in which they can be distinguished from one another, each portrait retains its own integrity; to the degree that they resemble one another, they implicate the artist in each image as if he mirrored his own anxious appearance in their faces.

76 Parmigianino,
*Self-Portrait in a
Convex Mirror*,
1523–24

Bacon imposes his alien self as a subject upon his portrait subjects, but what if the artist represents himself directly as a subject who is experiencing his own (re)presentation in a mirror, as if he were able by this means to alienate himself from himself? Parmigianino's *Self-Portrait in a Convex Mirror* (1523–4) is a tour-de-force of contradictory illusion, self-deception, and abortive alienation (illus. 76).[35] The spectator is made to feel that in looking at this mirror image he is intruding into the apparently reciprocal relation between the artist and the mirror, although the projecting right hand leaves no room for an interloper. The intrusive eye of another is permitted access only by the painter's crafty objectification of the distinction between himself and his reflection, through his art. Vasari said of this painting:

> . . . in order to investigate the subtleties of art, (Parmigianino) set himself one day to make his own portrait, looking at himself in a convex barber's mirror. And in doing this, perceiving the bizarre effects produced by the roundness of the mirror, . . . the idea came to him to amuse himself by counterfeiting everything. Thereupon he had a ball of wood made by a turner, and, dividing it in half so as to make it the same in size and shape as the mirror, set to work to counterfeit on it with supreme art all that he saw in the glass, and particularly his own self . . . So happily,

indeed, did he succeed in the whole of this work, that the painting was no less real than the reality.[36]

How many removes there were from the physical self to its reflection in the mirror, to the reproduction of the fact and circumstances of that reflection, all mediated by the artist's right hand! Their coalescence in Parmigianino's painting enriches the quality of its sheer conceit, a play on the mutability of reality through the false transparency of the illusory 'mirror'. The modern American poet, John Ashbery, wrote a long poem on this painting, observing *inter alia* that what Parmagianino saw in the glass was 'Chiefly his reflection, of which the portrait / Is the reflection once removed'.[37] What strikes Ashbery, in looking at the small, convex panel, less than ten inches in diameter, is the remoteness of that 'other Parmigianino', even from himself. In one sense the portrait seems to incorporate his narcissistic vanity in an intensely personal manner, as if he were visible only to himself, but in another sense he has objectified this vanity, making it public and permanent, because it is not a mirror but the opaque counterfeit of a mirror. The viewer is privy to the intimate reception of the apparent mirror image precisely because it is not a reflection – with all the transiency of a reflection – but an art work and, therefore, real only as an art work – and indeed as a special genus of art work, namely a portrait, of which Parmigianino is both subject and maker. The artist's struggle to insert himself into the portrait and to exclude himself from the work of art, to make of himself an image or a reflection of reality at considerable remove, bespeaks his awareness of the difficulty, if not the futility, of self-representation. At least Parmigianino began with the original as he alone could see it.

Parmigianino's *Self-Portrait* sets up an opposition between his actual but perishable body and its transient reflection, a reflection that not only survives him but preserves the true nature of his being as an artist. In effect, he does for himself what Picasso did for Gertrude Stein (illus. 72), projecting this pictorial realization of an act of self-knowing far into the future where it will be seen and responded to by strangers. With greater or lesser degrees of success, self-portraiture always makes a concentrated autobiographical statement, the manifesto of an artist's introspection.

Norman Rockwell's self-portrait, presented as a *Saturday Evening Post* cover, 13 February 1960 (illus. 77), lays out the typical programme of such works because it is so explicitly self-referential and demonstrates so well the distortions in the mirror reflection.[38] Rockwell was always very clever in presenting his artlessly realistic depictions of the American scene, and no less so here. First, we see him with his back to us, painting his own portrait, while he looks at his reflection from the front in the mirror. The mirror reflects the fact that Rockwell wears glasses and holds his pipe on the left, but the portrait he is painting shows no glasses, and the pipe is held on the right side of his mouth, parallel to the mirror image – which is, however, reversed. We also see a preparatory sketch, hung on the edge of the canvas, that shows four versions of his head and one of his hand. Our guess that the hand (of the artist) is reminiscent of famous prototypes in the history of art – a deliberate reference to traditional self-portraiture – is confirmed by the 'pictures' of the works of famous artists of the past, pinned to the easel, beginning with Dürer whom Rockwell admired. And in the lower right-hand corner of the 'portrait' within the painting, there appears his characteristic bold signature to reaffirm his authorship of the entire work and to identify through the inscriptive label the subject of the inner portrait.

Everything has been done without apparent pretence, and yet one could hardly imagine a more explicit statement of the 'I' in the work and of the artist's engagement with that concept of 'I-ness' as the principal aim of his painting and image-making. Rockwell owed his enormous popular reputation partly to the patronage of the *Saturday Evening Post*, which frequently used his humorous scenes of American life for its covers. This cover of 13 February 1960 served to proclaim the long association between Rockwell and the publisher. The painting, shown on the cover, is also truly autobiographical; it focuses on the artist, with Rockwell playing his public self, the famous painter-illustrator who looks very carefully at the world and describes people and things accurately and sympathetically, even if he is sometimes sentimental in his choice of subject matter. By representing himself in the act of painting a self-portrait, Rockwell seems to shift the emphasis from the subject, 'I', to a painting whose subject is 'Me', maintaining his public persona as an unpretentious, innocent, and

77 Norman Rockwell, *Triple Self-Portrait*, 1960, from the cover of *The Saturday Evening Post*,
13 February 1960

rather sentimental realist. Actually, the *Saturday Evening Post* cover is no less flagrant in its self-conscious presentation of the artist at work than the Parmigianino *Self-Portrait* (illus. 76), although more fully documented.

For Rockwell, the mirror and the mirror image demonstrated the artist's apparent dedication to close observation and his dependably realistic mode of depicting the everyday world, including his studio. The style, or visible process of the work, thoroughly complements Rockwell's identity as an artist and contextualizes these multiple images of him in Rockwellian history. Some self-portraits may be difficult to recognize as such, because the label is missing or concealment of the subject too successful. Rockwell, however, has constructed his work with such thoroughness that the identification of the painting as a self-portrait seems inevitable. His calculation is well plotted, an effort surely not expended only for his own benefit nor merely as an elaborate form of confession, but rather for the benefit of an observer, or many observers. Standing behind the artist at work, the observer can observe the artist observing himself, presenting himself to the observer both in the self-portrait on the easel and in the act of painting it. Authorship of the painting as a whole and of all its parts can thus never be questioned, although we might ask how the painter ever saw himself from the back, unless he used a mirror in the place of the observer. Ultimately Rockwell, the realist, does not conceal the artificial nature of his self-portrait nor the difficulty he experienced in knowing and presenting himself as an 'other' to himself and to another.[39]

Rockwell tried to see himself as another might, but it is much easier to see oneself as others do if one lets someone else perpetuate that inspection in a work of art – and then contemplates the result. Manny Warman's photograph, *Presidential Likeness, Low Library 1964* (illus. 78), presents an image of Dwight D. Eisenhower looking at himself, or looking at his own likeness, a bust by the sculptor Antonio Salemme on display at Columbia University in New York City. Conditioned by the conventions of journalistic photography, we are quite prepared to take this photograph at face value, that is, of Eisenhower, or Ike, looking at his portrait bust. The two Ikes do not coincide, but they are remarkably similar, given the descriptive realism of the bust. In Warman's photograph of the 'real' Ike and Ike's bust, Ike looks so much like himself

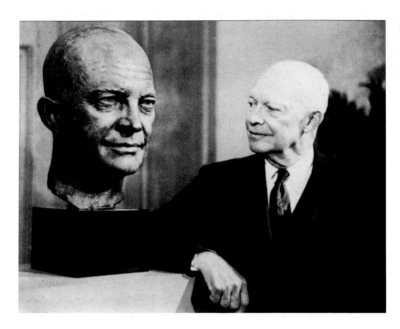

78 Manny
Warman,
*Presidential
Likeness, Low
Library*, 1964

looking at himself that it is not easy to decide whether the
bust is more like 'Ike' than Ike, whether Ike has set his face
to look like the bust, or whether Ike is at the moment looking
especially like the 'Ike' – victorious general and successful
political leader – that we all know.

These questions are not easy to answer because they bring
to mind, once again, the very problem of likeness itself. In
Warman's photograph we can see how an individual may
conform to an extant image, highly recognizable as 'Ike' from
many similar images, embedded in the public consciousness.
But we can also see the way in which the self, the individual
Ike whom we think we can recognize as a historical person-
age, may not be subject to variation. Both the photograph
and the sculpted bust are moderate approximations, not
necessarily a record only of Ike addressing his portrait but,
rather, a congregation of moments, both casual and highly
structured. Warman's photograph is a record of an encounter
and it provides the illusion that a real person has been
depicted, while the bust in the photograph offers the
counter-illusion that we are looking at a portrait, distinguish-
able as an art work from the real Ike. Given the careful compo-
sition of the photograph, it is clear that we are looking at a
doubled portrait with remarkable internal and external con-

sistency. The doubling of the portrait by the photographer –
as in Rockwell's *Saturday Evening Post* cover (illus. 77) – allows
the viewer to judge the portrait's reliability and to see what
the artist saw. But Warman's photograph does not question
Ike's apparent satisfaction with his portrait bust, as he gazed
upon it with a personal interest unavailable to anyone else.[40]

The image of Ike looking at his bust also has some of the
properties of a mirrored reflection, not to Ike in the picture
but to an external observer who can see the left and right
profiles simultaneously. Daumier had explored the possibili-
ties of multiple viewers in the confrontation between art
object and portrait subject, satirized in his *'There is no doubt
about it'* print of 1864 (illus. 19); both his print and Warman's
photograph pose the question, 'Who is doing the looking?',
that has more than one answer. The importance of this ques-
tion in the consideration of all self-portraits cannot be denied,
but sometimes it surfaces obliquely, as in David Hockney's
truncated reflection in his *My Parents and Myself* (1975). His
small, mirrored reflection (illus. 79) does less to proclaim him

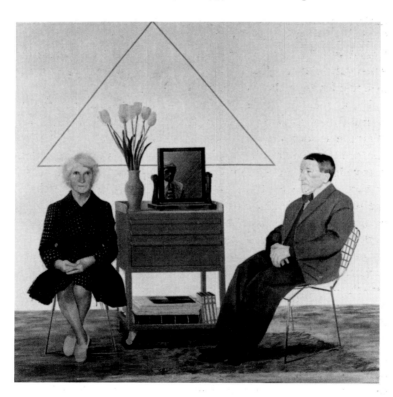

79 David
Hockney, *My
Parents and Myself*,
1975

as the artist responsible for the portrait than to assert his family membership, the son of his mother and of his father, too.[41] Yet the scale of Hockney's self-imaging, its position in the composition, and its partiality, suggest a very private family portrait whose intimacy was not intended to be violated by an outside viewer, even if eventually that would happen.

In many self-portraits, the feeling of privacy that governs and occasions so much figurative introspection may seek to restrict the potential class of viewers to a chosen few, or to an audience of one (e.g., Rembrandt). The natural impulse to protect one's personal privacy from others conflicts with the artist's equally natural desire to create an autobiographical image that, being a separate entity, lives outside of himself and may escape his control. Near the end of his life, Lovis Corinth painted a *Self-Portrait with Mirror* (1925) that realized the ambiguity of the doubled image in a poignant combination of artistic pride and personal doubt (illus. 80).[42] Although the reflecting mirror in the background reiterates his presence in the work and the rich, painterly treatment of the entire surface proclaims Corinth's bold touch, these self-made marks seem strangely at odds with the artist's troubled visage, as if he were reluctant to reveal so much of himself, or no longer cared whether he did. Indeed, this work has such an intimate focus that we can imagine the existence of an unrepresented mirror standing between us and Corinth, a mirror that reflects his image away from us to him alone. What we see then is not what Corinth saw but what he chose to reveal, an image at least once removed from himself, but still a characteristic expression of the viewer as artist, and a reification of that unique relation.

Reification in the context of self-portrait imagery is another way of referring to the artist's visualization of the act of painting and of his or her uniquely personal connection with that manifest act. Three centuries earlier than Corinth, Artemesia Gentileschi painted a *Self-Portrait as La Pittura* (c.1630) that allegorized the art of painting through the representation of her own female person (illus. 81). She also showed herself painting, the very action which gave her, a woman in seventeenth-century Italy, the special identity of an artist, even if that was then an anomalous role for one of her sex.[43] The striking perspective is composed as if the viewer were looking over her shoulder at the work in progress or at her

80 Lovis Corinth, *Self-Portrait with Mirror*, 1925

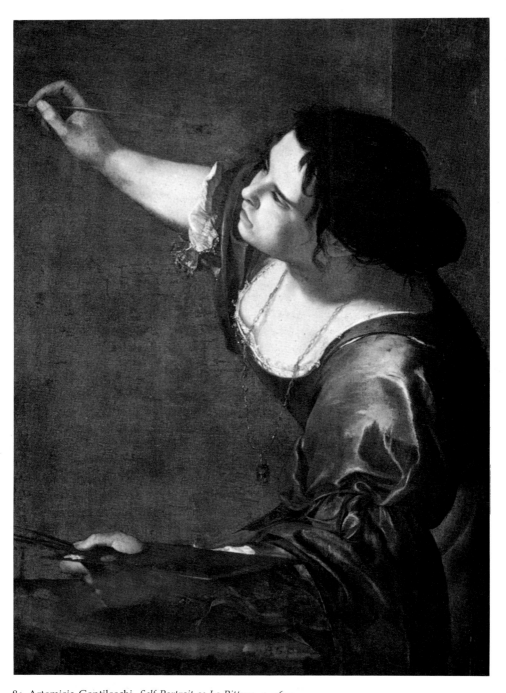

81 Artemisia Gentileschi, *Self-Portrait as La Pittura, c.* 1630

bosom, or both, equally pertinent to her identity. The oblique view forces the eye to move from the palette to her person to the implied, but unrendered, painting on which she is working – perhaps this very one – suggesting that the viewer will see what she sees when the artistic conception has been conveyed to the canvas. Since the only way she could have seen herself in this perspectival view was conceptually, the composition reinforces the dramatic authority of the painter's brush-laden right hand, suspended in the act of painting, the act of self-designation, the act of making her creative impulse visible through art. Of course the viewer could not see what she was painting but only what she had, in fact, painted: the self-portrait of the artist in action.[44] Because she looks away from the viewer towards the work, the painter assumes a partially self-effacing pose, despite her vivid presence in the picture, thus guaranteeing the primacy of what she is creating. In effect, she has put her self into the work, as much as any male artist of the time.

Both Lovis Corinth and Artemisia Gentileschi present images of themselves burdened with a high degree of self-awareness, although taking a different attitude towards its private or public expression. Matisse had exhibited a similar awareness in his *The Painter and his Model* (illus. 61) in the subtle pursuit of the special aspects of his relationship to the model and to his painting of her, through which his art and himself would be revealed. Otto Dix, a younger contemporary of Corinth's, painted a self-portrait with model (1923) that makes no bones about the difference between himself and his model (illus. 82).[45] Whatever erotic charge may have been imposed upon this unlikely pair – the relaxed, curvaceous nude model and the tense, fully clothed artist – Dix has strictly maintained the distinction between the object of his artistic endeavours and the subject of his intention to portray. The artist and his model do not exist in the same psychological space, despite the common mode of realistic depiction; rarely has an artist made the identity of his model so deliberately irrelevant and his own, in comparison, so transcendentally significant.[46] In a sense Dix has asserted his proprietorship of the model, that as an artist he can use her to pose as a nude – and she is nude, or at least naked – or for anything he wishes. Therefore, the model's identity will be submerged in whatever images Dix makes, while con-

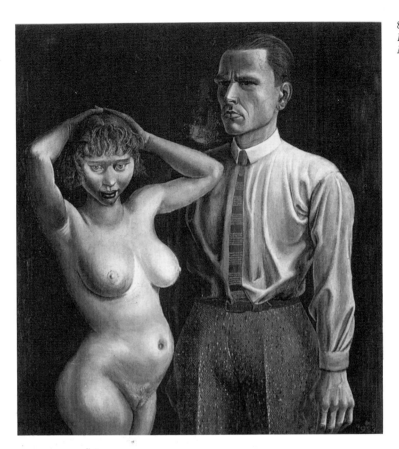

versely whatever Dix makes will bear his mark so that he will be present no matter how he uses her.

Dix's painting declares the actual and potential expressive power of the artist, asserting his absolute possession of the artistic product in all its forms and appearances. In spirit, it is not so different from Goya's self-portrait as the frontispiece of the *Caprichos*, issued in 1797–8 (illus. 83).[47] Of course, the Goya etching is an intrinsic part of the collection of prints under that title, and the artist shows himself checking up on their (his) reception 'on the sly', as he shifts his eye from the near profile to glance at the viewing public. Goya, gentleman and painter ('Pintor'), thus reveals his vulnerability in taking the risk of learning that his work and, in effect, himself, will not be esteemed for what he has done, for what he is. Despite the apparent imperturbability of the subject, suggested by the profile, Goya is anything but disconnected. Indeed, the print

clearly reveals how exposed any artist is, once the work leaves the studio and enters the world, when only the art and the quality of its reception can preserve the artist's composure.

Ultimately, artists' self-portraits seem to follow two divergent paths. One marks the course of a personal inquiry after the self, wherever it is to be found, culminating in the attempt to realize fully that self in some outwardly expressive image, not previously known; the other follows a more worldly path, guardedly revealing the artist's identity in those highly personal art works that are recognizably 'his' or 'hers'. Of course, artists rarely follow either path exclusively. However, all of them must contend with the uncertain relation between the particular image as a fragment of themselves and the whole body of their work, whether they intentionally presented each art work as a representative part of their total being or believed that the significant fragment is all that anyone could show of themself at one time because there is no demonstrable unity in the self.

83 Francesco Goya, *Self-Portrait*, from *Los Caprichos*, 1797–98

84 William Rush,
Self-Portrait, 1822

William Rush's *Self-Portrait* (1822) in terra-cotta shows the
artist, a master sculptor in wood and a virtuoso craftsman,
vigorously emerging from a pine-knot, notoriously difficult
to carve (illus. 84).[48] This is Rush, a supremely confident
maker of sculpture, the apparently secure author of his self-
imaging. In 1903 Lorado Taft described this fragmentary bust
most appreciatively:

> The bust is a unique and curious work. The shaggy shoul-
> ders are in appearance but a rough knotty log over which
> a pine sprig has fallen, its needles mingling with the artist's
> thin locks . . . There is no question of its veracity; it shows
> us exactly what manner of man was William Rush. The
> pose is strong but contained, and despite the unconven-
> tionality, not to say the grotesqueness of the wood-carver's
> fancy, the whole effect is one of power.[49]

For the Americans William Rush and Lorado Taft, it was
still possible to accept the *pars pro toto* because they held
fast to 'the Western conception of the person as a bounded,

unique, more or less integrated motivational and cognitive universe, a dynamic center of awareness, emotion, judgement, and action organized into a distinctive whole and set contrastively both against other such wholes and against its social and natural background'.[50] In the twentieth century the traditional view of the fully integrated, unique, and distinctive person has been severely compromised by a variety of factors, commonly accepted as causing the fragmentation of self and the perceived decline in the belief that the 'individual' is a legitimate social reality. The alleged causes are well known: psychology's dissolution of the concept of the rational human being, Marxist notions of a non-distinctive social existence, sociologists' and social historians' insistence on the social rather than the personal nature of identity, philosophers' doubts about the nature or reality of the self, and the anxious decentring and fragmentation of human experience in the modern age, characterized by the disruptive force of world wars, atom bombs, mass culture, and the broken hegemony of the West over world politics, and so forth. Less important than the identification of these supposed causes is the general perception that the concept of the distinctive individual is on the wane and that the very existence of the self, even in its most inchoate form, is in jeopardy.[51] What then can modern portraits, even self-portraits, represent?

If personhood were not to have a separate, distinct existence, or if it cannot be properly demonstrated, then nothing but an arbitrary connection between an image, *qua* portrait, and some named individual need be represented. Marcel Duchamp exploited the fragility and artificiality of this connection with his typical improvisatory brilliance in *Wanted, $2000 Reward* (1923, illus. 85), a small replica of which he included in his *Box in a Valise* (1941–2), now in the Arensberg Collection.[52] Duchamp had picked up a ready-made placard, distributed by a New York City restaurant as a joke, inserted his photograph in the blanks, changed the last line of the inscription, and made this comical, anonymous poster his own. *Wanted, $2000 Reward* deliberately reminds us of the stereotyped posters and handbills frequently encountered in post offices:[53] graphic, passport-style photographs or 'mug shots', with a brief physical description of the wanted person, and names, including the usual aliases. Nowhere does the name Marcel Duchamp appear, although the artist deliber-

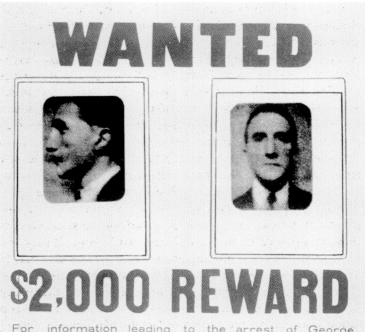

ately appropriated the poster as a vehicle of self-represen-
tation. Small in format, large in pretension, *Wanted, $2000
Reward* makes an ironic contrast between the poster's implied
promise to portray some identifiable person and its fictive
complexity.

Duchamp's photographs are too small for their frames and,
in their greyness, resemble fingerprints, the supposedly
unique sign of identity. Even the arrangement of the photo-
graphs is atypical for 'Wanted' posters, especially because the
left profile looks away from the frontal view and therefore
out beyond the poster's frame. There is something false about
these small photographs, as if they did not belong, suggesting
that this poster resembles a forged identity card.[54]

Then the list of false names, taken on by Duchamp, aptly characterizes the typical confidence man but it also marks the artist as a maker of (false) illusions. His doing so here is not wholly false, however, because as an artist he makes visual illusions, a form of promise that is both calculating and collusive. The aliases themselves are pertinent clues to the artist's self-declared manipulation of reality, to the promises he and his work make, and to the suckers who are taken in by him. In New York street jargon, to *welch* is to refuse to meet one's financial obligations, especially in wagering; *bull* is self-aggrandizing puffery; *slim pickens* (pickings) is the paltry result of a swindle; a *bucket shop* is an illegal brokerage or gambling house[55] – and Duchamp was a renowned card player; and *hook, line, and sinker* describes the sucker's complete acceptance of the confidence man's line. Clearly, the perceptive viewer is instructed not to believe that what he sees in *Wanted, $2000 Reward* is true, because everything, or almost everything, is false; of course, if it is true that everything is false, then there must be some truth in the representation that behind the screen of falsehoods lurks something else, concealed within an average person's appearance. RROSE SÉLAVY is, after all, a well-known alias for the person also known as (a.k.a.) Marcel Duchamp, who therefore no more hides his true identity under an alias than did George Sand (illus. 21).

A small work with a heavy burden of significance and interpretation, *Wanted, $2000 Reward* reveals Marcel Duchamp at his most playful, creating a self-indulgent self-portrait in the form of an anti-portrait, a parody of portraiture itself. Duchamp has here visualized the distinction between the representation of specific human beings and their portraits despite the use of names, even aliases, that provide references to a presumed reality outside of themselves. Anyone who knew the artist would have been able to recognize him in this borrowed 'poster', for a portrait of Duchamp by any other name, like a rose, would implicitly remain the same. In the act of recognition, the viewer would have had to respond critically to Duchamp's serio-comic attack on the concept of objectivity and on the presumed value of personal names, while also acknowledging that despite all the verbal denials, the work portrayed the artist 'as he really was', with his customary alias, his distinctive physiognomy, and his pro-

vocative artistry. This ostensible anti-portrait takes the investigation of modern portraiture, and its defence, as a subtext. After all, in *Wanted, $2000 Reward* Duchamp has commented on the imprecision of the self's boundaries, on the potential, if not actual, interchangeability of human beings by category, and on the ultimate submergence of the self under the weight of labels. And yet, he also seems to admit a very human reluctance to accept, as fact, the irrelevance of one's individual existence, or its reduction to a mere cipher.

In the *Comédie humaine* Balzac created a character, Colonel Chabert, whose fictional life collapsed with the destruction of his identity: Chabert, an officer in Napoleon's army, was wounded and declared dead at the battle of Eylau in 1807, but he survived, suffered severe amnesia, and only months later returned to Paris, but could not reclaim his identity. As a 'dead man', he had officially ceased to exist and therefore could not bear the name Chabert, a name no longer available to him, although it once was his. Eventually, this not-Chabert became insane, ending his life as number 164, room 7, in an old people's home, a true nonentity.

The tragic separation of Chabert's name from his person had destroyed his identity, and with it his life, separating for ever the nominal sign from its still living, but no longer legitimate, referent.[56] Namelessness, however, is not an unfamiliar condition in the twentieth century; it is characteristic of the dispossessed everywhere, of the prisoner and of the concentration camp inhabitant. For the latter, there were numbers instead of names, numbers tattooed on the arm, numbers that symbolized dehumanization and the loss of anything but an actuarial identity. The lack of a name and of the name's reference makes the visual representation, or portrayal, of such a subject both futile and pointless. Indeed, before long, one may expect that instead of an artist's profile portrait the future will preserve only complete actuarial files, stored in some omniscient computer, ready to spew forth a different kind of personal profile, beginning with one's Social Security number. Then, and only then, will portraiture as a distinctive genre of art disappear.

References

Introduction

1 Hans-Georg Gadamer, *Truth and Method*, trans. G. Barden & J. Cumming (London, 1975), pp. 127–9.
2 Compare with the English philosopher A. J. Ayer's concept of personal identity that 'depends on the identity of the body, and that a person's ownership of states of consciousness consists in their standing in a special relation to the body by which he is identified', in *The Concept of the Person and Other Essays* (New York, 1963), p. 116. For a further discussion of these issues, see ch. III.
3 See P. Enkman and W. V. Friesen, *Unmasking the Face: A Guide to Recognizing Emotions from Facial Clues* (Englewood, NJ, 1975); G. Simmel, 'The Aesthetic Significance of the Face', in *Georg Simmel 1858–1919* (Columbus, Ohio, 1959), pp. 276–81. For further discussion of the importance of the face in portraiture, see esp. ch. II.
4 Quoted in R. Wittkower, *Bernini's Bust of Louis XIV* (London, 1951), p. 72.
5 For an excellent analysis of this phenomenon, see P. Fisher, 'Appearing and Disappearing in Public: Social Space in Late Nineteenth Century Literature and Culture', in S. Bercovitch, ed., *Reconstructing American Literary History* (Cambridge & London, 1986), pp. 155–86.
6 For important and, to me, vital contributions to the present philosophical discourse about the nature of identity, see D. Parfit, *Reasons and Persons* (Oxford, 1984), esp. pp. 199–347; T. Nagel, *The View from Nowhere* (New York, 1986), pp. 32–45, 54–66; C. Taylor, *Sources of the Self. The Making of Modern Identity* (Cambridge, Mass., 1989); R. F. Baumeister, *Identity, Cultural Change and the Struggle for Self* (New York/Oxford, 1986), esp. pp. 18–22, 198–203. See also ch. I.
7 For the impact of Hume's views on contemporary portraiture, see E. Wind, 'Hume and the Heroic Portrait', in *Hume and the Heroic Portrait. Studies in Eighteenth-Century Imagery* (Oxford, 1986), pp. 1–52 (orig. pub. 1932).
8 David Hume, 'Of Personal Identity', from *A Treatise of Human Nature* (1739), I.VI.
9 For a more complete discussion of the 'who' being represented and in 'what capacity', see chs. II and III.
10 The issue of truth and falsehood in art goes directly to the truth value of representation, seemingly a central one in portraits; for a discussion of the general issue, see M. Roskill & D. Carrier, *Truth and Falsehood in Visual Images* (Amherst, Mass., 1983); the point is also raised, if indirectly, by S. Koslow in 'Two Sources for Vincent Van Gogh's "Portrait of Armand Roulin": A Character Likeness and a Portrait Schema', *Arts Magazine* 56.1 (1981), pp. 156–63; see also chs. I and IV.
11 Quoted by G. Glueck, 'Revival of the Portrait', *New York Times* (6 Nov. 1983), p. 52.

12 For the conceptual basis of posited 'resemblances' in art, see J. A. W. Heffernan, 'Resemblance, Signification and Metaphor in the Visual Arts', *Journal of Aesthetics and Art Criticism* 44.2 (1985), pp. 167–80, and the analysis of 'likeness' in chs. I and II.

13 This issue is central to ch. IV.

14 Porphyry, *Life of Plotinus*, trans. S. MacKenna & B. S. Page, *The Enneads of Plotinus* 4th edn. (London, 1969).

15 See the discussion of the problems of attributed identification encountered in the so-called portraits of Brutus (illus. 17), the Pseudo-Seneca (illus. 13), and Homer (illus. 32).

16 Gadamer, *Truth and Method*, p. 131.

17 Plato, *Cratylus*, p. 432 b–d.

18 Most recently, and exhaustively, treated by D. Freedberg, *The Power of Images: Studies in the History and Theory of Response* (Chicago, 1989).

19 The Latin text in V. Golzio, *Raffaello nei documenti nelle testimonianze dei contemporanei*, 2nd edn. (London, 1971), p. 43; trans. J. P. Richter, *The Literary Works of Leonardo da Vinci*, 3rd edn. (London, 1970), vol. I, p. 56n; for a recent discussion of the painting, now in the Louvre, see L. Campbell, *Renaissance Portraits* (New Haven, Conn., 1990), p. 220, pls. 243, 244.

20 According to *The New York Times* (4 June 1990, C6), when the Naples soccer team won the national championship three years ago, some Neapolitans plastered photographs of dead relatives against their car windows, facing out to the street. 'Uncle or Cousin, they explained, would not have wanted to miss out on the fun.'

21 After W. J. T. Mitchell, *Iconology. Image, Text, Ideology* (Chicago, 1986), pp. 31–43.

22 For my earlier attempts to deal with this critical tradition, see 'On Portraits', *Zeitschrift für Ästhetik und allgemeine Kunstwissenschaft* 16.1 (1971), pp. 11–26; 'Portraits: The Limitations of Likeness', *Art Journal* 46.3 (1987), pp. 171–2; 'Portraits: A Recurrent Genre in World Art', in J. Borgatti and R. Brilliant, *Likeness and Beyond. Portraits from Africa and the World* (New York, 1990), pp. 11–27.

23 Plutarch's biography of Alexander the Great was written in the second century AD, trans. B. Perrin, Loeb Library edn. (Cambridge, Mass., 1919), vol. VII, pp. 224–5; for a relevant discussion of identity as a sum of characteristics that separate and distinguish one sign from another, see M. Foucault, *Les mots et les choses* (Paris, 1966), pp. 32–136.

1 *The Authority of the Likeness*

1 J.-P. Sartre, *The Psychology of Imagination* (New York, 1948), p. 30.

2 These issues have been extensively treated by M. Horowitz, *Image Formation and Cognition* (New York, 1970), pp. ix, 53–92.

3 See T. Ziolkowski, *Disenchanted Images: A Literary Iconology* (Princeton, NJ, 1977) on talking statues, pp. 18–77.

4 See W. J. T. Mitchell, *Iconology. Image, Text, Ideology* (Chicago, 1986), pp. 14–40, 'The Idea of Imagery'; M. Richard, *Propositional Attitudes. An Essay on Thoughts and How We Ascribe Them* (Cambridge, Mass., 1990), esp. pp. 78–105.

5 39 *Alabama* 1863 (June Term), pp. 193ff., 200; but compare with Gadamer's opposite opinion, discussed in the Introduction.

6 See E. H. Gombrich, *Art and Illusion*, 5th edn. (Oxford, 1977), pp. 122, 123.

7 On this structuring of data, see S. M. Kosslyn, *Image and Mind* (Cambridge, Mass., 1980), pp. 29ff., 91, 116ff.

8 Quoted by N. Annan, *The New York Review of Books* (29 May 1984), p. 4.

9 R. Scruton, *The Aesthetic Understanding: Essays in the Philosophy of Art and Culture* (London/New York, 1983), p. 11; for further discussion of the importance of proper names in portraiture, see ch. II.

10 For Cosimo's medal, see G. Pollard, *Renaissance Medals from the Samuel Kress Collection in the National Gallery of Art* (London, 1967), no. 245, an entry that also refers to this painting; on Botticelli as a portrait painter, see L. Campbell, *Renaissance Portraits* (New Haven, Conn., 1990), p. 12.

11 See M. Schapiro, *Words and Pictures* (The Hague, 1973), on the frontal 'I' and the profile 'he' or 'she', pp. 44ff.

12 After B. Chambers, *Old Money: American Trompe l'Oeil Images of Currency* (New York, 1988), pp. 40–42, fig. 15.

13 E.g. N. Bryson, *Looking at the Overlooked: Four Essays on Still Life Painting* (London, 1990).

14 A representative sample of work that bears on the general nature of portraiture would include the following: J. D. Breckenridge, *Likeness. A Conceptual History of Ancient Portraiture* (Evanston, Ill., 1968); Campbell, *Renaissance Portraits*; H. P. Chapman, *Rembrandt's Self-Portraits. A Study in Seventeenth-Century Identity* (Princeton, NJ, 1990); A. Dülberg, *Privatporträts. Geshichte und Ikonologie einer Gattung im 15. und 16. Jahrhundert* (Berlin, 1990); E. H. Gombrich, 'The Principles of Caricature', in E. Kris, *Psychoanalytic Explorations in Art* (New York, 1964), pp. 189–203; E. Hatfield & S. Sprecher, *Mirror, Mirror . . . The Importance of Looks in Everyday Life* (Albany, NY, 1986); M. Jenkins, *The State Portrait* (New York, 1947); I. Lohmann-Siems, *Begriff und Interpretation des Porträts in der kunstgeschichtlichen Literatur* (Hamburg, 1972); B. Maddow, *Faces. A Narrative History of the Portrait in Photography* (Boston, 1977); J. Pope-Hennessy, *The Portrait in the Renaissance* (New York, 1966); A. Reinle, *Das stellvertretende Bildnis. Plastiken und Gemälde von der Antike bis ins 19. Jahrhundert* (Zurich & Munich, 1984); A. Riegl, *Das holländische Gruppenporträt* (Vienna, 1931; 3rd edn., Darmstadt, 1964); W. Waetzoldt, *Die Kunst des Porträts* (Leipzig, 1908); the portrait issue of *Art in America* 63.1 (Jan.–Feb. 1975).

15 See ch. II and Manet's portrait of *Zola* (illus. 14), Man Ray's portrait of *Gertrude Stein* (illus. 72).

16 See G. Lukacs, *The Historical Novel* (London, 1962), p. 45.

17 See L. J. Budd, *Our Mark Twain. The Making of his Public Personality* (Philadelphia, 1983); G. Wills, *Reagan's America. Innocents at Home* (New York, 1987), pp. 150–55; and ch. III.

18 Waetzoldt, *Die Kunst des Porträts*, p. 1.

19 E. Buschor, *Das Porträt* (Munich, 1960), p. 7; cf. A. Dülberg, *Privatporträts*, pp. 25–98; Campbell, *Renaissance Portraits*, pp. 41–107.

20 See G. M. A. Hanfmann, 'Observations on Roman Portraiture', *Collections Latomus* 11 (1953), pp. 33ff., 39ff., and in general G. Boehm *Bildnis und Individuum. Über der Ursprung der Porträtmalerie in der italienischen Renaissance* (Munich, 1985).

21 Quotation from Pope-Hennessy, *The Portrait in the Renaissance*, Preface; see also C. Page, '"Delineated Lives": Themes and Variations in Seventeenth-Century Poems About Portraits', *Word & Image* 2.1 (1986), pp. 1–17, esp. 11ff.

22 From *The Remembrance of Things Past*, trans. C. K. Scott-Moncrieff (London, 1925), p. 23.

23 There are two versions of this portrait of Belley: one a painting in Versailles from the Salon of 1798 (no. 194), J.-F. Heim et al., *Les Salons de Peinture de la Révolution Française 1798–1799* (Paris, 1989), p. 126; the other a drawing in the Art Institute, Chicago, *Great Drawings from the Art Institute of Chicago: The Harold Joachim Years 1958–1983* (New York, 1985), no. 47; for Raynal's reputation, see J. C. Lavater, *Essays in*

Physiognomy, Designed to Promote the Knowledge and Love of Mankind
trans. from the Vienna edn. of 1775–8 by H. Hunter with engravings
by T. Holloway (London, 1789–92), vol. I, pp. 250ff.

24 Lavater, *Essays in Physiognomy*, vol. II, p. 240.

25 G. E. Rizzo, *Prassitele* (Rome, 1932), pp. 34ff., pls. LIII–LV; the
Romantic attitude towards the *Capitoline Satyr* is fully expressed in
Nathaniel Hawthorne, *The Magic Faun* (1860).

26 After C. Mauclair, *The Great French Painters* (London, 1903), p. 54.

27 Jonathan Richardson, *Essay on the Art of Criticism* (1719), published in
his *Works* (Strawberry Hill edn., 1792), p. 119; see R. Wendorf, *The
Elements of Life. Biography and Portrait-Painting in Stuart and Georgian
England* (Oxford, 1990), pp. 7, 135–50, and *passim*.

28 Gombrich, *Art and Illusion*, p. 88.

29 See John Updike's poem in the Introduction, and ch. II.

30 See P. Meller, 'Physiognomical Theory in Renaissance Heroic
Portraits', *Acts of the XX International Congress of the History of Art*
(Princeton, NJ, 1963), vol. II, pp. 53–69 and ch. II.

31 For further discussion of the mirror and the gaze, see ch. IV.

32 Gombrich, *Art and Illusion*, p. 90.

33 In *Lectures and Conversations on Aesthetics, Psychology, and Religious Belief*
(Oxford, 1966), p. 5.

34 See W. J. T. Mitchell's discussion of this problem in *Iconology*, in the
chapter entitled 'Nature and Convention. Gombrich's Illusions', pp.
75–94; also in the Introduction.

35 A more complete analysis of representation lies beyond the scope of
this book, although the manner of its application to the study of
portraiture permeates it. See also R. Bernheimer, *The Nature of
Representation* (New York, 1961), pp. 38–52, 66–87, 125–53; G.
Hermerén, *Representation and Meaning in the Visual Arts* (Lund, Sweden,
1969), pp. 24–54; M. Foucault, *This is Not a Pipe* (Berkeley, CA, 1982),
esp. pp. 43–52 on affirmation. See also the Introduction.

36 Louis Marin, 'Towards a Theory of Reading in the Visual Arts:
Poussin's *The Arcadian Shepherds*', in S. R. Suleiman & I. Crossman, eds.,
The Reader in the Text (Princeton, NJ, 1980), p. 306.

II *Fashioning the Self*

1 From *Twice-Told Tales and Other Short Stories* (1835). In 1850, while
sitting for his portrait, Hawthorne remarked, 'There is no such thing
as a true portrait. They are all delusions and I never saw any two alike'
in *American Notebooks* (1911 edn)., pp. 372–3; see T. Ziolkowski,
Disenchanted Images: A Literary Iconology (Princeton, NJ, 1977), pp. 118ff;
also Parmigianino's *Self-Portrait* (illus. 76) and ch. IV.

2 See R. G. Collingwood, *The Principles of Art* (New York, 1958), pp. 76ff.

3 W. Steiner, 'The Semiotics of a Genre: Portraiture in Literature and
Painting', *Semiotics* 21 (1977), pp. 111–19.

4 After Hobbes, *Leviathan*, I.iv.

5 Zelda, 'Each Man Has a Name', from *The Penguin Book of Hebrew Verse*
(Harmondsworth, 1981), ed. & trans. T. Carmi, p. 558.

6 See, later in this chapter, the discussion of portraits by Southworth &
Hawes (illus. 18), Daumier (illus. 19), Wunderlich (illus. 21), Dürer (illus.
28), Rubens (illus. 13), and Manet (illus. 14).

7 The relation between the name of an object and what it incorporates
has been investigated in a manner useful to this discussion by L.
Wittgenstein, *Tractatus Logico-Philosophicus* (1921), sec. 3, p. 3411, trans.
D. F. Pears & B. F. McGuinness (London 1961, 2nd edn., 1972), p.
33; see also Bertrand Russell's Introduction to the 1972 edition.

8 Warhol is well-known for his exploitation of common iconography in serial imagery; see B. H. D. Buchloh, 'Andy Warhol's One-Dimensional Art: 1956–1966', in K. McShine, ed., *Andy Warhol. A Retrospective* (New York, 1989), pp. 39–61.

9 For the status of proper names as 'rigid designators', see esp. S. A. Kripke, *Naming and Necessity* (Cambridge, 1972, rev. edn. 1980), pp. 3–15, 48–164; and commentaries on his idea by P. Ziff, 'About Proper Names', *Mind* 86 (1977), pp. 319–32; B. Harrison, 'Description and Identification', *Mind* 91 (1982), pp. 321–38.

10 Lillian Gilbreth (1878–1972) was a distinguished engineer, efficiency expert, industrial psychologist, and author, but few know it; see B. Sicherman & C. H. Green, eds., *Notable American Women. The Modern Period* (Cambridge, Mass., 1980), pp. 271–3.

11 See J. Fisher, 'Entitling', *Critical Inquiry* 11 (1984), pp. 286–98.

12 See K. Levy-van Halm & L. Abraham, 'Frans Hals, Militiaman and Painter: The Civic Guard Portrait as an Historical Document', in S. Slive, ed., *Frans Hals* (London, 1989), pp. 87–102, fig. 15; for further discussion of group portraits, see ch. III and ills. 35–42.

13 For the convoluted history of the *Capitoline Brutus*, see R. Brilliant, *Roman Art* (London, 1974), pp. 231, 232; note that the *Brutus* is set in a later bronze bust.

14 See the discussion of the 'Homer' in Rembrandt, *Aristotle Contemplating a Bust of Homer* (illus. 32) and of the Pseudo-Seneca in Rubens, *Four Philosophers* (illus. 13) later in this chapter.

15 *Siren Land* (Harmondsworth, 1948), pp. 66–8.

16 From Joseph Brosky, 'The Bust of Tiberius', published in *The New York Review of Books* (25 June 1987), p. 18.

17 *'The Spirit of Fact'. The Daguerrotypes of Southworth and Hawes, 1843–1862* (Boston, 1977), no. 17.

18 See R. Barthes, *Camera Lucida. Reflections on Photography* (trans. R. Howard, New York, 1981), pp. 10ff.

19 R. Scruton, 'Photography and Representation', *Critical Inquiry* 7 (1981), pp. 586–7.

20 *The Basic Problems of Philosophy* (Bloomington, Ind., 1982), p. 161; cf. Hawthorne's observation, quoted at the beginning of the chapter.

21 For the most complete exposition of the flexible nature of personal identity as a feature of existence, as a product of belief or disbelief, as a worthy or unworthy issue, as a mental, physical and/or psychological entity, or as a moral statement, see D. Parfit, *Reasons and Persons* (Oxford, 1984), pp. 199–347.

22 Daumier, 3316; J. Wechsler, *A Human Comedy. Physiognomy and Caricature in 19th Century Paris* (London, 1982), fig. 93 and pp. 132ff; compare with *Ike Regarding Ike* (illus. 78) in ch. IV.

23 Cf. Lavater's *Socrates* (illus. 28).

24 According to Jacques Lacan, the adult person cannot even have a full grasp of himself as a *real* being because the pronoun 'I' can never fully represent the enunciator but instead stands in for the ever-elusive subject. See Lacan, *The Four Fundamental Concepts of Psychoanalysis* (New York, 1978).

25 See the Introduction.

26 Shown in the Redfern Gallery, London, December 1983, and reproduced on the *Times Literary Supplement* (30 Dec 1983) cover. Compare with Peto, *Reminiscences of 1865* (illus. 4).

27 *Magritte Retrospective Loan Exhibition*, Oct.–Nov. 1973, Marlborough Fine Arts, London, p. 49, pl. 86.

28 From *Paul Klee* (exhibition cat., Marlborough Fine Arts, London, 1966), no. 45; see M. Plant, *Paul Klee. Figures and Faces* (London, 1978), ch.

2, 'The Mask Face', pp. 30ff.; for further discussion of masks in portraiture, see ch. III.

29 Plant, *Paul Klee*, p. 42.

30 From *The Man Without Qualities* (1930), trans. E. Wilkins & E. Kaiser (London, 1954).

31 K. Fittschen & P. Zanker, *Katalog der römischen Porträts in den Capitolinischen Museen* I (Mainz, 1985), no. 78, pls. 91–4.

32 See D. Smith, 'Arcimboldo: Fantasy and Symbolism', *Apollo* (March 1987), pp. 231–4, pl. xxv; T. DaCosta Kaufmann, *The School of Prague, Painting at the Court of Rudolph II* (Chicago, 1988), no. 2.22, pp. 171–2.

33 From *Le Charivari*, 17 January 1831 and 1 May 1835; see Wechsler, *A Human Comedy*, pp. 71ff., and figs. 45, 46; *idem*, 'The Issue of Caricature', *Art Journal* 43 (1985), pp. 317–84; E. Gombrich & E. Kris, *Caricature* (Harmondsworth, 1940).

34 Maurice Grosser, *The Painter's Eye* (New York, 1951), pp. 15, 16.

35 As observed by Porphyry, Plotinus' biographer, in his *Contra Christianos*, p. 76, trans. P. Cox, *Biography in Late Antiquity. A Quest for the Holy Man* (Berkeley, CA., 1983), p. 109.

36 For the portraits of Erasmus, see E. Treu, *Die Bildnisse des Erasmus von Rotterdam* (Basel, 1959); A. Hayum, 'Dürer's Portrait of Erasmus and the Ars Typographorum', *Renaissance Quarterly* 38 (1985), pp. 650–87; L. Campbell, *Renaissance Portraits* (New Haven, Conn., 1990), pp. 97, 103, 162, 164, 193, 210. See R. Wendorf, *The Elements of Life* (Oxford, 1990), pp. 71–2, on Quentin Matsys's Erasmus medal of 1519. For the concept of self-fashioning in the sixteenth century, see G. Greenblatt, *Renaissance Self-Fashioning from More to Shakespeare* (Chicago, 1980), esp. pp. 2–4.

37 R. Bernheimer, 'In Defense of Representation', in *Art: A Bryn Mawr Symposium* (Bryn Mawr Notes and Monographs IX, 1940), pp. 14, 15; see also the Introduction, and Man Ray's *Portrait of Gertrude Stein* (illus. 72), discussed in ch. IV.

38 See W. L. Strauss, *The Complete Drawings of Albrecht Dürer* (New York, 1974), vol. IV, p. 2305, on Dürer's personal knowledge of Melanchthon; G. F. Ravenal & J. A. Levinson, *Dürer in America* (Washington, DC, 1971), on the artist's endeavours to capture his intellectual and ascetic qualities, pp. 157–8.

39 The literature on physiognomics is enormous, but see E. C. Evans, *Physiognomics in the Ancient World* (Transactions of the American Philosophical Society, LIX.5, Philadelphia, 1969); H. Bruyères, *La Phrénologie, le geste et la physiognomie* (Paris, 1847); G. Tytler, *Physiognomy in the European Novel* (Princeton, NJ, 1982), esp. chs. I & II; E. H. Gombrich, 'The Mask and the Face: The Perception of Physiognomic Likeness in Life and Art', in M. Mandelbaum, ed., *Art, Perception and Reality* (Baltimore, 1972), pp. 1–46; see also M. Cowling, *The Artist as Anthropologist, The Representation of Type and Character in Victorian Art* (Cambridge, 1989), and the review by L. Jordanova in *Art History* 13.4 (1990), pp. 570–5.

40 J. C. Lavater, *Essays in Physiognomy, Designed to Promote the Knowledge and Love of Mankind*, translated from the Vienna edn. of 1775–8 by H. Hunter with engravings by T. Holloway (London, 1789–92); see also J. Graham, *Lavater's Essays on Physiognomy. A Study in the History of Ideas* (Bern, 1979).

41 From Lavater's *Physiognomie*, vol. I (Vienna, 1829), pl. 24; for the problem of Socrates' representations in antiquity, see G. M. A. Richter, *The Portraits of the Greeks* (London, 1965), vol. I, pp. 109ff; I. Scheibler et al., *Sokrates* (Munich, 1989). On Socrates' portraits and the

harmonizing of moral and physical beauty, see Lavater, *Essays in Physiognomy*, vol. I, pp. 166ff; the passage from Cicero's *de Oratore* trans. H. Rackham, in *Cicero*, Loeb Library edn., vol. II (Cambridge, Mass., 1942), p. 13.

42 Cicero, *de Oratore*, vol. III. iv, p. 15.

43 Lavater, *Essays in Physiognomy*, vol. I, pp. 171, 172.

44 See esp. W. Prinz, 'The *Four Philosophers* by Rubens and the Pseudo-Seneca in Seventeenth-Century Painting', *Art Bulletin* 55 (1973), pp. 410–28; J. L. Saunders, *Justus Lipsius. The Philosophy of Renaissance Stoicism* (New York, 1955), pp. 61ff.

45 Richter, *Portraits of the Greeks*, vol. I, pp. 58ff.; H. von Heintze, 'Pseudo-Seneca – Hesiod oder Ennius?', *Romische Mitteilungen* 82 (1975), pp. 143–63.

46 Lavater, *Essays in Physiognomy*, vol. III, p. 310.

47 See Kripke, *Naming and Necessity*, pp. 1–70, on the act of naming, the intentional reference made in naming, and the necessary connection between the name and the properties of the thing or person named.

48 J. Held, *Rembrandt's Aristotle and Other Rembrandt Studies* (Princeton, NJ, 1969), pp. 3–44; J. L. Koerner, 'Rembrandt and the Epiphany of the Face', RES 12 (1986), pp. 5–32, esp. pp. 23ff.; H. Perry Chapman, *Rembrandt's Self-Portraits* (Princeton, NJ, 1990), pp. 28, 31, 93.

49 Richter, *Portraits of the Greeks*, vol. I, pp. 45–56, figs. 1–108.

50 From *The Picture of Dorian Gray* (London, 1891), ch. 1.

51 R. Shiff, *New Literary History* 15 (1984), p. 351; see esp. T. Reff, 'Manet's Portrait of Zola', *Burlington Magazine* 117.862 (1975), pp. 35–44; F. Cachin et al., *Manet 1832–1883* (New York, 1970), no. 106; see also the discussion of Matisse, *The Painter and his Model* (illus. 61) in ch. IV.

52 For the conception of the creative work as an (auto)biographical sign, see P. Jay, *Being in the Text. Self-Representation from Wordsworth to Roland Barthes* (Ithaca, NY, 1984), esp. pp. 21–38.

53 G. W. F. Hegel, *On Art, Religion, Philosophy* (New York, 1970), pp. 57, 58.

54 Sotheby-Parke Bernet auction catalogue, *19th Century European Painting* (New York, 4 June 1975), no. 202; Vibert was active from the 1860s to the end of the nineteenth century.

55 N. Penny, ed., *Reynolds* (London, 1986), no. 151; the original is in the Henry Huntington Art Gallery, San Marino, the replica in Dulwich Picture Gallery. Sparshott, '"As", or the Limits of Metaphor', *New Literary History* 6 (1974), pp. 75–94, passage quoted on p. 94; see also J. Weinsheimer, 'Mrs Siddons, The Tragic Muse, and the Problem of *As*', *Journal of Aesthetics and Art Criticism* 36 (1978), pp. 317–28.

56 *The Graphic Work of M. C. Escher*, trans. J. E. Brigham (New York, 1960), p. 18, pl. 51.

57 M. Merleau-Ponty, 'What is Phenomenology', reprinted in *European Literary Theory and Practice*, ed. V. W. Gras (New York, 1973), p. 75.

III *Fabricated Identities: Placements*

1 In the essay 'Portraits of Meditation or Likeness' that accompanies the catalogue, *Portraits. Richard Avedon* (New York, 1976).

2 Compare with Argan's statement, 'The iconology of a portrait is the pose, the dress, the social or psychological meaning which can be attributed to the figure', in *Critical Inquiry* 2 (1975), p. 301.

3 R. Strong, *Hans Eworth. A Tudor Artist and his Circle* (Leicester, 1965), no. 43, pl. 43.

4 See, e.g., L. Stone, *The Family, Sex and Marriage in England 1500–1800* (New York & London, 1977), pp. 85ff, 105ff, 159ff; S. Schama, 'The

Domestication of Majesty: Royal Family Portraiture 1500–1850', *Journal of Interdisciplinary History* 17 (1986), pp. 155–83; D. O. Hughes, 'Representing the Family: Portraits and Purposes in Early Modern Italy', *ibid.*, pp. 7–38. The family group portrait is a major subject in itself.

5 *New York Times* (11 Aug. 1987), C1, p. 6; cf. the grave altar of *Diotimus and Brittia* (illus. 56).

6 See D. R. Smith, 'Irony and Civility: Notes on the Convergence of Genre and Portraiture in Seventeenth-Century Dutch Painting', *Art Bulletin* 69 (1987), pp. 407–30; and the classic study by A. Riegl, *Das hollandische Gruppenporträt* (Vienna, 1931, orig. pub. 1901).

7 R. Calvocoressi et al., *Oskar Kokoschka 1886–1980* (New York, 1986), no. 10; K. Varnedoe, *Vienna 1900* (New York, 1986), pp. 166ff., fig. p. 167; but see Norbert Lynton's trenchant observation in the *Times Literary Supplement* (3 Oct. 1986), p. 1086, that Kokoschka wrote to his mother complaining about Tietze's 'boring head'.

8 See the discussion of Picasso's and Man Ray's 'Gertrude Stein' (illus. 72) in ch. IV.

9 See R. Brilliant, 'Intellectual Giants: A Classical Topos and the *School of Athens*', *Source* III.4 (1984), pp. 1–12.

10 E. Lucie-Smith, *Henri Fantin-Latour* (New York, 1977), pp. 27–30, pl. 21.

11 After L. Althusser, 'Ideology and Ideological State Apparatuses', in *Lenin and Philosophy, and Other Essays*, trans. B. Brewster (New York, 1971), pp. 127–86, esp. pp. 158–76 (essay originally published in *La Pensée*, 1970).

12 See esp. M. Praz, *Conversation Pieces: A Survey of the Informal Group Portrait in Europe and America* (College Park, Pa., 1971); R. Edwards, *Early Conversation Pictures from the Middle Ages to about 1730 – A Study in Origins* (London, 1954).

13 R. Paulson, *Hogarth: His Life, Art and Times* (New Haven, Conn., 1971), vol. I, pp. 196ff., 458, pl. 177; J. Campbell, 'Politics and sexuality in portraits of John, Lord Hervey', *Word & Image* 6.4 (1990), pp. 281–97.

14 See M. Fried, *Realism, Writing, Disfiguration* (Chicago, 1987), pp. 1–89, analysing Thomas Eakins' *Gross Clinic* (1875). See also ch. IV on the matter of gaze and the spectator's entry.

15 F. Cochin et al., *Manet 1832–1883* (New York, 1970), pp. 280–86.

16 How much more can be done to characterize the intellectual achievements of a great poet is evident in Tischbein's admiring portrait of *Goethe in the Campagna* (illus. 54), discussed below.

17 W. Grohmann, *Paul Klee* (London, 1967), p. 96; C. Geelhaar, *Paul Klee and the Bauhaus* (Geneva, 1973), no. 56, pp. 85, 86; Sotheby's *Impressionist and Modern Painting and Sculpture*, sale cat., London, 28 Nov. 1989, no. 67.

18 According to Henry Mee, portraitist of the Queen in 1982, quoted in *The Economist*, 19 May 1990, p. 107.

19 See esp. L. Marin, *Portrait of the King* (Minneapolis, 1988), pp. 169–214; F. A. Yates, *Astraea. The Imperial Theme in the Sixteenth Century* (London, 1975), pp. 29ff., 215ff.; in general, R. Strong, *Gloriana: The Portraits of Queen Elizabeth I* (London, 1987).

20 R. Strong, *Portraits of Queen Elizabeth* (London, 1963), engraving 23; F. Yates, *Astraea* 58, pl. 6b.

21 See, e.g., the portraits of *Fred Perry*, tennis player (illus. 59), and *Jackie Kennedy* (illus. 60) discussed later in this chapter.

22 See B. Erkkila, 'Greta Garbo: Sailing Beyond the Frame', *Critical Inquiry* 11 (1985), pp. 595–619, esp. 613ff.; L. Braudy, 'Film Acting: Some Critical Problems and Proposals', *Quarterly Review of Film Studies*

(Winter 1976), pp. 1–18, on the interpenetration of role and star; see also the discussion of *Mae West* (illus. 62) and *Gloria Swanson* (illus. 74) in ch. IV.

23 See R. S. Wyer & L. L. Martin, 'Person Memory: The Role of Traits, Group Stereotypes, and Specific Behaviors in the Cognitive Representation of Persons', *Journal of Personality and Social Psychology* 50 (1986), pp. 661–75; also the Introduction.

24 See ch. I for an analysis of this portrait.

25 On such biographical placements, see R. Wendorf, 'UT PICTURA BIOGRAPHIA', in R. Wendorf, ed., *Articulate Images* (Minneapolis, 1983), pp. 112–20.

26 For a valuable discussion of ethnic portraiture and its problems, see B. Smith, 'Captain Cook's Artists and the Portrayal of Pacific Peoples', *Art History* 7 (1984), pp. 295–312.

27 F. W. Goetzmann et al., *Karl Bodmer's America* (Lincoln, NE, 1985); the McKenney and Hall began publication in Philadelphia in 1836.

28 L. Campbell, *Renaissance Portraits* (New Haven, Conn., 1990), pp. 132, 133, fig. 157.

29 See the Introduction and ch. II.

30 See S. Brennen, 'Caricature Generator: The Dynamic Exaggeration of Faces by Computer', *Leonardo* 18.3 (1985), pp. 170–78; N. McWilliam, 'Making Faces', *Art History* 7 (1984), pp. 115–19.

31 See A. Baddeley, *Your Memory: A User's Guide* (London & New York, 1982), pp. 124–33; D. Tranel & A. R. Damasio, 'Knowledge without Awareness: An Automatic Index of Facial Recognition by Prosopagnosics,' *Science* 228 (21 June 1985), pp. 1453–4; A. J. Goldstein et al., 'Identification of Human Faces', *Proceedings of the IEEE* 59.5 (1971), pp. 748–60; and the Introduction.

32 S. MacDonald, '"Wanted" Art: Meet a Man Who Draws Shady Characters', *The Wall Street Journal* (2 Aug. 1984), p. 1; M. Grosser, *The Painter's Eye* (New York, 1951), pp. 28, 29.

33 Quoted by Grace Glueck, 'Giacometti and Sitter', *New York Times* (27 June 1980), taken from J. Lord, *A Giacometti Portrait* (New York, 1964); for real 'mug shots', see H. Korell, 'Portraits im Auge des Gesetzes', *Kritische Berichte* 12 (1984), pp. 43–9; cf. M. Duchamp, *Wanted, $2000 Reward* (illus. 85) and ch. IV.

34 Grosser, *The Painter's Eye*, p. 26.

35 See R. B. Zajonc, 'Emotions and Facial Efference: A Theory Reclaimed', *Science* 228 (5 April 1985), pp. 15–21; P. Enkman et al., 'Automatic Nervous System Activity Distinguishes among Emotions', *Science* 221 (16 Sept. 1983), pp. 1208–10; J. McDermott, 'Face to Face: it's the expression that bears the message', *Smithsonian* 16.12 (1986), pp. 112–23.

36 In *The Face of Another* (New York, 1966), p. 100.

37 See P. Enkman et al., 'Facial Affect Scoring Technique: A First Validity Study', *Semiotica* 3 (1971), pp. 37–58; H. L. Wagner et al., 'Communication of Individual Emotions by Spontaneous Facial Expression, *Journal of Personality and Social Psychology* 50 (1986), pp. 737–43.

38 After L. Wittgenstein, *Tractatus Logico-Philosophicus*, (1921), sec. 3. 3411 and the earlier discussion in ch. II; also G. Deleuze & F. Guattari, *A Thousand Plateaus* (Minniapolis, 1987) on 'faciality', pp. 167–70.

39 B. L. Ogibenin, 'Mask in the Light of Semiotics – A Functional Approach', *Semiotica* 13 (1975), pp. 1–9, quotation pp. 1, 2.

40 See A. D. Napier, *Masks, Transformation and Paradox* (Berkeley, CA., 1986), esp. p. xxiii (on impersonation) and pp. 1–29, the title essay.

41 From the *Notebooks of Malte Laurids Brigge* (1904–10), trans. S. Mitchell,

Selected Poetry of Rainer Maria Rilke (New York, 1984), p. 93; see T. Ziolkowski, *Disenchanted Images* (Princeton, NJ, 1977), pp. 198–201, on Rilke's *Notebooks* as a symbol of impenetrability.

42 See Deleuze & Guattari, *A Thousand Plateaus*, on 'faciality', pp. 167–91, esp. pp. 167–70; E. H. Gombrich, 'The Mask and the Face', in M. Mandelbaum, ed., *Art, Perception and Reality* (Baltimore, 1972), pp. 1–46, esp. pp. 14ff., and ch. IV.

43 See G. Scharf, *On the Principal Portraits of Shakespeare* (London, 1864); M. H. Spielmann, 'Shakespeare's Portraiture', in I. Gollancz, ed., *Studies in the First Folio* (London, 1924).

44 Exemplified by Charles Perrault's *Les Hommes Illustrés*, and esp. in the portraits in his *Parallèles des Anciens et des Modernes* (1688–92).

45 See K. Schefold, *Die Bildnisse der antiken Dichter, Redner und Denker* (Basel, 1943).

46 For the double herm, see J. Marcadé, 'Hermes doubles', *Bulletin des correspondences helléniques* 76 (1952), pp. 596ff. This pairing is the basis of Plutarch's *Lives*.

47 E.g., Manet's *Zola* (illus. 14), Phillips' *Portrait of Byron* (illus. 44), Fantin-Latour's *L'Atelier* (illus. 41), all discussed in ch. II.

48 J. F. Moffitt, 'The Poet and the Painter: J. H. W. Tischbein's "Perfect Portrait" of Goethe in the Campagna (1786–87)', *Art Bulletin* 65.3 (1983), pp. 440–55; perhaps Goethe most consciously reveals, even fashions, himself in *Conversations with Eckermann* (1824), as being second only to Shakespeare. The relief at the right in the painting refers to Goethe's revision of Euripides, *Iphigenia in Aulis*.

49 See C. J. Rzepka's discussion of 'visionary solipsism' in *The Self as Mind. Vision and Identity in Wordsworth, Coleridge, and Keats* (Cambridge, Mass., 1986), pp. 1–30, esp. pp. 24, 25; in this context, note Manet's *Zola* (illus. 14).

50 For the effect of headlessness or head-displacement, see the Roman statue in Cyprus (illus. 20) and Wunderlich's *George Sand* (illus. 21); also ch. II.

51 See (if you wish) Dante's death-mask in the Palazzo Vecchio in Florence, and F. J. Mather, jun., *The Portraits of Dante compared with the Measurements of his Skull and Reclassified* (Princeton, NJ, 1921); on the truth value of the death-mask, M. Roskill & D. Carrier, *Truth and Falsehood in Visual Images* (Amherst, Mass., 1983), pp. 72, 73.

52 Quoted by W. S. Heckscher in 'Reflection on Seeing Holbein's Portrait of Erasmus at Longford Castle', in *Essays in the History of Art Presented to Rudolph Wittkower* (London, 1967), pp. 144, 145.

53 H. Zaloscer, *Porträts aus dem Wüsten Sand* (Vienna, 1961); J.-E. Beyer, *Portraits romains et grecs du Fayoum* (Neuchâtel, 1976).

54 See J. Burckhardt, 'Das Portrait in der italienischen Malerei', *Beitrage zur Kunstgeschichte von Italien* 2nd edn., (Berlin, 1911), pp. 163–337; L. Sheptzoff, *Man or Superman? The Italian Portrait in the Fifteenth Century* (Jerusalem, 1978); G. Boehm, *Bildnis und Individuum* (Munich, 1986).

55 See T. E. Mommsen, 'Petrarch and the Decoration of the Sala Virorum Illustrium in Padua', *Art Bulletin* 34 (1952), pp. 95–116.

56 R. Hatfield, 'Five Early Renaissance Portraits', *Art Bulletin* 47 (1965), pp. 315–34, esp. pp. 321–9; J. Mazzeo, 'Castiglione's Courtier: The Self as a Work of Art', ch. 3 in his *Renaissance and Revolution* (New York, 1965).

57 H. W. Janson, *The Sculpture of Donatello* (Princeton, NJ, 1957), pp. 56ff.; A. F. Moskowitz, 'Donatello's Reliquary Bust of Saint Rossore', *Art Bulletin* 63 (1981), pp. 41–8; in general, I. Lavin, 'On the Sources and Meaning of the Renaissance Portrait Bust', *Art Quarterly* 33 (1970), pp. 207ff., 212.

58 J. Schuyler, *Florentine Busts: Sculpted Portraiture in the Fifteenth Century* (New York, 1976), pp. 114–45, in favour of the attribution to Donatello; Janson, *Sculpture of Donatello*, pp. 237–40, against.

59 Claudio Tolomei, *Delle Lettere* (Venice, 1549), pp. 95ff., trans. E. H. Ramsden in *'Come, Take this Lute': A Quest for Identities in Italian Renaissance Portraiture* (Salisbury, 1983), pp. 67, 68; see also B. K. Debs, 'From Eternity to Here: Uses of the Renaissance Portrait', *Art in America* (Jan.–Feb. 1975), pp. 48–55.

60 *The Philosophy of Art*, ed. D. W. Stoot (Minneapolis, 1989), p. 146.

61 *New York Times*, 5 July 1985.

62 C. Ratcliff, *Warhol* (New York, 1965), fig. 43; K. McShine, *Andy Warhol Retrospective* (New York, 1989), figs. 241–6.

63 H. H. Arneson, *Sculpture by Houdon* (Worcester, Mass., 1964), pp. 54–62; C. C. Sellars, *Benjamin Franklin in Portraiture* (New Haven, Conn., 1962), pp. 304ff.; John Updike, 'Many Bens', *The New Yorker* (22 Feb. 1988), pp. 105–16. On biographical portraits, see R. Wendorf, *The Elements of Life* (Oxford, 1990), pp. 22–64, 136–69, 189–226.

64 H. von Erffa & A. Staley, *The Paintings of Benjamin West* (New Haven, Conn., 1986), no. 618.

65 E. M. Forster, *Aspects of the Novel* (Cambridge, 1927), p. 103.

IV *'Here's Looking at You!'*

1 London, 1824, vol. 1, pp. 142, 143.

2 C. Eisler, '"Every Artist Paints Himself": Art History as Biography and Autobiography', *Social Research* 54.1 (1987), pp. 74–99.

3 A. H. Barr, jun., *Matisse, His Art and his Public* (New York, 1951), pp. 191, 413; L. Aragon, *Henri Matisse, roman* (Paris, 1971), vol. I. pp. 87ff. On the role of the painting within the painting, and the model, see M. Roskill, 'On the Recognition and Identification of Objects in Paintings', *Critical Inquiry* 3 (1977), pp. 677–707, esp. pp. 684ff.; on this painting, see R. Shiff, 'Representation, Copying, and the Technique of Originality', *New Literary History* 15 (1984), pp. 344–8; cf. Manet's *Portrait of Zola* (illus. 14), and ch. II.

4 The implications of this dual vision have been explored by T. Nagel, *The View from Nowhere* (Oxford, 1987); see also M. Fried, 'The Beholder in Courbet: His Early Self-Portraits and their Place in his Art', *Glyph* 4 (1978), pp. 85–129, esp. pp. 111ff.

5 Cf. C. Armstrong, 'Reflections on the Mirror: Painting, Photography, and the Self-Portraits of Edgar Degas', *Representations* 22 (1988), pp. 108–41, for another view of the artist's fragmentation of the self.

6 See D. Posner, 'A Picture of Painting in Poussin's Self-Portrait', in D. Fraser & M. Lewine, eds., *Essays in Art Presented to Rudolf Wittkower* (London, 1967), pp. 200–203.

7 J. Bialostocki, 'Begegnung mit dem Ich in der Kunst', *Artibus et historiae* 1 (1980), pp. 25–45.

8 As brilliantly analysed by A. Wilden, *System and Structure: Essays in Communication and Exchange*, 2nd edn. (London, 1980), pp. 88–109; also G. Craig & M. McGowan, eds., *Moy Qui Me Voy. The Writer and the Self from Montaigne to Leiris* (Oxford, 1990).

9 In general, see E. Goffman, *The Presentation of the Self in Everyday Life* (Garden City, New York, 1959).

10 See L. A. Sass, 'The Self and its Vicissitudes: An "Archaeological" Study of the Psychoanalytic Avant-Garde', *Social Research* 55 (1988), pp. 551–607.

11 See D. C. Dennett, 'Why everyone is a novelist', *Times Literary*

Supplement (16–22 Dec. 1988), pp. 1016, 1028–9, on the concept of the self and the fictional unity of 'normal' life.

12 For recent contributions to this hot debate, see K. V. Wilkes, *Real People: Personal Identity without Thought Experiments* (Oxford, 1988); J. Gover, *The Philosophy and Psychology of Personal Identity* (New York, 1988); H. W. Noonan, *Personal Identity* (London, 1989); and ch. II.

13 David Hume, *A Treatise of Human Nature* (1739), I.IV, sec. 6.

14 See R. Carline, A. Causey & K. Ball, *Stanley Spencer* RA (London, 1980), no. 23, the 1914 portrait in the Tate; no. 169, the 1936 portrait in the Stedlijk Museum, Amsterdam; and no. 280, the 1959 portrait in the Tate, note that J. Bratby, *Stanley Spencer's Early Self-Portrait* (London, 1969) dates the first portrait to 1912–13.

15 In this regard Spencer is much like Max Beckmann, if less aggressive; see F. Ergel, *Max Beckmann. Lebem im Werk. Die Selbst bildnisse* (Berlin, 1985).

16 From the *Journal of Soren Kierkegaard*, trans. & ed. A. Dru (London, 1938); the epigraph of R. Wollheim, *The Thread of Life* (Cambridge, Mass., 1984), esp. pp. 97–196.

17 See D. Arasse, '"La prudence" de Titien. Ou l'autoportrait glissé à la rive de la figure', *Corps écrit* 5 (1983), pp. 109–15; L. Marin, 'Variations sur un portrait absent; les autoportraits de Poussin 1649–1650', *Corps écrit* 5 (1983), pp. 87–107.

18 Stieglitz's photographic portraits of Georgia O'Keefe over three decades, beginning in 1918, constitute such a connection between the charged gaze of the photographer-lover and the object of his passion.

19 Quoted in 'A Short History of Photography', *Screen* 13 (Spring 1972), p. 7.

20 See W. Steiner, *Exact Resemblance to Exact Resemblance: The Literary Portraiture of Gertrude Stein* (New Haven, Conn., 1978), esp. pp. 64–130, 161–205.

21 Cf. Marsden Hartley's emblematic *One Portrait of One Woman* (1916) in the University Art Museum, Univ. of Minnesota, Minneapolis, presumed to be a portrait of Gertrude Stein and bearing the inscription, 'MOI'; B. Haskell, *Marsden Hartley* (New York, 1980), pp. 52–3, pl. 23, no. 43.

22 E. Erikson, 'The Problem of Ego Identity', *Journal of the American Psychoanalytic Association* 4 (1956), pp. 56–121.

23 See R. Krauss, 'Seeing as Believing', *Raritan* 2.2 (1982), pp. 75–86.

24 W. Rubin, *Picasso and Braque Pioneering Cubism* (New York, 1989), pp. 21ff., 181, 369; M. Roskill, 'On the Recognition and Identification of Objects in Paintings', *Critical Inquiry* 3 (1977), pp. 687ff.; and M. Baxandall, *Patterns of Intention: On the Historical Explanation of Pictures* (New Haven, Conn., 1985), pp. 41–73.

25 *Salvador Dali, Retrospective 1920–1980* (Paris, 1979), p. 274, fig. 208; R. Cohen, 'Star Quality', *Portfolio* (Sept.–Oct. 1983), pp. 80–87; for the significance of visual agnosia, see O. Sachs, *The Man Who Mistook his Wife for a Hat* (New York, 1985), the title essay; A. Kertesz, 'Visual Agnosia,' *Cortex* 15 (1979), pp. 403–19, on the separation of the familiar name from the familiar image.

26 See, e.g., J. Kobol, *The Art of the Great Hollywood Portrait Photographers 1925–1940* (New York, 1980).

27 In *The Play of the Eyes*, trans. R. Mannheim (New York, 1986), reprinted in *The New Yorker* (7 April 1986), pp. 43ff.

28 See *The Philosophy of Peirce. Selected Writings* 7. 'Logic as Semiotic: The Theory of Signs', ed. J. Buchler (New York/London, 1940), pp. 98–119, esp. pp. 104–8.

29 M. L. Borraš, *Picabia* (Barcelona/New York, 1985), fig. 313, cat. no. 191, pp. 175, 153ff., on the universe as machine; see also W. Bohn, 'Picabia's "Mechanical Expression" and the Demise of the Object", *Art Bulletin* 67 (1985), pp. 673–7.

30 See W. Bohn, *Apollinaire et l'homme sans visage: création et évolution d'un motif moderne* (Paris, 1984).

31 See n. 23 above.

32 C. J. Rezepka, *The Self as Mind. Vision and Identity in Wordsworth, Coleridge and Keats* (Cambridge, Mass., 1986), p. 24.

33 William Wordsworth, *The Prelude* [1850], VII, ed. Ernest de Selincourt (Oxford, 1926), lines 637–46.

34 J. Russell, *Francis Bacon* (Greenwich, Conn., 1971), pp. 131ff., 162ff.; J. Keates & G. Deleuze, 'Portraits in Extremis', FMR 12 (1985), pp. 45–60.

35 S. Freedberg, *Parmigianino* (Cambridge, Mass., 1950), pp. 104ff., 202; G. Boehm, *Bildnis und Individuum* (Munich, 1985), pp. 240ff.

36 G. Vasari, *Lives of the Painters*, vol. V, pp. 221–2, trans. G. du C. de Vere (New York, 1979), pp. 1139, 1140.

37 John Ashbery, *Self-Portrait in a Convex Mirror* (New York, 1975), pp. 68–83; see R. Stamelman, 'Critical Reflections: Poetry and Art Criticism in Ashbery's "Self-Portrait in a Convex Mirror"', *New Literary History* 15 (1984), pp. 607–30.

38 T. S. Buechner, *Norman Rockwell. A Sixty-Year Perspective* (New York, 1972), p. 111; see P. Lejeune, 'Regarder un autoportrait', *Corps écrit* 5 (1983), pp. 135–46.

39 See esp. the critical discussion of Rockwell's self-portrait in P. Lejeune, *On Autobiography*, trans. K. Leary (Minneapolis, 1989), pp. 108–18; cf. Poussin's *Self-Portrait* (illus. 67) and Escher's *Hand with Reflecting Sphere* (illus. 35).

40 See M. Mathiot, 'Toward a Frame of Reference for the Analysis of Face-to-Face Interaction', *Semiotica* 24 (1978), pp. 199–220; consider also Fred Perry's Wimbledon portrait (illus. 59) and his response.

41 D. Hockney, *David Hockney* (London, 1976), p. 294, fig. 414.

42 G. van der Osten, *Lovis Corinth* (Munich, 1955), p. 167, dated 5 July 1925, and for Corinth's self-portraits in general, see H. Uhr, *Lovis Corinth* (Berkeley, CA, 1990), pp. 54ff., 93ff., 158ff, 299, 300, pl. 40.

43 M. Levey, *The Late Italian Pictures in the Collection of Her Majesty the Queen* (Greenwich, Conn., 1964), p. 82; M. D. Garrad, 'Artemesia Gentileschi's Self-Portrait as the Allegory of Painting', *Art Bulletin*, 62 (1980), pp. 97–112; idem, *Artemesia Gentileschi. The Image of the Female Hero in Italian Baroque Art* (Princeton, NJ, 1989), pp. 84–8, 174–8, 337–9, pls. 14, 15.

44 The gestural language of Franz Kline, Pollock, De Kooning and other New York Action Painters in the 1950s and 1960s made that action visible.

45 Sold at Sotheby's, London, 29 June 1983; see P. Schmidt, *Otto Dix im Selbstbildnis* (Berlin, 1978), pp. 90ff., fig. 15.

46 See the discussion of Gadamer in the Introduction.

47 O. Bihalzi-Merin, *Francisco Goya Caprichos: Their Hidden Truth* (New York, 1981), p. 180, pl. I.

48 L. Bantel et al., *William Rush. American Sculptor* (Philadelphia, 1982), pp. 165–6, no. 90.

49 L. Taft, *The History of American Sculpture* (New York, 1903), p. 23.

50 C. Geertz, *Local Knowledge* (New York, 1983), p. 59; and see L. A. Sass, 'Introspection, Schizophrenia, and the Fragmentary Self', *Representations* 19 (1987), pp. 1–34; for a superb statement of the older view of the 'central nucleus of the self', see William James, 'The

Consciousness of Self', in *The Principles of Psychology*, vol. I (New York, 1890), pp. 291–401.

51 See M. C. Taylor, 'The Disappearing Self', *Notebooks in Cultural Analysis* 1 (1984), pp. 125–42.

52 The original 19½″ × 14″ poster belonged to Mrs Louise Hellstrom and is now unlocated; illus. 85 reproduces the smaller replica made by Duchamp for insertion in his *Box in a Valise*; for the complicated story of this work, see A. Schwarz, *The Complete Works of Marcel Duchamp* (New York, 1969), p. 489, no. 278, and p. 511, no. 311; also A. D'Harnoncourt & K. McShine, *Marcel Duchamp* (New York, 1973), p. 297, no. 144.

53 Cf. illus. 9, the United States Immigration form.

54 Long appreciated by Paul Klee, *A New Face* (illus. 23); see M. Plant, *Paul Klee. Figures and Faces* (London, 1978), pp. 30ff.

55 See A. Fabian, *Card Sharps, Dream Books & Bucket Shops, Gambling in 19th-Century America* (Ithaca, NY, 1990).

56 See S. Petrey, 'The Reality of Representation: Between Marx and Balzac', *Critical Inquiry* 14 (1988), pp. 448–68, on the ideological implications of Chabert's life.

List of Illustrations

44 Thomas Phillips, *George Gordon, 6th Lord Byron*, 1813, oil. National Portrait Gallery, London.

45 Crispin van de Passe (attrib.), *Elizabeth I of England*, 1596, engraving (photo: Warburg Institute).

46 Benjamin West, *Colonel Guy Johnson*, 1776, oil sketch. National Gallery of Art, Washington, D. C., Andrew W. Mellon Collection.

47 Jean Auguste Dominique Ingres, *Princess de Broglie*, 1853, oil. Metropolitan Museum of Art, New York.

48 Clarence John Laughlin, *The Masks Grow to Us*, 1947, photograph.

49 Inge Morath, *Portrait of Artist-Celebrities Wearing their Own Masks*, 1961, photograph, (masks by Saul Steinberg). (Photo: Magnum Photos).

50 Paul Klee, *Die Sängerin L. als Fiordiligi*, c. 1923–39, watercolours and mixed media. Wanibuchi Collection, Tokyo.

51 Hans Mielich, *Ladislaus of Fraunberg, Count of Haag*, 1557. The Collections of the Prince of Liechtenstein.

52 Martin Droeshout, *William Shakespeare*, from the First Folio of Shakespeare's *Works*, 1623.

53 *Aristophanes/Terence*, Roman double herm, 1st cent AD. National Museum, Naples.

54 J. H. W. Tischbein, *Goethe in the Campagna*, 1786–87, oil. Städelsches Galerie, Frankfurt-am-Main.

55 *Autoicon of Jeremy Bentham*, 1832, natural materials, wax and textiles. University College, London.

56 *Grave Altar of Tullius Diotimus and Brittia*, c. AD 100. Borghese Gardens, Rome.

57 Donatello, *San Rossore*, 1422–7, silver reliquary bust. National Museum of San Mateo, Pisa.

58 Donatello(?), *Niccolò da Uzzano*, mid-15th century, terra-cotta. Museo Nazionale del Bargello, Florence.

59 David Wynne, *Fred Perry*, 1985. All-England Lawn Tennis and Croquet Club, Wimbledon.

60 Andy Warhol, *Sixteen Jackies*, 1964, acrylic and silkscreen. Walker Art Center, Minneapolis.

61 Henri Matisse, *The Painter and his Model*, 1917, oil. Musée Nationale d'Art Moderne, Paris.

62 Salvador Dali, *Mae West*, 1933–35, gouache on paper. Art Institute of Chicago, Gift of Mrs Gilbert W. Chapman in memory of Charles B. Godspeed.

63 Andy Warhol, *#204 Marilyn Diptych*, 1962, acrylic and silkscreen. Tate Gallery, London.

64 Jean-Antoine Houdon, *Benjamin Franklin*, 1778, tinted plaster sculpture. Toledo Art Museum, Gift of Mr and Mrs Roy Rike.

65 Benjamin West, *Benjamin Franklin Drawing Electricity from the Sky*, 1801, oil. Philadelphia Museum of Art.

66 Charles Addams, cartoon from *The New Yorker*, 7 July 1986. © 1986 The New Yorker Magazine, Inc.

67 Nicolas Poussin, *Self-Portrait*, oil, 1650. Musée du Louvre, Paris.

68 Jim Stevenson, *'Hi. I'm Larry Hoskins as portrayed by me'*, cartoon from *The New Yorker*, 14 May, 1983. © 1983 The New Yorker Magazine, Inc.

69, 70, 71 Stanley Spencer, *Self-Portrait*, 1914. Tate Gallery, London; *Self-Portrait*, 1936. Stedelijk Museum, Amsterdam; *Self-Portrait*, 1959. Tate Gallery, London; all oils.

72 Man Ray, *Gertrude Stein Sitting in Front of Picasso's Portrait of Her*, 1922, photograph.

73 Pablo Picasso, *Portrait of Daniel-Henry Kahnweiler*, 1910, oil. The Art Institute, of Chicago, Gift of Mrs Gilbert W. Chapman in memory of Charles B. Goodspeed.

74 Edward Steichen, *Gloria Swanson*, 1924, photograph. © Sotheby's, Inc.

75 Francis Picabia, *Portrait of Marie Laurencin*, 1917

76 Parmigianino, *Self-Portrait in a Convex Mirror*, 1523–24. Kunsthistorisches Museum, Vienna.

77 Norman Rockwell, *Triple Self-Portrait*, 1960, from the cover of *The Saturday Evening Post*, 13 February 1960. Printed by permission of the Norman Rockwell Family Trust. © 1960 The Norman Rockwell Family Trust.

78 Manny Warman, *Presidential Likeness, Low Library*, photograph, 1964. Columbia University, New York.

79 David Hockney, *My Parents and Myself*, 1975, oil. Collection of the Artist. © David Hockney 1975

80 Lovis Corinth, *Self-Portrait with Mirror*, 1925, oil. Kunsthaus Zürich.

81 Artemisia Gentileschi, *Self-Portrait as La Pittura*, c. 1630, oil. Collection of Her Majesty the Queen, Kensington Palace, London.

82 Otto Dix, *The Painter and his Model*, 1923, oil. Private collection (photo: Sotheby's).

83 Francesco Goya, *Self-Portrait*, engraving from *Los Caprichos*, plate 1, 1797–98.

84 William Rush, *Self-Portrait*, 1822, terra-cotta. Pennsylvania Academy of Fine Arts, Philadelphia.

85 Marcel Duchamp, *Wanted, $2000 Reward*, 1923, colour lithograph. Philadelphia Museum of Art. The Louise and Walter Arensberg Collection.